Vows

For Mary & Hermann
Happy Wedding Day
April 26, 1997
All of our love,
from one happy couple
to another ♡♡
Alice & Patrick

Vows

Weddings of the Nineties
from *The New York Times*

Lois Smith Brady with photographs by Edward Keating

William Morrow and Company, Inc., New York

It is the policy of William Morrow and Company, Inc., and its imprints and affiliates,
recognizing the importance of preserving what has been written, to print the books we publish
on acid-free paper, and we exert our best efforts to that end.

Library of Congress Cataloging-in-Publication Data
Vows: weddings of the nineties from *The New York Times*/Lois Smith Brady;
with photographs by Edward Keating.
p. cm. ISBN 0-688-15052-7. 1. New York times. 2. Newspapers—Sections, columns, etc.—Weddings.
I. Brady, Lois Smith. II. Keating, Edward, 1956—
PN4899. N42T586 1997
070.4'493925'097471—dc20 96-22843 CIP

Printed in the United States of America
First Edition
1 2 3 4 5 6 7 8 9 10

Couples I Have Known

Every weekend, I crash a wedding, sometimes two.

Writing about weddings on a weekly basis was not the sort of job I always dreamed of having—I was never interested in flowers, big dresses, ceremonies or rituals of any kind. In fact, I chose my high school, The Putney School in Putney, Vermont, mainly because they had an alternative senior prom—you didn't have to dress up for it. Even better, you didn't have to be invited. Students were *assigned* dates by a committee.

But from the first about-to-be-married couple I interviewed—two modern dancers living in an apartment filled with wind chimes and cats—I developed an interest that verged on nosiness when it came to weddings. For two hours the dancers and I sat drinking herbal tea and talking about how they met, the state of modern dance, soulmates, wedding dresses, characters in their neighborhood, love songs, who does the dishes, where they bought their wedding rings. It became clear that while writing about weddings, I could cover any subject from first kisses to family values in the 1990s to the invitations. It could be a combination of anthropology, gossip, fashion, psychology, home economics and dreams. That is how I have approached all the stories in this book, wherever possible mixing insights into life with descriptions of the flowers.

One thing about love I've learned from my job is that

it is a lot like wine—everyone describes it differently. Some brides and bridegrooms recount falling in love as an incredibly quiet experience, like walking in the woods and knowing you won't get lost. Others compare it to a physical trauma, a type of chills they'd never before experienced. Some were friends for years and found themselves falling in love one night in the middle of a telephone conversation or halfway through sharing an apple. I often hear "It was love at first sight!" but I hear "It was love at hundredth sight" just as often.

I rarely hear about fireworks; the stories I'm told are usually much more subdued, even mundane, than that. One bride told me she knew she was in love when she and her future husband were at a dinner party and she found herself *dying* to butter his bread. For her, love was not about butterflies in the stomach or wishing the phone would ring. It was wanting, more than anything, to take care of her mate. Another bride knew she was crazy about her future husband mainly because she wanted to be with him more than she wanted to watch the Knicks, her favorite basketball team.

I think the most wonderful description of love I've ever heard came from a woman who met her husband at work. "As soon as I met him," she recalled, "my heart lurched toward him and it's never lurched back."

Love in the movies generally arrives like the shark in *Jaws*, accompanied by pounding music and sudden weather changes, but in everyday life it comes in more like an unexpected dinner guest at a party. One bridegroom in this book was riding in a taxi during a late-afternoon rainstorm when he saw his future bride walking down the sidewalk, sobbing. (She had just broken up with a boyfriend.) He was in a melancholy, mystical mood and she seemed like a modern-day angel—wet, not dressed in particularly nice clothes, crying but somehow also glowing. He yelled for the cab-driver to stop and pursued her on foot for about six blocks before she would talk to him.

Another couple I know met at the Seventy-ninth Street Boat Basin in New York City, a community of houseboats floating in the Hudson River. One night, the bridegroom's boat sank suddenly and the bride invited him to

stay on hers until he found another place to live. After he temporarily moved in, he made espresso for her in the mornings and elaborate pasta dinners in the evening, which they ate together on the deck while the sun was setting. Pretty soon, he stopped reading the roommate-wanted ads in the newspaper with any real interest and after a year, they were married. His boat is still at the bottom of the Hudson River.

Meeting the person you end up marrying is rarely the sort of thing you can put down on your calendar. Shortly after I began covering weddings, I met my own husband, in a stationery store near the beach in East Hampton, Long Island. He was looking at Filofaxes; I was buying a typewriter ribbon. I remember his eyes matched his faded blue jeans; he remembers that my sneakers were filled with sand. He thought that was cute. While trying to meet men, I had tried everything from wearing miniskirts to putting on bright blue eyeshadow but I'd never thought of pouring sand in my shoes.

Whether the couples in this book met on a blind date, in the office, on an airplane or at a dinner party in an apartment filled with Matisses and Picassos, most of their stories seem like modern-day fairy tales to me. They are stories that involve things like boat sinkings and broken hearts in the past, about people of all ages who live in five-thousand-square-foot lofts as well as tiny cramped one-bedroom walkups. Some have been divorced before. Some have answered personal ads. Several have gone to church simply to pray for a good date, after sixty-six horrible ones. All have had their prayers answered.

A common thread among them is that glamour, beautiful table decorations, humor and elegance are not found just in the kind of homes and weddings that appear in glossy magazines. Like daisies popping up through concrete, they are all the more amazing when they flourish elsewhere, and they often do. I constantly observe that money alone does not buy heart, style, fun or a great wedding.

Some of the best weddings I've covered have cost hundreds of thousands of dollars but some have cost less than five thousand. One wedding I attended took place in City Hall in a telephone booth–sized room with carpeting

the color of beets and a window that was about as narrow as a ruler. There were no flowers. The officiant yawned throughout the two-minute ceremony. Afterward, the bride and bridegroom and their two casually dressed witnesses walked to a half-empty restaurant nearby and shared a bottle of champagne. Even though the whole thing was over in about an hour, it felt like an incredibly romantic, big, expensive wedding. Small things, like the way the bride and bridegroom looked at each other, or how he held the door for her, made it that way.

A friend of mine, Mallory Samson, photographs weddings and says that when you go to one every week, you really learn the difference between inner beauty and outer beauty. Most weddings have a combination of both, but inner beauty is definitely the trump card. A wedding can be fabulous just because of the good feelings but breathtaking decorations cannot make a wedding. In fact, nothing is sadder than a wedding with gorgeous weather, incredible food, a beautiful bride and a silent dull feeling at the center.

The job of covering weddings has been an unexpected adventure, partly because weddings have become like blank canvases for a couple to draw upon—almost anything is possible and permissible these days. I've watched ceremonies in hayfields, deep forests, ski lodges and cathedrals; one in the middle of a city street; and another on a beach with barefoot bridesmaids. One week, I attended a reception in a tiny Russian restaurant with bright yellow chicken fat as centerpieces; a few weeks later, I went to one in an abandoned airport hangar in Brooklyn surrounded by rolling fog and empty runways.

I'll never forget a wedding that took place during the blizzard of 1993 in New York City. The weather was so bad the minister, Lois Kellerman, had to hitchhike as well as climb six-foot-high snowbanks to get there. One guest arrived wearing ski clothes and carrying what she described as her survival kit—a backpack containing lipstick, food and a flask of whiskey. At another wedding, under a small tent set up in a backyard, the bride placed plastic rings on the tables as gifts for her single friends so they could put them on and feel married for the day, too.

Those are the kinds of things I remember—the quirky heartfelt details, the friends, the look on the father-of-the-bride's face, the toasts and the stories. My favorite weddings make me feel as if I'm reading a high school yearbook—there's a mix of nostalgia, good quotes about life and love and a sense that while one experience is ending, a huge adventure is beginning.

Now, I always cry at weddings, occasionally because the bride is so beautiful it's like watching a movie with Audrey Hepburn in it. But mainly I get choked up because weddings are not the dusty old rituals I once thought they were. Getting married today is more of a challenge than a convention, scary rather than boring, a leap of faith rather than a plunge into housework and nights on the couch watching television. There is nothing certain about it but that's what makes weddings in the 1990s so romantic. At one ceremony I covered, the minister said, "In a sense, the person we marry is a stranger about whom we have a magnificent hunch." At another, a guest compared getting married to throwing a ball of wool out into the world and following it.

On this beat, I have seen lots of awe-inspiring things—a bride arriving at her wedding in a canoe full of yellow roses, another singing love songs with a country band in her long white dress as the guests danced. But I think the most memorable thing about weddings these days is the overall mood that we who are married are all following hunches and little balls of string. And still, we say I do.

Getting married is no longer something you *have* to go through—for your parents, your personal survival or respect from the neighbors. I meet very few brides these days under twenty-five; the only "shotgun wedding" I ever attended was one where the bride, a New York City policewoman, had survived a gunfight several weeks before her wedding. That night, she said to her future husband, "Life is short. Let's get married."

Last summer, I attended a ceremony between a kayaker–house painter and a strawberry blond decorative painter, at the foot of a mountain in Idaho. The barefoot bridegroom recited vows he had written, including a line I think says everything about weddings today: "I could live without you," he told his bride. "But I don't want to."

Vows

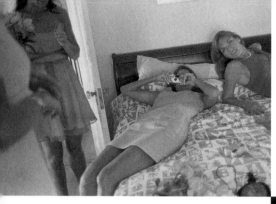

Stephanie Mooney *and*
Christopher Clark JUNE 18, 1994

"Every now
and then you
heard a couple
of words, such
as 'will you
honor,' and
then the sound
of the waves."

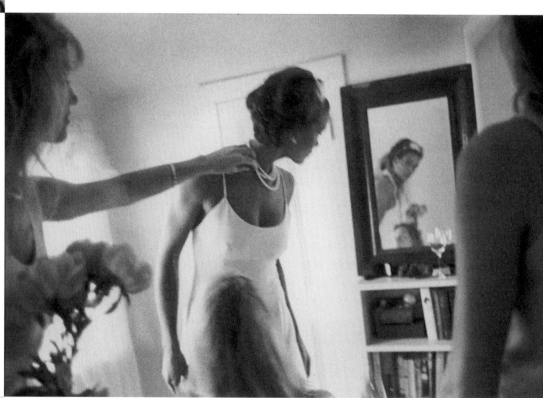

Christopher Clark, the thirty-six-year-old president of the Clark Construction Corporation in TriBeCa, is well known for the parties he gives at his old, shingled oceanfront house in East Hampton, Long Island.

Almost every weekend, the house fills up with friends (and friends of friends) who play touch football on the beach, go in-line skating and surfing, organize big sit-down dinners and bang on an old piano that's painted the color of a lobster, creating an atmosphere that one regular house-guest described as "misspent youth over thirty."

Peter Moore, an architect in New York and a longtime friend of the bridegroom's, said, "Chris's house parties have been famous for the last fifteen years. He's a great host be-cause he really doesn't bother you too much. We just walk in, sit down and start partying. It's the same people year after year. They never lose the scent."

Two years ago, on the Fourth of July, Stephanie Mooney had no plans for the weekend and ended up accompanying a friend to Chris's house. Stephanie, whom some call "Moonlight," is a thirty-year-old model who rides horses and is often described by friends as a cross between Jacque-line Kennedy Onassis and Lucille Ball—a dark-haired beauty with the zany vivaciousness of a stand-up comedian.

Stephanie remembered her first visit to Chris's home this way: "It was a *Big Chill* weekend," she said. "It was a great, fun group of people. Probably the best moment was when we all went and sat in the sand and kidded around and had a drink and watched the sunset. I never wanted it to end, and it never has."

Last September, Chris proposed while they were vaca-tioning in a seaside cottage lighted by kerosene lamps on Tuckernuck, an island off Nantucket, Massachusetts. "He had the ring in a manila working envelope from the city," Stephanie recalled. "It wasn't in a big, contrived box. That's very Chris: He's a bottom-line, businesslike guy."

On June 18, in the early evening, they were married on the beach outside the house in East Hampton. About one hundred guests wandered down a path lined with wild beach roses, kicking off everything from Belgian loafers to Converse sneakers.

Once gathered on the sand, everyone watched the wed-ding procession make its way over the dunes. There were ten barefoot bridesmaids, most of them professional models, who wore short, sleeveless summer dresses in different col-ors, from seashell-pink to the light-green shade of dune grass. They were so stunningly beautiful that at least one guest wondered aloud whether the event was a fashion shoot or a wedding.

"This is like the model Olympics!" said Nathalie Smith, a guest who is a fashion stylist. "I think I'll go home now. No man is going to talk to me at this wedding."

The bride arrived in a cream-colored gown with spaghetti straps and a diaphanous chiffon stole that billowed and flut-tered as she walked over the dunes. The civil ceremony was as ephemeral as the bride's outfit: With the ocean roaring in the background, it seemed to be made up mostly of whis-pers, breezes and mist.

"Every now and then, you heard a couple of words, such as 'will you honor,' and then the sound of the waves," said Annabelle Selldorf, a guest who is an architect in SoHo. "It was incredibly beautiful and romantic."

Everyone returned to the house for the reception, which was like a large version of the bridegroom's weekend parties, with one guest playing the red piano and others reminiscing about old times.

"Chris has gone through many stages," said Caio Fon-seca, a painter and a longtime friend of the bridegroom. "He's been the rebel, the bohemian, the go-getting busi-nessman; today, he became the mellow, loving husband we always hoped he would be."

Kathy Phillips *and*
Jake Daehler MAY 16, 1992

"Kathy was
this totally wild
person.
She hitchhiked.
She went
hang gliding.
She ran with bulls
in Spain."

When Jake Daehler, a thirty-three-year-old actor, met Kathy Phillips, a thirty-one-year-old bike messenger, it was not love but fear at first sight.

"We met four years ago in an acting class," Jake remembered. "Kathy was this totally wild person. She hitchhiked. She went hang gliding. She ran with the bulls in Spain. I remember I saw her on the street once: She was on her bike, smoking a cigarette and wearing this nutty Mary Poppins hat and a cat suit. I thought, 'She's cute but probably criminally insane.'"

Jake is the opposite: a self-described Felix Unger type who always uses a place mat at dinner and drove a station wagon rather than a hot rod when he was a teenager. "I love his manners and control," Kathy said. "He loves my out-of-control."

On Saturday, May 16, they were married at the Biodome, a loft-and-rooftop space in a brownstone on East Forty-third Street in Manhattan. The Reverend Claire North performed the rooftop ceremony, which was written partly by Jake and included lines like "Your journey together has often been bumpy, especially in the last couple of weeks" and "This marriage is truly a testament to the effectiveness of the analytical process." (Both Jake and Kathy are in couples therapy, group therapy and psychoanalysis.)

After they were pronounced "wife and husband," most of the guests headed down to the loft, but Patricia Scanlon, a playwright, lingered. Wearing a black velvet dress and lavender boots, she said, "That was such a funny, unpretentious ceremony. It was so Jake and Kathy. They didn't hide the fact that having a relationship is tough stuff."

The bride, who was also on the roof, suddenly lifted her Victorian dress to reveal brown lace-up riding boots, neon-green socks, a garter belt and a snake tattoo on her right thigh.

In the loft, many of the guests were under forty and dressed like Julia Roberts or Daryl Hannah, in mismatched skirts and tops, cowboy boots, campy or oversized thrift-shop jackets and retro eyeglasses.

Guy Veryzer, a ceramics artist, wore six medallions picturing Greek gods around his neck. "They're my past lives," he explained.

Several people introduced themselves using slashes, as in "I'm a stand-up comic slash photographer slash aerobics instructor."

At one point, Jake gave a speech in honor of his new wife. He quoted a J. D. Salinger story in which the narrator advises the reader, "Never marry no ordinary dame . . ."

During dinner—vegetarian lasagna and Caesar salad—most of the guests gathered in the kitchen, where there was the kind of camaraderie you might find in the smoky back room of a small-town café. Everyone drank wine out of plastic cups and used paper plates.

"This is a very no-frills wedding," said Ben Dimmitt, a photographer among the guests. "It's just a bunch of people sitting around seeing each other."

Before the carrot wedding cake was cut, the bride and bridegrooms' psychotherapists each delivered a toast. The groom's therapist began: "When I first met Jake, he used to dream he was bald. This obviously did not correspond with any reality." She added: "But Kathy is perfect for Jake. He is now a guy who no longer feels bald."

Janet Cross *and* Steven Holl NOVEMBER 11, 1992

When Steven Myron Holl proposed to Janet Olmsted Cross, a fellow architect, he didn't give her an actual ring; he gave her a *rendering* of a ring. "At our engagement party, we passed the drawing around among the guests," recalled Janet, who works with Steven in New York and whose great-great-grandfather was Frederick Law Olmsted, the designer of Central Park.

Like many of the buildings Steven and Janet work on, their wedding was simple and spartan, with many references to poetry, music, nature and mathematics. The time of the ceremony was, as the bride put it, "a number puzzle." It took place on Wednesday, November 11, at eleven minutes past eleven in the morning, a detail that invited guests

to search for more elevens in the wedding, like looking for Ninas in an Al Hirschfeld drawing. There were plenty to be found, among them the eleven-year age difference between the bride, who is thirty-three years old, and the bridegroom, forty-four.

Just before 11:11 A.M., thirty-three guests huddled together inside the Chapel of Our Lady Restoration, a small, unheated chapel built on a rock alongside the Hudson River in Cold Spring, New York. When the bride arrived, in a long white chenille sweater dress, she paused in the entryway—smiling, shivering, statuesque—with the river and the Catskill Mountains behind her.

The wedding seemed at times like a poetry reading, not

> "The person we marry
> is a stranger
> about whom we
> have a magnificent
> hunch."

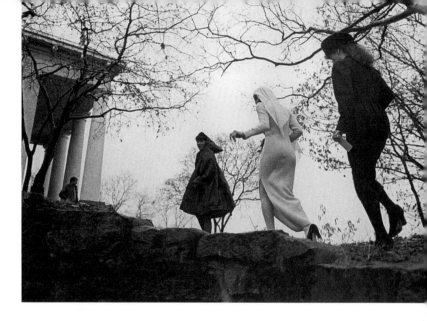

only because works by Carl Sandburg, Walt Whitman, Robert Bly and Rainer Maria Rilke were read but because the officiating Presbyterian minister, the Reverend Leonard Rust, described marriage in such romantic, mysterious terms. "In a sense, the person we marry is a stranger about whom we have a magnificent hunch," he said.

A few guests contributed to the ceremony in ways that reflected Mr. Holl's playful, intuitive architectural style. Mark Mothersbaugh, a former member of the band Devo, played tunes on the organ ranging from "God Bless America" to the *Jeopardy!* theme song.

"I decided to become a human Ouija board and let the moment reign," Mr. Mothersbaugh said. "I was as shocked as anyone when 'God Bless America' came out."

Afterward, guests walked to the reception at Hudson House, a country inn, where the wide plank floors in the dining room were covered with autumn leaves, a decoration chosen by the bride. "The actor Klaus Kinski had an apartment in Paris with leaves on the floor," she said. "He never had to sweep; he just added fresh leaves. I guess you could say the leaves are in memory of him."

One guest, Ken Kaplan, an assistant professor of architecture at Harvard University, called the wedding a major architectural statement. "So many architects believe the only way you can make it is by being a solitary *Old Man*

and the Sea loner," he said. "This marriage sends out the message that architects can have love in their lives, too."

The couple, who once lived in a tiny apartment downtown overlooking a church and a cemetery, recently moved into a four-story house in the West Village, a block from the Hudson River. "We used to look out the windows and watch nuns shoveling the snow," said the bride. "Now we look out the window and see the river."

When asked to describe their new house, the bride said it perfectly fit her definition of *home*. "It's a place of refuge, of rest, of celebration, both intimate and with friends, and a place to keep all of our books," she said.

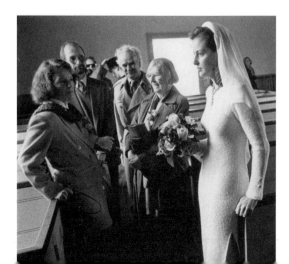

Felicia Thomas *and* Walter Parrish NOVEMBER 27, 1993

"Yes,
ministers
have love
lives!"

T he Union Theological Seminary, on the Upper West Side of Manhattan, is a Gothic-style building with high stone walls, ornately carved towers and heavy wooden doors. It looks like a nineteenth-century monastery, the sort of place where a vow of silence is required to get in and mountain-climbing skills are needed to get out.

When Felicia Thomas entered the seminary as a theology student in 1987, not long after graduating from Mount Holyoke College, she did not expect to drink a beer ever again or to listen to anything but gospel music, let alone fall in love. "I thought, 'Oh, these people will be so holy and I won't be able to date or dance and have fun,'" she recalled. "I didn't know whether to be scandalized or relieved when I got here and found out they have plenty of parties, and you can bring your own liquor."

In her first year, she met Walter Parrish, a fellow student who rode a motorcycle, played tennis and was an avid fan of the Union's basketball team, called Air Jesus. Both are now ordained ministers known for their contemporary, down-to-earth preaching styles. Felicia, who is thirty-one and has just been named pastor of the First Baptist Church in Princeton, New Jersey, often talks about feminist issues or her own love life during sermons. "I was preaching recently and I said I would never marry a man who doesn't cook," she said. "There is only so much Chinese take-out food in New York."

Walter, who cooks and still rides a motorcycle, always carries a Bible in his pocket, a small one that's about the size of a DoveBar. He is thirty-four and an executive on the Ministers and Missionaries Benefit Board of American Baptist Churches, which is located at the Interchurch Center, a modern building in Manhattan known as God's Box.

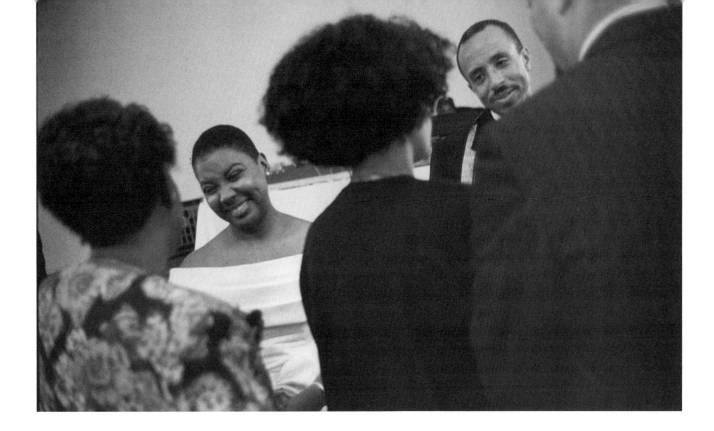

The two were married on November 27 at the seminary, in the James Memorial Chapel, a "flexible worship space." Almost everything but its stone walls and stained-glass windows is portable. Couples who marry there are allowed to rearrange the pews, refurnish the space and replace the crosses on the walls with their own spiritual symbols.

Walter and Felicia decorated the chapel simply. Their three hundred or so guests sat in chairs around a center aisle that was covered by a runner as blue as a Hockney swimming pool and strewn with red rose petals.

Unlike many weddings, the ceremony was much longer and more elaborate than the reception. It lasted nearly two hours and was filled with readings, hymns, vows written by the couple and musical performances of all kinds. The wedding party was escorted into the chapel by three women who wore traditional African robes and played drums and cowbells; a gospel ensemble sang; and Regina Carter, a friend of the couple, performed a series of slow, moody, twangy blues songs on an electric violin.

"Most people have a five-minute ceremony and spend thirty thousand dollars on the reception," said the bride. "We wanted to concentrate on the worship."

Afterward, guests gathered briefly for coffee, fruit punch and cake in the seminary's social hall. Janet Cooper Nelson, the chaplain at Brown University, was among them. An old friend of the bride, Ms. Nelson reminisced about the many nights they had stayed up together talking about everything from spiritual issues to the Oscar awards to men.

"Yes, ministers have love lives!" she said. "Felicia and Walter have a wonderful love affair, full of dips and swoops and twirls and spins, and tough times, too."

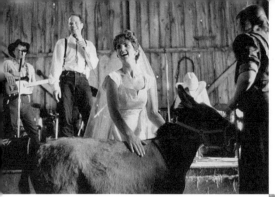

Susan Hawe *and* Marc Parent

June 27, 1992

"Marriage is a
big deal no
matter how cool
or modern
you get."

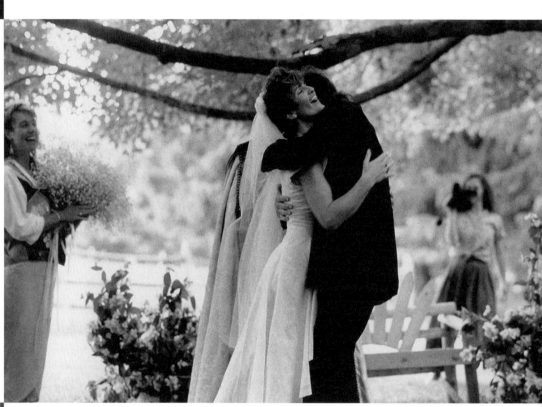

Four years ago, Marc Parent and Susan Hawe were living in a tiny, crowded apartment in Greenwich Village. "There were three guys, two bedrooms and three girlfriends," Marc, an actor, recalled.

Many of the roommates—Marc and Susan among them—had moved to New York from rural Wisconsin, and at night they would play country music together, with two of the guys on guitars, one on pots and pans, and Susan, now a teacher at St. Luke's School in the Village, singing.

The mood of those nights was recaptured in their wedding. Marc and Susan, both twenty-nine years old, were married outside an eighteenth-century stone house on a farm owned by friends in Stillwater, New Jersey. The ceremony began shortly after someone rang the porch bell and the Reverend Molly McGreevy, an Episcopal priest, yelled toward the house, "Is the bride and her party ready?" While one of the guests played "Blue Ridge" on the harmonica, the bride, who wore white, and her three bridesmaids, who wore denim, loped down the porch steps holding hands. They all wore cowboy boots and looked as though they were on their way to a square dance or a picnic down by the creek.

Most of the 140 guests were dressed for the farm, in jeans, work shirts, cowboy hats, bolo ties and flowered dresses. During the ceremony, friends stood up to sing songs they'd written or read poems aloud while the bride and groom sat in Adirondack chairs next to pails full of flowering mock orange branches.

Though the wedding seemed as if it had been as easy to arrange as a bunch of daisies, it actually took months of careful planning to keep it so simple. "The institution of marriage is very commercial," Marc said. "It's easy to do everything people tell you to do and just pay for it. But if you want the wedding to be an expression of yourself, it's a lot more work. I looked for a wedding ring for eight months until I found one that didn't look like all of my best friends' mothers' rings."

The guests—a mix of people from Manhattan; from Wisconsin, where the bride and groom grew up; and from Stillwater, where they often spend weekends—gathered in a tent near the barn for lunch at tables decorated with wild flowers in mason jars. The meal was a community effort. The groom baked the bread; a local dairy farmer roasted the pig on a spit; and Elizabeth Anderson, who raises sheep down the road, made the apple pies (in lieu of a wedding cake).

Netta Lavalle, a guest who runs a local Christmas tree farm, called it a true Stillwater wedding: "You have a pig. You have beer. You have country music, although usually it's on a cassette player. You have horseshoes, animals in the backyard, and everyone's in T-shirts and cowboy boots."

After lunch, country music and dancing began in the barn, where swallows, cats and dogs wandered in and out of the open doorways along with the guests. A local band, Sundown, played songs about lonesome pines and blue northern winds, the kind of music that makes you feel in love, whether or not you are.

At one point, the band members pulled the bride up onstage (actually a hayloft), where she took the microphone and sang "Someday Soon." Flanked by hay bales and country musicians, she closed her eyes and sang in a gutsy, heartfelt way while guests slow-danced and two stepped in their cowboy boots around the barn. Later in the afternoon, the bride and groom thanked the owners of the farm for hosting the wedding and presented them with a surprise gift—a donkey.

"Marriage is a big deal no matter how cool or modern you get," said Eric about a week before the wedding. "It's huge, and it means something. Even though we've been together for ten years, it still feels like a giant step."

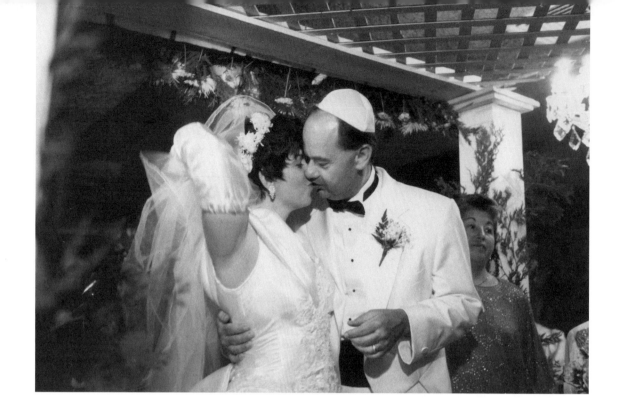

Bonni Nieschawer *and* William Smith June 14, 1992

Bonni Ann Nieschawer rarely notices that William Smith is twenty-two years older than she is, except when they're together on a dance floor. "He knows the lindy, the double lindy, the fox-trot, the cha-cha," she said, as if speaking of impossible algebra problems. "I had to take lessons!"

But others notice their age difference all the time. "When some people meet us, it's like they're watching a tennis match," said William, who is fifty-two years old. "Their eyes go from me to her to me to her. It's like they're watching McEnroe or Connors. We know they're wondering about us. Our attitude at this point is 'Who cares? We've put our flag up; the land belongs to us.'"

The role of explorer did not come naturally to Bonni, who belongs to an organization called Wives of Older Men (girlfriends and fiancées are also welcome). The approximately four hundred members of the group, which is headquartered in Tinton Falls, New Jersey, often meet, write or call each other to discuss issues such as bringing an older man home to meet your parents; explaining the romance to peers, who call him everything from a fossil to a father figure; and getting along with his children.

"My children are cool about it," said William, a salesman for National Credit Systems in Manhattan, who was divorced from his first wife more than ten years ago and has two children in their early twenties.

"When some people
meet us, it's like
they're watching a
tennis match.
Their eyes go from me
to her to me to her."

Bonni, who works for the Private Label Manufacturers Association in Manhattan, added: "The big question for us was, 'Will Bill want more children?' That took us a year to resolve. He wasn't sure he wanted to go through raising another family."

He finally decided he did. "It's latish in life, but doable," he said. (As a side job, Bonni also sells and promotes a new vitamin that supposedly slows the aging process. Bill now takes it daily.) They were married in Brooklyn, in a room decorated with mirrors, chandeliers and a *huppah* covered in white spider mums. The bridal party was as intergenerational as the couple—Mr. Smith's twenty-four-year-old son, Stephen, was the best man; the maid of honor was fifty-nine-year-old D. Rebecca Fleischman.

Many of the seventy guests remarked on the fact that the bridegroom's former wife, Barbara Smith, was present. William, who also invited one of his former girlfriends, explained, "If someone was wonderful in your life for a period of time, but it didn't work out in the long run, that doesn't mean they suddenly become Darth Vader and the symbol of all evil. Why cut a relationship off completely just because it wasn't forever?"

Among the guests, there were more than a few couples who had crossed the lines of religion, race, generation or language. One engaged couple, Judith Ray, thirty-three, and Frank Viollis, forty-four, met at a Jack LaLanne gym. Besides the fact that she's Jewish and he's Greek Orthodox, they have a height difference—he's five feet four and a half inches while she's five feet ten.

"They say men have to be taller than women," said Adam Marcus, an usher. "But look, Frank is half the size of Judy. Anything is possible!"

Francine Friedman *and* Arun Alagappan SEPTEMBER 2, 1992

"Some saris are
made of silk and pure
silver threads.
If you melt them
you'll end up
with a ball
of silver. I melted
my mother's
wedding sari into
a silver dish."

They didn't choose their wedding date in the usual way, which sometimes boils down to "Pick a weekend, any weekend!"

Following Indian tradition, the bridegroom's father, Dr. Alagappa Alagappan, the founder of New York City's first major Hindu temple, consulted religious elders before arriving at an "auspicious" date for the wedding.

For Arun Alagappan, thirty-three years old, and Francine Friedman, thirty, the favorable time was nine A.M. on Wednesday, September 2. At that hour, about two hundred guests gathered in the auditorium of the Hindu Temple Society of North America, in Flushing, Queens. Tinsel streamers, crepe wedding bells and silver stars decorated the room, and many guests wore hot pink or turquoise and gold saris.

"Some saris are made of silk and pure silver threads," said Victoria Ambrose, an Indian guest. "If you melt them, you'll end up with a ball of silver. I melted my mother's wedding sari into a silver dish."

The bridegroom wore white silk pants, a white shirt and a turban decorated with pearls and a peacock feather. The bride, who is not of Indian descent, wore an azure and magenta silk dress with a long braid of roses and mums that hung down her back like a floral hair extension. During the ceremony, they sat cross-legged on the stage, smiling but rarely speaking while a Hindu priest, T. R. Rangarajan, performed one allegorical rite after another. Chanting in Sanskrit, he threw curried rice at the couple, to bring them prosperity; tied red ribbons around their wrists, to protect them on the "householder's journey"; and planted seeds in a silver urn filled with soil to represent the germination of their union. The rites, nearly two hours long, ended soon after banana-and-honey paste was applied to the bride's lips, to give her a taste of the sweetness of married life.

The bridegroom, who founded Advantage Testing, a test preparation and tu-

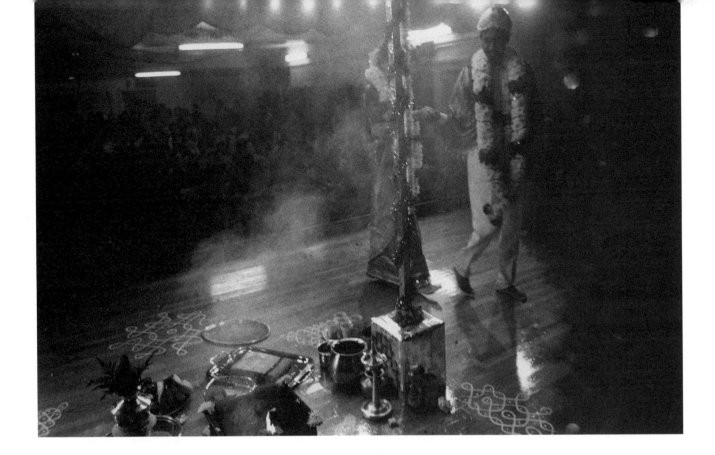

toring service in Manhattan, said, "I like symbolic and allegorical elements in weddings because allegory makes the intangible ideas of love, loyalty and commitment accessible to everyone." The bride works in the creative department of FCB/Leber Katz Partners, an advertising agency in Manhattan.

Before traveling to the lunch reception at a nearby Indian restaurant, guests were offered coffee, candies, fruit, crushed lentil doughnuts, spicy rice with cashews and a dab of rosewater perfume—as if they were setting off across the desert on foot and needed to both fortify and beautify themselves.

At lunch, the only Western course was a chocolate cake, and conversations were reminiscent of late-night talks at college. Among the guests were professors, graduate students and classmates of the bridegroom from Harvard Law School, and they deconstructed and analyzed the wedding as if it were a long poem.

Andrea Nelson, currently a graduate student at New York University, said, "The ceremony was a very societal event. There was less emphasis on who the bride and groom were, or how they met, and more on the bond and all these mystical ways of bringing two people together."

In Indian terms, the couple made a "love marriage," not one arranged by their parents. They met seven years ago through friends. Despite their different religious and cultural backgrounds, the bride said, "We both have an ecumenical view of the world. We believe in strong, extant religions and enduring traditions, but we also feel that ultimately everyone is the same."

Candice Solomon *and*
Louis Michel Doyon FEBRUARY 14, 1993

"I think every
bride wants to
look like a
princess, in
some sense of
the word."

As guests arrived at Louis Michel Doyon and Candice Solomon's wedding, the big question was, What will the bride be wearing?

Candice, who owns a bright red Harley-Davidson motorcycle and has cropped blond hair, is a wedding dress designer. Her tiny pink shop downtown, One of a Kind Bride, is filled with dresses inspired by Christian Dior ball gowns from the 1950s, ballerina costumes and the wardrobe of Glenda the Good Witch.

"A lot of women get married later these days, so they're afraid to go for their fantasy look, but I think every bride wants to look like a princess, in some sense of the word," Ms. Solomon said. "They want to be a vision, a real vision, something that does not look real."

Candice, who is thirty-one, met Louis Michel, twenty-three, at a downtown nightclub that changes its name each week. He is an actor, motorcyclist, roller blader and romantic who often literally carries her through the streets of SoHo, singing love songs.

They were married in a loft on Spring Street that belongs to the Cuban floral designer Luis Collazo. About eighty chairs were set up amid candles, flowers, photographs of sumo wrestlers and Mr. Collazo's collection of Cuban artwork, including sculptures made out of everything from paper to mesh wire.

Most of the guests wore white, as the invitation had requested, and, once assembled, they looked like a gang of beautiful, eccentric ghosts. Everyone seemed to have a precise, scholarly knowledge of his or her outfit. The fashion designer Juan Pisonero arrived in white chaps, pointy boots and a neck scarf tied in a style, he explained, "that began just after the beheading of Marie Antoinette."

The ceremony was like a fashion show for friends. While "Old Love," an Eric Clapton song, blared over the speakers, nine bridesmaids walked down the makeshift aisle in white outfits they had either designed or chosen themselves.

The first, Titi Chimenti, wore a linen Empire-style gown and had a sculpture of feathers and fake birds in her hair (she called it "the love nest"). Another, an actress named Essence, appeared in blue granny glasses and a spandex full-length gown that she later transformed into a minidress.

"We're like Candice's rainbow tribe," said one bridesmaid, Amy Hogan-Bibb. "We all have very different personalities and styles. She wanted it to show through."

As in many fashion shows, the bride appeared last and she definitely was a vision. Wearing a white top hat, a pearl choker and an Edwardian dress that would fill an elevator to capacity, she received a standing ovation.

Willy Lama, the Chanel sales director for Bergdorf Goodman, called her a "neoromantic queen" and said, "It was like candy coming down the runway!"

Almost immediately after the couple was married by the Reverend Darrell Berger, a Unitarian Universalist minister, the dancing began. A disk jockey stationed behind a metal sculpture played Cuban and club music while the guests did everything from slow-dancing to something that looked like improvisational aerobics.

Watching them, Therese Marie Wagner, a wedding photographer and guest, said, "I feel like I'm from Ohio!"

Occasionally, the antic celebration was punctuated by the observance of an old-fashioned tradition such as cutting the cake, a small, delicate one decorated with purple candy grapes and green sugar ivy from Gail Watson Custom Cakes in New York.

In many ways, the wedding set the tone for the marriage, which the bride envisions as partly traditional (he'll bring her flowers and carry her knapsack for her) and partly like an adventure on a motorcycle. "Louis Michel will never be a couch potato," she said. "He *lives*."

Josefa Mulaire *and* William Tester MAY 31, 1992

"Billy popped the question to Josefa when they were on a driving trip out West. He said, 'Honey, would you hand me the cookies and, by the way, will you marry me?'"

66Bring your umbrella," Josefa Mulaire said a few days before her wedding. It was good advice. During a downpour on May 31, she married William Tester in the backyard of her childhood home in Hastings-on-Hudson, New York. Throughout the ceremony, they stood on the bride's favorite spot in the yard, holding umbrellas that buckled in the wind, while about ninety guests watched from a nearby tent. The rain soaked the bride's dress, splattered the groom's eyeglasses, leaked through the roof of the tent, ruined hairdos and turned the ground to mud. But in the end, the monsoonlike weather only added to the merriment.

The wedding was a mix of the traditional, the alternative and the mystical. Josefa, thirty-four years old, is a bartender at El Teddy's restaurant in Manhattan and an artist. She wore a thirty-five-year-old wedding dress that belonged to her aunt, and was so big and puffy it knocked down chairs as she walked through the tent. William, a novelist, wore a morning suit in the oldest style he could find at Baldwin Formals in Manhattan.

The ceremony was performed by the Reverend Melissa Townsend, a Gnostic minister who also reads tarot cards at El Teddy's. Reverend Townsend often read the couple's cards during their eight-year relationship, guiding them through breakups, reunions, anxiety over book reviews and career changes. "I really believe if ever there were two people who will be together, it's Josefa and Bill," she said. "The readings have confirmed that."

In the tent, everyone sat at round tables that were decorated with gifts, including windup toy monsters and miniature boxes containing plastic rings, for

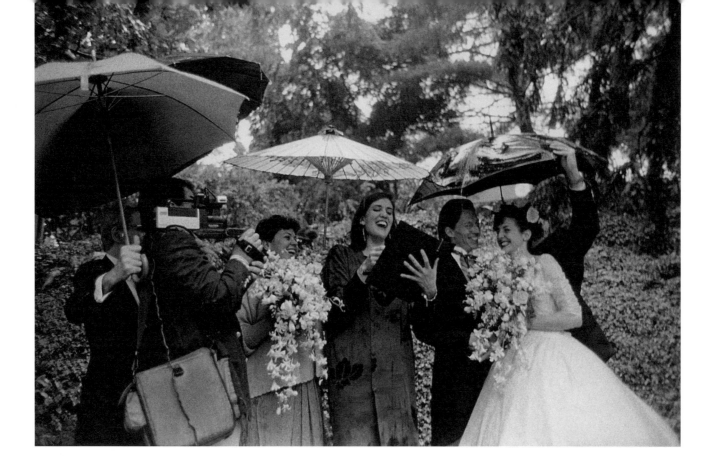

guests who were without them and might want to wear one for a day.

The band, an all-male trio that was stationed in one corner of the tent, was called the Unwed Dudes. Decked out in bowling shoes and red suspenders, the musicians played everything from "Amazing Grace" to "Singin' in the Rain," on instruments ranging from an 1886 fold-up organ to a cello that hadn't been touched in ten years.

The groom's older brother, Ken Tester, surveyed the dripping tent, muddy ground and crying babies and said: "Bill and Josefa love chaos. The more chaotic, the more unplanned, the more at home they feel. Did you hear their proposal story? Billy popped the question to Josefa when they were on a driving trip out West. He said, 'Honey, would you hand me the cookies and, by the way, will you marry me?'"

The one element of the wedding that went as planned was the feast, which was so well orchestrated, the bridegroom compared it to a military invasion. The buffet table looked like one at a picnic in Tuscany—there were baskets filled with homemade loaves of bread, a salad bowl of edible flowers, *crostini*, a white bean salad with sage and artichoke hearts, and an enormous poached salmon.

William, who grew up on a cattle-and-produce farm in Ocala, Florida, said, "This wedding started out as a quiet, sit-down picnic. But if you live in New York, you can't just have cold cuts and white bread. You have to have pâté; no, venison pâté; no, venison pâté with sun-dried tomatoes on top."

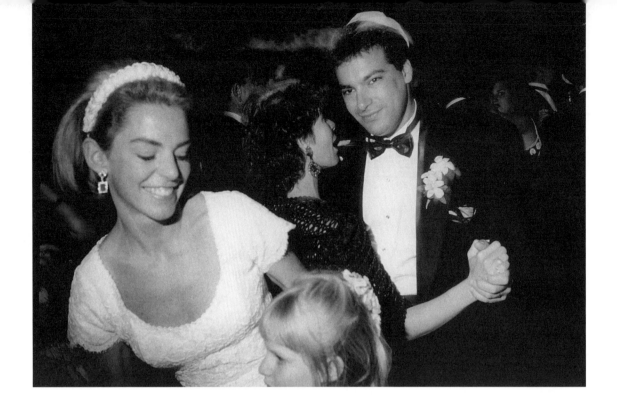

Elizabeth Egan *and* Emmanuel Stern JUNE 21, 1992

66 I always thought I'd get married in the woods with the chipmunks," said Elizabeth Egan, twenty-seven, a schoolteacher in Manhattan who grew up in Southern California and still goes barefoot whenever possible.

Both Liz and Emmanuel Stern, whom she met four years ago, like to spend their free time in the wilderness, in places where they have to hang their food in the trees so that the bears don't eat it. Their idea of a great vacation together is to hire a bush pilot to fly them into the backwoods of Maine, drop them off with a canoe and pick them up a week later.

"If two people can get along and survive in the wilderness together, there's nothing else they can't overcome together," said Liz.

Emmanuel, who is a twenty-nine-year-old real estate developer, proposed to Liz in the city—on the rooftop of his apartment building, which was accessible only by a ladder. "He said, 'I'm going up on the roof, do you want to come with me?'" she recalled. "As I got higher and higher, I saw a table and a woman in black tie pouring champagne." (Their proposal dinner was catered by Glorious Food in New York.)

On Sunday, June 21, they were married in the one place in Manhattan that has woods and chipmunks, as well as polar bears, monkeys, penguins and puffins: the Central Park Zoo.

It was not, however, a rustic affair. Many of the three hundred guests arrived by limousine, and all the men wore

"There's nothing like an outdoor wedding. It shows confidence and optimism in both the weather and the marriage."

black tie. Nevertheless, the wedding felt at times like a simple ceremony in the wilderness. The bride and groom said their vows next to the seal pond, beneath a *huppah* of twigs, vines and flowers that looked as fragile as a bird's nest. While they took their vows, sea lions barked in the background and tropical birds let out jungle calls. "This is like being in the wilds off Fifth Avenue," said one guest.

Afterward, as the sun was setting, everyone gathered for cocktails outside the penguin house. Some guests were happy to be surrounded by so many wild things. Kirk Scott, a computer software designer in a ponytail and a friend of the bride, said: "This is a society wedding, but everyone feels comfortable because they can go and look at the animals. It's a leveler."

Another friend, Bryan McCormick, agreed. "Polar bears don't care how we're dressed or where we come from," he said.

Robert Abrams, the New York State Attorney General, said: "As one who was married in the New York Botanical Garden in the Bronx, I can fully appreciate this venue for a wedding. After I told my parents I wanted to be married outside, my mother called me every rainy day, saying, 'Look what it's doing outside! What if it rains on your wedding day?' There's nothing like an outdoor wedding. It shows confidence and optimism in both the weather and the marriage."

Dinner was served near the monkey habitat, in a tent decorated with life-size topiaries shaped like lions, bears, a giraffe and even an ostrich wearing a garland made out of white orchids. At the center of each table were rose mallows that looked like tall pink lollipops.

Before the kosher-southwestern feast was served, everyone gathered on the dance floor to do the hora. Women wearing couture dresses and high-heeled mules held hands and danced in a circle as if they were stomping the floor in a country-and-western bar. "I bet the monkeys are freaking out right now!" yelled one guest.

The next day, the bride and groom left for their honeymoon, in Venice and Turkey. They had very few hotel reservations and no definite plans. "Waking up and deciding what to do is the way we like to travel," the bride said. "We have a lot of responsibilities in our lives, so whenever we get a chance to fly by the seat of our pants, we take it."

Julie Halston *and* Ralph Howard

AUGUST 9, 1992

"It's fatal attraction that worked. I don't have to pull rabbits out of boiling water. He's offering marriage!"

The comedienne Julie Halston, thirty-five, is often described as a cross between Joan Rivers and Hayley Mills. She's blond, hilarious, improper when she wants to be and always optimistic, no matter what she's going through. At the time of her wedding she was working on a television show based on her one-woman Off-Broadway show, *Julie Halston's Lifetime of Comedy*.

"It's about a girl from Long Island who is divorced and moves into the city and she's trying to find love in all the wrong places and she wants desperately to be a celebrity and she has a gay roommate," she said. "It's my life on television."

That is, it *was* her life, until she met Ralph Howard, fifty-one, an anchor and entertainment reporter for WINS Radio. They met a year ago, when he interviewed her for WINS. Ms. Halston's press agent, Sam Rudy, recalled the interview: "Julie was answering the questions in a tone I was unaccustomed to hearing from her—a breathy, girly tone. I kept thinking, 'Turn on the juice!' Then I realized she *was* turning on the juice. It was just a different kind of juice."

On Sunday, August 9, in a small room at the Algonquin Hotel decorated with framed *Playbills*, thirty guests watched Julie and Ralph tie the knot. When the bride emerged from the elevator wearing a dress with a halter top and dangling earrings, she whispered to a guest, "Do I look like a drag queen?"

The ceremony, conducted by both a Roman Catholic and an Episcopal priest struck a balance between Scripture and comedy. The couple recited short tributes to each other. Hers included lines like, "I love you so much, I'll even listen to you once in a while." His began, "Julie didn't blink when I told her I had five children."

While the ceremony was small and private, the reception was an extravaganza and open to the public—it was a cabaret show, fund-raiser and campy celebration of matrimony all at once. It began at seven P.M. in the Algonquin lobby and was organized like one of the bride's theatrical productions—there was a long line to get in; ushers handed out programs describing the night's entertainment; and there was a title for the event, "Our Love Is Here to Stay."

Unlike most weddings, total strangers were welcome. They could buy a ticket for fifteen dollars at the door, and proceeds from the ticket sales were donated to Broadway Cares/Equity Fights AIDS. (In lieu of wedding presents, the couple also asked guests to make donations to the cause.)

About four hundred people, a mix of friends and strangers, showed up. Many worked in the theater or loved theater so much, they could recite passages from obscure turn-of-the-century musicals. No one seemed to find it strange that some guests had never met the couple before or that the receiving line was open to all. "Julie lives for her public," said Ed Taussig, a friend who is an associate creative director at Grey Advertising. "Her best friend is her audience."

Everyone eventually settled into the Algonquin's eclectic collection of old-fashioned sofas and armchairs and the lights went down. On a small, spotlit stage in the corner, cabaret stars such as the Wiseguys, Baby Jane Dexter, B. D. Wong and Charles Busch—all friends of the bride and groom—stood up one after the other to sing about love and marriage. No one seemed to take the subjects of romance and long-term commitment too seriously. Jeff Harner sang "Matrimonial Stomp," a song that portrays family life as a combination of nonstop work, noise, fast food and unhappy children.

Throughout the performances, the newlyweds laughed, sang along and stared at each other. "I'm horribly in love with Ralph," the bride said. "I think about him all the time. It's fatal attraction that worked. I don't have to pull rabbits out of boiling water. He's offering marriage!"

Mimi Lister *and* Sheldon Toney AUGUST 15, 1992

Mimi Lister, twenty-eight, and Sheldon Toney, twenty-six, started dating six years ago, when they were both undergraduates at Howard University. Like the school year, their romance had several long breaks.

"We split up for a year once, but we kept calling each other," Mimi said. "In my mother's day, that was known as sweethearting. People would break up but stay in contact by letter or phone to see if the relationship would spark up again. For us, it did."

Like the couple's courtship, their wedding contained more than a few rituals from their parents' era. The bride's father, who grew up in Bermuda and has a British-Bermudan love of pomp and formality, planned the entire event. He chose everything, from the invitations in Old English script to the bride's lace wedding gown, which was so elaborate it looked harder to assemble than a VCR. "Most girls take their girlfriends to look for a dress," said the bride, a social worker. "I took my dad."

The ceremony, held on a Saturday afternoon at the Fellowship Deaconry in Liberty Corner, New Jersey, was conducted by the Reverend Herbert Groce, an Episcopal priest. His booming baritone voice had exactly the effect the bride's father wanted—it created a combination of mortal fear and goose bumps. "I really believe the couple should be struck with the solemnity of what they're getting into," said Mr. Lister.

"I'm real happy about the ball-and-chain aspect of marriage. I have nothing bad to say about it."

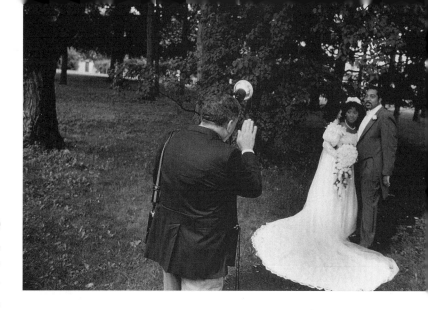

After the ceremony, as is customary in Bermuda, the 220 guests and the bridal party formed a long procession of cars, all with their headlights on, and traveled together in one unbroken line to the reception. Following back roads, the procession wound quietly past farms and country estates, eventually ending up at the home of the bride's parents in Chester, New Jersey.

In a large white tent behind the house, a string quartet played while guests filled their glasses with fruit punch or sparkling apple cider. (In keeping with the solemn tone of the day, no liquor was served.) The father of the bride had spent weeks deliberating over the centerpieces for the tables, finally settling on arrangements of calla lillies and white helium-filled balloons.

After the dinner ended and the cake was cut, the newlyweds planted a young cedar tree in the yard, a Bermudan tradition symbolizing the beginning of their new life together.

"I love the fact that they didn't try to wipe out the past and create a completely new script for the wedding," said Mikki Taylor, a guest and the beauty and cover editor of *Essence* magazine in Manhattan.

Many of the guests were relatives of the Listers from Bermuda. The bride's great-aunt Lady Richards is the widow of Bermuda's first black premier. "I didn't like being a political wife," she said. "During elections, people would say the nastiest things about my husband. I would think, 'Is that the man I married?'"

The bridegroom's parents, Mr. and Mrs. Albert L. Toney, of Colonial Heights, Virginia, have been married for thirty-seven years. When asked at the reception what advice she might give to newlyweds, Mrs. Toney replied: "Sometimes it seems that when couples make it legal and tie the knot, they suffer the green-grass syndrome. They suddenly get the feeling they're missing something. It's like what B. B. King sings, 'The Thrill Is Gone.' The thing to remember is it's possible to get the thrill back."

The bridegroom, a computer specialist, didn't seem to have any apprehensions about the green-grass syndrome or marriage in general, even though a few of his wedding presents were rather foreboding. One friend gave him a bowling ball with a chain attached and the message "You are no longer a free man" written on it. The bridegroom said, "I'm real happy about the ball-and-chain aspect of marriage. I have nothing bad to say about it."

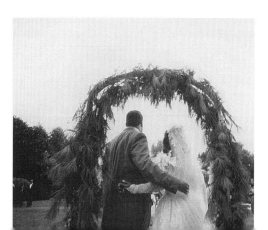

Toni Kotite *and* Adam Guild

FEBRUARY 24, 1996

"They're
both grounded,
but beserk."

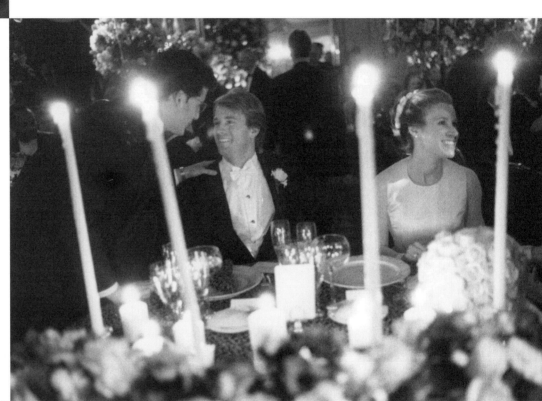

Many members of the class of 1981 at the Dalton School in Manhattan remember Toni Kotite, thirty-two, very well. She would regularly walk into ninth-grade classes wearing one red stocking and one blue stocking, with a sweater, a miniskirt and a giant grin. "She was crazy, she was fun, she had terrific spirit, she had insane clothes," recalled Angela Janklow Harrington, a classmate and friend.

During her senior year, Toni applied to Brown University. In lieu of an essay, she included a vat of popcorn and a movie she had made, entitled *Jail Bait*, about teenage life in New York. (She was accepted.)

By many accounts, Adam Guild, twenty-seven, was equally zany while growing up. "Adam and I met when he came to my back door in Bronxville asking for pancakes at about five or six years old," said Chuck Scarborough, the newscaster, who lived near the Guild family in Westchester County for many years. "It became a weekly ritual and it turned out Adam was working the entire neighborhood. He was very precocious and gregarious."

Toni and Adam are still striking, colorful people. Toni, who showed up for a recent interview wearing a red vinyl suit and carrying a leopard-print hat with a red satin lining, recently quit her job as the artistic director of Naked Angels, the theater troupe in New York, to direct her own movies.

Adam runs a radio consulting company, Triple Platinum, sails catamarans, looks like a young Paul Newman and enjoys such outings as shark fishing in thunderstorms.

The couple met five years ago, when Toni asked Adam to dance at a rehearsal dinner for Ms. Harrington at the Metropolitan Club in New York. They became inseparable friends, and several months later, at Christmastime, they traveled to Moscow "to see the fall of communism," as the bride put it. As she always does when traveling, Toni carried several enormous suitcases, including one filled with bottles of Evian water and one filled with madcap hats.

At midnight on New Year's Eve, the couple kissed for the first time. "After the kiss, all night I stared out the window and watched people walk their dogs in the snow, I was so surprised and spooked," Toni said. "He never seemed interested in me as a girl."

Since then, they have been like the lead characters from the movie *When Harry Met Sally*, as well matched as a couple as they were as buddies. "Adam is a fireball, but he also has a strong center and in that way they are very compatible," Ms. Harrington said. "They're both grounded, but berserk."

Adam proposed on September 13, Toni's birthday. "Before we left for dinner, he said, 'Do you want your present now,' real anticlimactic, like he was going to pull out a Sony Walkman," Toni recalled. "Then he pulled out a little suede box and said, 'You are going to be Mrs. Brownie.' He calls me 'Brownie' because I have brown eyes."

After the February 24 ceremony at Saint Ignatius Loyola Church, Toni arrived at the reception in the Pierre Hotel and walked regally down a pink marble curving staircase in front of two hundred guests, including many members of the Naked Angels troupe, such as Ron Rifkin, Marisa Tomei, Patrick Breen and John F. Kennedy, Jr.

The bride, who wore a Vera Wang gown and a long white velvet overcoat with a high white fur collar, looked as if she belonged at an ice-skating party in a Tolstoy novel. "Toni is a grand lady of the 1990s," said Johnnie Moore, a guest. "And I'm part of her court."

After cocktails, guests gathered in the blue-and-white room at the Pierre for a four-hour, seven-course dinner. "The wedding was really opulent, I mean beyond," Ms. Harrington said a few days later. "It had every kind of food imaginable, lots of entertainment, incredibly beautiful flowers, lots of friends and lots of heart, like Adam and Toni."

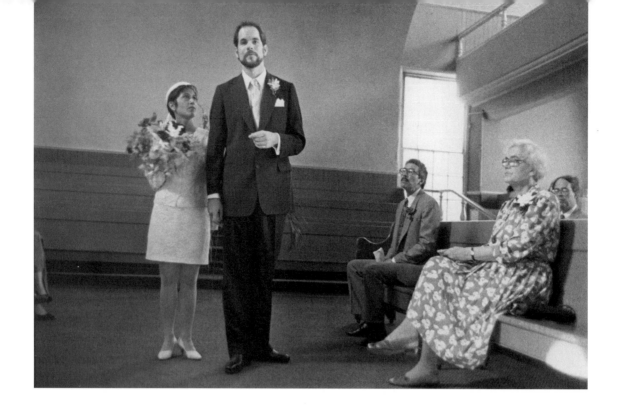

Scottie Mirviss *and* Paul Carvajal OCTOBER 3, 1992

Paul Carvajal, thirty-six, still recalls the exact moment he fell for Adrienne Mirviss, thirty-eight, who is known as "Scottie."

"Things happened for me when Scottie told me she got all these environmental magazines but could never read them because they made her so sad," he said. "I felt like I had met my match. The first time she ever got angry with me was when I said whales were not as intelligent as dolphins."

Their wedding was held on October 3 at a place where there are proenvironment and pacifist pamphlets in the entrance: the Friends Meeting House on Stuyvesant Square in Manhattan. Had you walked in during the first half hour of the wedding, you might not have recognized it as a wedding.

The seventy guests sat in silence, as if each were posing for a portrait. Quaker weddings, like Quaker meetings, follow no schedule or written text; participants simply sit quietly until someone is moved to speak.

At the start of the ceremony, the bridegroom, a counselor for drug-addicted adolescents at New York Hospital, asked that the guests not be afraid of the quiet. "Silence isn't emptiness," he said. The bride, a former modern dancer who is now a lawyer for the Gay Men's Health Crisis in New York, had joked several days earlier: "What if nobody talks? What if it's a wedding in total silence?"

Eventually, one by one, old friends, coworkers and family members stood up and spoke about the couple, weaving a

"Quaker weddings follow no schedule or written text. Participants simply sit quietly until someone is moved to speak."

story of their lives, their work, their childhoods and their romance. One woman who works with the bride, Randye Retkin, described Scottie as "a fighter for the people she serves." The bride's sister-in-law, Diane Mirviss, recounted how Scottie called after first meeting Paul and said, "I met this guy and I want to marry him."

The couple wrote their own vows, which were political, personal, pacifist and numerous. In the bridegroom's nearly forty vows he promised "to give you space and time and allow you separateness"; "to let you know every part of me"; and "to work for peace and justice and compassion in this world, because it is our home."

Scottie covered everything from finances (to be shared equally) to her philosophy on arguing: "In absolute conflict, I promise to be humble enough to accept assistance to reach an understanding."

Emily Wasserman, a friend of the bride from law school, said afterward, "They were real lawyer vows. You always leave room for negotiation."

After the Reverend Maureen Burwell-Orfino declared the couple "wife and husband," she added, "The lives the two of you have lived until this point are now truly and completely over."

Later, everyone headed to a reception aboard *Bargemusic*, a small teak barge tied up at the Fulton Ferry Landing in Brooklyn. Although the barge floats directly beneath the Brooklyn Bridge, it seemed like a summer afternoon out in the country. Sailboats dotted the East River; downtown Manhattan shimmered like a silvery forest on the other side of the water; guests sunbathed while the barge rocked gently in the waves.

Several guests were talking about the long silences in the ceremony. Paula Court, the photographer who shot the wedding, said: "During the silence you think about the nature of love, and it's very pleasant, because as New Yorkers we don't allow ourselves to be sentimental that often. I was crying. I had to wash my glasses."

Tracy Horton *and* Jon Leshay

SEPTEMBER 26, 1992

"Love is very plain and simple when you find it. It's two plus two is four, the simplest equation there is."

Instead of choosing traditional marches or hymns for their wedding, Tracy Horton and Jon Leshay, who both work in the promotions department at Elektra Records in New York, made a soundtrack. They filled it with their favorite songs, as if they were taping tunes for a cross-country drive or a party in their apartment.

The tape played on the evening of September 26 while 140 guests, wearing such outfits as a tailcoat over blue jeans with lizard boots or a black minidress with spandex shorts underneath, took their seats in the Museum Club at Bridgewaters, a loftlike space on top of the Fulton Market Building in Manhattan.

When a folk-rock song about bridegrooms by John Wesley Harding came on the tape, the wedding began. The bridegroom, twenty-eight, ambled out onto a stage where his nine groomsmen, wearing T-shirts, jeans and vests, at least one of which was tie-dyed, were waiting. Children ran around freely, as if they were in an open field. Dozens of white candles—little ones in glass cups, fat ones wrapped in moss and wildflowers—lit the scene.

The bride, twenty-six, walked down the aisle to "I Am Calling You" by Javetta Steele, a plaintive ballad that sounds like a love song you would hear inside a conch shell. Wearing a wreath of dried roses, a long white Charivari coat dress with a fringed hem and no shoes on her feet, she looked like the quintessential flower child. One of the groomsmen, Timothy Jimenez, a drummer from Los Angeles, said, "Tracy and Jon are very sixties-ish. Our group of friends has a thing about 1968. We weren't there, but we should have been."

During the ceremony, which was officiated by the Reverend Orlanda Brugnola, a Unitarian Universalist chaplain at Columbia University, there was no music, but the mood was so laid-back, you had the feeling you could walk up

and join the bride and groom without seriously breaking protocol. At the moment the ceremony ended, a song by the Cufflinks, entitled "Tracy," blared through the speakers.

"'Tracy' is the grooviest sixties pop song," said the bridegroom. "It's like a game-show song. It makes you laugh, and it's a great way to end everything."

Afterward, many guests lingered on the Museum Club's terrace and watched yachts, outlined in Christmas lights, glide up the East River. The crowd was filled with old friends who had shared a lot of zany times, songwriting sessions and road trips. When one woman in the crowd, a former roommate of the bridegroom's in a group house in California, was asked if he would make a traditional husband, she replied, "No! He used to wake me up in the morning by throwing avocados at my bed."

After dinner, a few members of an alternative rock band, the Rave-Ups, performed with Kimm Rogers, a singer. All friends of the bride and groom, they sang songs like "Washing Dishes," which suggests that men give women kisses as well as help with the dishes.

A few guests spoke about how music had shaped their ideas about romance. The bridegroom's brother, Mike Leshay, president of Peace Love and Youth Records in Los Angeles, said: "When I was really young, 'ABC' by the Jackson Five explained love to me. It means love is very plain and simple when you find it. It's two plus two is four, the simplest equation there is. That's how it was for Jon and Tracy."

31

Lucy Schulte *and* James Danziger

SEPTEMBER 22, 1992

"Lucy and I worked together as a team on what we wore. We both had veto approval over each other's clothes."

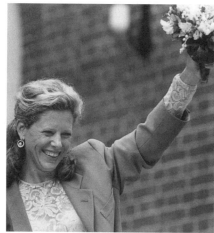

As Lucy Shulte sees it, every wedding has a left brain and a right brain. There is the solemn side and the shooting-champagne-corks-at-the-moon side.

"You want to do the vows with dignity in an intimate setting," said Ms. Schulte, who is thirty-two years old. "But you also want to let your hair down and celebrate. We decided the perfect solution was a two-part deal: a small ceremony with a big party four days later."

She added, "I've seen people go into a state of shock at their wedding. They're not really aware there's food, even though there's lobster a foot away. It's emotional overload. You can have two reactions—one is you feel it all and you're crying and emotionally exhausted or you're in such a state of shock you shut down and let the whole thing glaze by. So what I'm hoping to do is keep it manageable by having it in two stages. It's a way to space out the high."

She and James Danziger, thirty-nine, had their small ceremony at the Knickerbocker Club at a time when most people hold business lunches rather than weddings—half past noon on a Tuesday. It was as minimal as a Philippe Starck teapot. There were no limos, flower girls, bridesmaids, tuxedos, bouquets or packets of birdseed. Lucy and James walked from their apartment to the wedding, both wearing suits and looking like an elegant couple on their way to lunch.

The bride, a freelance magazine writer and editor, wore a taupe Calvin Klein jacket and skirt over a lace body stocking, which she called "the one bridal touch." The bridegroom, who owns the James Danziger Gallery in New York, chose a slate-gray Armani suit.

"Lucy and I worked as a team on what we wore," James said. "We both had veto approval over each other's clothes. I vetoed her first choice of a dress and she vetoed two suits of mine."

When they entered the marble foyer of the Knickerbocker Club, they appeared calm enough to contemplate a chess move. The couple's understated attitude may have come from the fact that they didn't exactly rush into marriage. "We've been living together happily for six years," the bridegroom said. "The biggest surprise, once we got engaged, was how much we enjoyed being a soon-to-be-married couple rather than girlfriend and boyfriend."

Standing on the outdoor terrace of the club, where the wrought-iron tables were decorated with vases of white roses and long-stemmed champagne glasses, they took their vows in a civil ceremony officiated by Acting Justice Leslie Crocker Snyder of the State Supreme Court in Manhattan. Several of the sixty guests seemed grateful to be spending their lunch hour on a Tuesday in this way. Katie Carpenter, the bride's sister-in-law, said: "Lucy is a working girl. She wanted the wedding to be a spicy little event that fit snugly into people's work lives."

The bride said, "I wanted to get married in the daytime because I feel like marriage is your daily life. Everybody thinks a wedding shoud be your fantasy day. I think the opposite. I think a wedding should be a very real reflection of your life."

The right-brain part of the wedding—the big party to counteract the brief minimalist ceremony—was held in Bellport, Long Island, where Lucy and James spend weekends. One hundred guests were invited for cocktails at Howard and Katia Read's house on Great South Bay, then dinner and dancing at the Bellport Restaurant.

Sitting in the restaurant the weekend before the wedding, Lucy described herself as a realist about marriage. "A lot of people think once you get married, everything is cool," she said. "You've hit pay dirt. You've got the brass ring and everything is going to work out. My feeling is, you can't ever take that for granted. Marriage isn't safe ground you've reached. It's just new terrain to navigate."

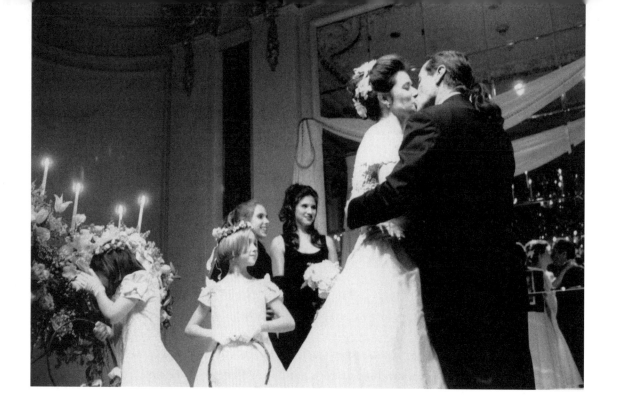

Lorraine Bracco *and* Edward James Olmos

JANUARY 28, 1994

Lorraine Bracco, the beautiful, spirited thirty-nine-year-old actress who grew up in Brooklyn, met Edward James Olmos, the forty-six-year-old Latino actor and political activist from Los Angeles, when they made the movie *Talent for the Game* three years ago.

As actors, they have very different sensibilities. She is known for portraying fast-talking, strong-willed women, the kind who throw high-heeled shoes at their lovers with the accuracy of expert dart players. He often plays brooding, mystical loners like the Mexican crime lord in *American Me.*

Offscreen, they are more similar, especially in their lack of Hollywood gloss. Edward spends his free time working for causes like improving schools in the worst Hispanic neighborhoods of Los Angeles and working with earthquake relief organizations in Mexico. He never tries to hide his rough, pockmarked skin. Similarly, she has kept, even flaunted, her Brooklyn-Italian accent.

The couple, who have lived together in New York and Los Angeles for the last few years, do not travel with an entourage—except for their combined six children. And their January 28 wedding was far more grounded than glamorous. While it took place in the Versailles Room at the St. Regis Hotel in New York, amid crystal chandeliers and one hundred fashionably dressed guests, it felt as if it were happening on a windswept mesa.

"The kids
begged us to
get married.
They were the
ones who kept
going, 'Come on!'"

The bridegroom was escorted by his four sons—Bodie, Mico, Brandon and Mike—almost all of whom wore ponytails. As he waited for the bride, he squinted down the aisle, looking more mystical and moved than he ever appeared onscreen.

Lorraine entered behind her two daughters, Margaux and Stella, wearing her hair in a bun surrounded by a ring of gardenias. "She looked so beautiful, I was stunned," Edward said afterward. "I was stunned by her womanness."

The Reverend Orlanda Brugnola, a Unitarian Universalist minister, officiated the ceremony, which was entirely scripted by the couple. It included love poems by e.e. cummings and by Rainer Maria Rilke and selected pieces from *Earth Prayers,* an anthology of blessings, salutations and meditations about the planet. Together, the readings emphasized the importance of letting rivers, wild geese, moons, tigers and humans take their natural course, reflecting the way the couple think about marriage.

"A person like Lorraine, who is very much her own person, grows and changes with every day," said the bridegroom. "If you try to possess that, you're in for an awakening that might be very rude."

After the ceremony, a strolling trio of musicians led by Jay Reuben Silverbird sang Mexican love songs while guests ate dinner at tables decorated by Preston Bailey, a New York floral designer. The five-foot-tall centerpieces looked like winter trees, with candles in the long, bare branches. At the base of each tree was a cloudlike arrangement of cream-colored orchids, roses, tulips, lilies and snapdragons.

At one point during the evening, several of the couple's children got up to perform a song they had written together around the dinner table the previous Thanksgiving. The Braccos-Olmos family is a sort of Brady Bunch for the 1990s, a bicoastal clan of six step-siblings with backgrounds including Mexican-American, African-American and Italian-American.

"I love Eddie, and in the last two and a half years, we've woven a family together who love each other and depend on each other," the bride said. "The kids begged us to get married. They were the ones who kept going, 'Come on!'"

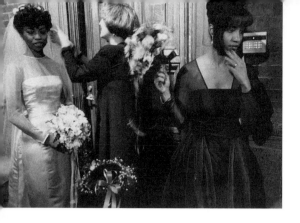

Amelia Marshall *and* Daryl Waters NOVEMBER 28, 1992

"I asked her to marry me and she said no. Later, I asked again and she said, 'Act right for six months.'"

Daryl Waters is the assistant music director of *Jelly's Last Jam*, the Broadway show about Jelly Roll Morton, who was the self-proclaimed inventor of jazz and who by all accounts had a Picassoesque ego and temper.

When Daryl proposed to Amelia Marshall, an actress who plays Gilly Grant on the soap opera *Guiding Light*, he did what Jelly rarely did—he calmly, coolly accepted rejection.

"I asked her to marry me four years ago and she said no," Daryl recalled. "I asked her why and she never could give me a straight answer. Later, I asked again and she said, 'Act right for six months.'"

Amelia and Daryl are typical of many couples in television and theater. They often work twelve-hour days, don't like to see their ages in print and keep a script-recycling pile next to the newspaper heap in their house, a brownstone in Harlem. Occasionally, Daryl will turn on the television and find Amelia in the middle of a love scene, his idea of television from hell.

"Let me put it this way," he said. "I'm from Cleveland, Ohio, which is a nice midwestern city where you don't watch your girlfriends or boyfriends kiss other people at any time."

They were married on Saturday, November 28, in Saint Paul's Chapel, an ornate Italian Renaissance–style building on the campus of Columbia University. Though it was an eleven-thirty A.M. wedding, the mood was not at all morning-like. During the ceremony, a friend of the couple sang the Lord's Prayer as if it were midnight in a small, smoky club and everybody was sitting at tiny candlelit tables.

"I love show-biz weddings," Chris Cotten, a dancer-turned-social-worker, said afterward. "You'd never hear a singer modulate the Lord's Prayer at a standard wedding."

36

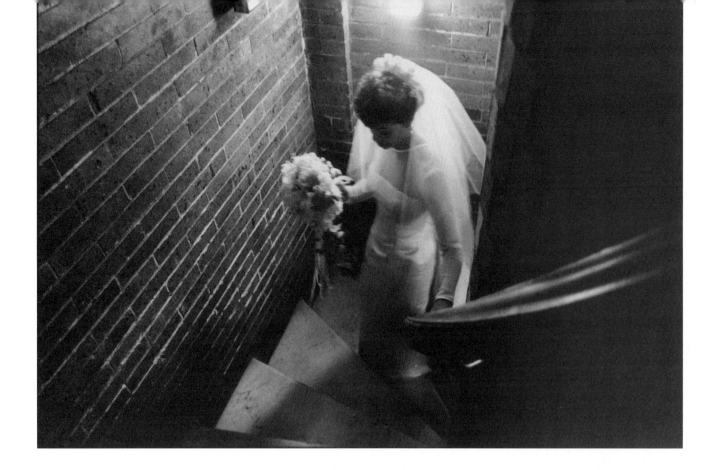

Several of the 150 guests were from the cast and crew of *Jelly's Last Jam*. Gregory Hines, who stars as Jelly and had to rush from the chapel to Saturday's matinee performance, sat with his wife, Pam Koslow, one of the show's producers. George C. Wolfe, who wrote and directed the show, was the best man. "My first priority as best man was to plan a terrorist bachelor party for Daryl," he said after the ceremony. "Just to unnerve him a little bit. The idea was for him to have fun but also to make him want to run home to Amelia."

At the reception, held in the social hall of the Union Theological Seminary, there was a strong sense of camaraderie among the guests. Like the bride and bridegroom, who met on the set of *Queenie Pie* at the Kennedy Center in Washington, almost everyone seemed to know one another from working together on nightclub acts, soap operas, movies or musicals. At the edge of the crowd stood Eartha Kitt, who is currently collaborating with the bridegroom on a show for the Hotel Carlyle in New York. She wore a white suit and her long black eyelashes were damp with tears.

"I don't know why I'm crying," she said in her gravelly purr. "I think we should all have partners in this world."

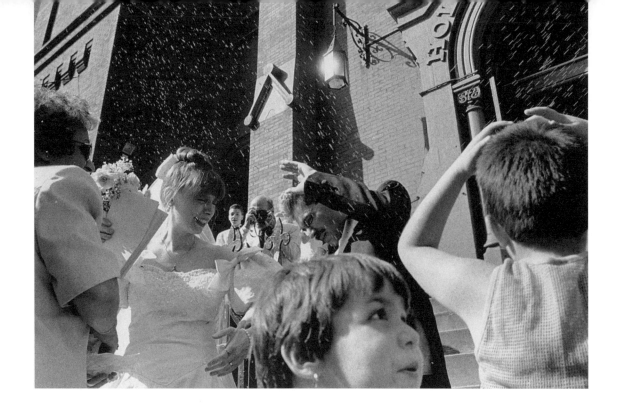

Joanna Romano *and* Joe Restuccia MAY 23, 1992

Joe Restuccia proposed to Joanna Romano in a parking lot at Kennedy International Airport. That was his idea of a quiet, quaint, out-of-the-way spot.

Both Joanna, thirty-seven years old, and Joe, thirty-five, are active in the preservation of tenements in Clinton (aka Hell's Kitchen). He's director of the Clinton Housing Development Company; she's a social worker at Fountain House, a rehabilitation center for the mentally ill. They met ten years ago in what Joe remembered as "a noisy, raucous" community meeting.

"I didn't like Joanna at first," he said. "I thought she was too prissy. I was deeply involved with community affairs,

and she wore a little flower-print Laura Ashley dress. I'm a city guy. There's no country in me."

There was no country in their wedding, either. They were married across from the Port Authority Bus Terminal, in an area of the city where the sky is always blue with exhaust plumes, at the Church of the Holy Cross on West Forty-second Street.

Most of the 150 guests were relatives of the couple or residents of Clinton. A contingent of older people, many of them women wearing cotton shifts and sun hats, sat in the back pews.

"All of Joe's parties are intergenerational," said Barry Din-

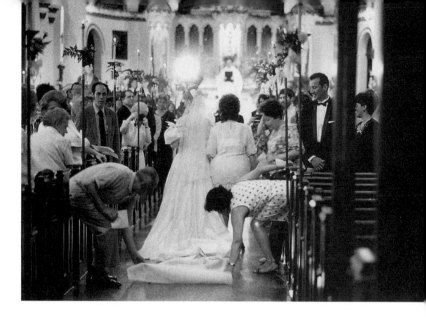

"When you get married, you go through these incredible highs and lows. Singing, especially the opera, expresses that."

erstein, a city planner, who was among the guests. "You see people in their thirties as well as the old Italian and Greek ladies who live upstairs or down the hall."

The wedding ceremony, a ninety-minute nuptial Mass, was filled with Latin hymns and opera. As candles flickered and the bride and her procession of twenty waited to walk down the aisle, several singers, including Giselle Montanez, a former member of the Metropolitan Opera chorus, added to the drama with arias from the operas *Nabucco* and *Don Giovanni*.

"When you get married, you go through these incredible highs and lows," said the bridegroom. "Singing, especially the opera, expresses that."

At the reception on the loftlike seventh floor of the Puck Building in SoHo, one of the guests asked the bride, "Did you know there was a homeless woman on the steps of the church during your wedding?"

"I hope you invited her in," said Joanna, who looks like Mia Farrow with red hair.

Between dances, several guests discussed the newly-weds' home, which is the antithesis of a traditional three-bedroom cape in the suburbs. Joanna and Joe live in a tenement near the Lincoln Tunnel, a fifth-floor walk-up that was burned out when Joe moved in about ten years ago. He has renovated most of it, but his family still jokes about

things like the missing living-room ceiling. Instead, you see beams and water pipes.

One of the groom's cousins, Michael Padula, said: "When Joe got engaged, he made some big improvements. He now has a bathroom door and a shower. He kept the bottomless chairs, though."

The bride's twin sister, Marylou Romano, described the newlyweds' neighborhood this way: "It's not a nice block," she said. "But Joanna and Joe love it, partly because they're nostalgic for the way people used to live. In Hell's Kitchen they can live in a tenement, know their neighbors and sit out on the stoop, just like past generations."

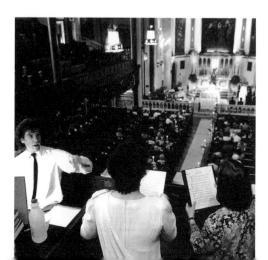

Diana Pizzuti *and* Robert Iovino

JUNE 7, 1992

"It's definitely
not a traditional
marriage, not
that there's
such a thing

Getting married in St. Patrick's Cathedral, which stays open to the public during weddings, is one way to learn what it is like to be a celebrity.

When two New York City police officers, Captain Diana Pizzuti and Lieutenant Robert Iovino, were married there, they attracted almost as much attention as a street appearance by Madonna.

The bride and groom walked down the aisle, which seems about as long as a runway for small aircraft, surrounded by 125 invited guests and at least as many curious onlookers—tourists, nuns, young couples and cathedral personnel with walkie-talkies.

Standing next to the couple on the altar, the bridesmaids added to the overall feeling that someone famous was getting married. They looked like an all-girl pop band in their short black dresses with pearl spaghetti straps, black seamed stockings, black gloves and pearl bracelets.

After the ceremony, the newlyweds paused on the sidewalk outside, where even more passers-by gathered, a few peering into the tinted windows of the waiting limousines or sneaking up and taking photos of the couple.

"There were all these tourists and a million cameras," recalled Robert, who is thirty-three years old. "We don't know them, they don't know us, but they'll go home with a picture of the bride and groom from St. Pat's. It's humorous."

Diana, thirty-four, said, "It's fun. Someone even came up to me and said something in a foreign language. I just kept repeating, 'Thank you, thank you.'"

The bride bought her dress at another institution known for its crowds—Kleinfeld's, the wedding-dress emporium in Brooklyn. "I went with my mother," she said. "Kleinfeld's is an event; it's like going to a tea. They even have pastries out. So many brides go there that when we drove through the Brooklyn Battery Tunnel, I asked the

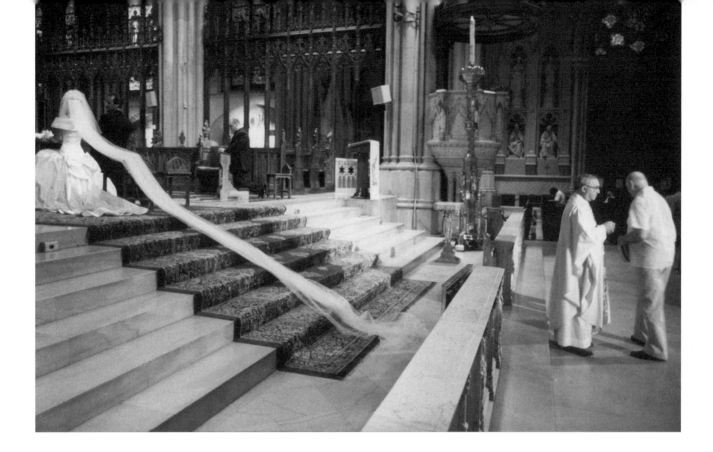

toll guy how to get to the Eighty-sixth Street exit and he said, 'Kleinfeld's?' Whenever he sees a mother and daughter headed for Eighty-sixth Street, he knows they're going to Kleinfeld's."

The reception took place in the penthouse of Terrace on the Park in Queens, a building that looks like an airport tower in a *Jetson* cartoon and even has panoramic views of jets headed steeply into the sky from nearby LaGuardia Airport. Many of the wedding guests were active or retired police officers, including Sergeant Jo Stainkamp, Alan Ostotis and Detective Charles Goetz, who were the bride's partners when she was a rookie ten years ago. Working with them in Queens, she sometimes posed as a hooker while they sat in a nearby car, waiting to make an arrest.

"As a prostitute decoy, Diana looked like Mary Poppins on Hillside Avenue," Detective Goetz said, laughing. "She was very prim and proper. She'd wear bobby socks and collegiate outfits."

Diana, who is one of only nine female captains in the police department, ran over and said: "These guys were my backups. They broke me in."

Carol Maynard, a friend of the bride who is now a police sergeant in Florida, sat with her husband, also a police officer. On the subject of two cops getting married, Sergeant Maynard said, "It's definitely not a traditional marriage, not that there's such a thing anymore. There's no place for boredom. Your assignments and hours change all the time. You always have something bizarre to talk about at dinner—arrests, sex crimes, confessions. I mean, how many people can come home from work and talk about a shootout?"

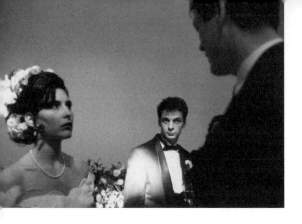

Stacey Daniels *and* Cas Trap

MARCH 13, 1993

He often arrived at her apartment by bicycle, with a bouquet of tulips zipped inside his jacket.

At about four A.M. each weekday, Cas Trap bicycles from his Greenwich Village apartment to the flower district, where he works at the Dutch Flower Line shop on West Twenty-eighth Street. For years he has sold flowers to Stacey Daniels, a freelance floral designer with a gravelly voice and the looks of Snow White. When they started dating, about a year ago, he often arrived at her apartment by bicycle, with a bouquet of tulips zipped inside his jacket.

Stacey and Cas, who was born in Holland, were married at seven P.M. on March 13, the day of the blizzard of '93, when television newscasters were calling Manhattan "a winter dangerland." About sixty-five intrepid guests (eighty were expected) made it to the Masterview Studios, a loft on West Thirty-first Street, wearing a combination of foul-weather gear and formal attire, all with harrowing tales of how they got there.

Lois Kellerman, a leader of the Brooklyn Society for Ethical Culture, who officiated the wedding, had traveled from Queens. She rode the subway, then caught a cab that fishtailed into a snowbank, then set out on foot through knee-deep snow and ended up hitchhiking.

"You have to picture me," she said. "I'm wearing this dress with sweat pants underneath and boots and a sweater and a muffler and a yellow mackinaw. It was my pilgrimage. My commitment is, I get there for my bride and groom. Unless I'm dead, I'll be at a wedding."

One guest, Sue Breindel, a fashion stylist, arrived with ski pants over her bell-bottoms and a backpack full of what she called the essentials for survival: food, whiskey and lipstick.

The loft was filled with flowers arranged mainly by the bridegroom's father,

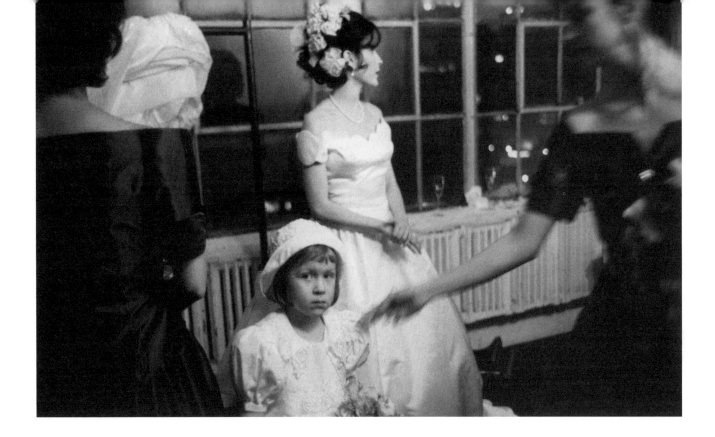

Evert-Jan Trap, and Elizabeth Ryan, a floral designer in New York. Beginning with the windowsills, which were lined with pink and blood-red rose petals, the scene in the loft was the antithesis of the whiteout beyond.

As guests entered, they passed a Victorian-style bouquet of lavender, mauve, light green and blackish-purple spring flowers, then an urn containing French tulips with stems so long and curvy, they appeared to be fashioned out of wire.

There were several tall Roman columns placed around the loft, each decorated a bit differently, with moss, bear grass, flowering pear branches and privet, to look like columns you might find in a slightly overgrown garden behind an old mansion.

Even the artwork evoked springtime. Three papier-mâché chandeliers, designed by Jean-Paul Jacquet, a former roommate of the bridegroom, resembled exotic flowers with mul-

tiple tentacles. The couple, who called the chandeliers "our octopuses," were married beneath the largest one, with bowls of yellow daffodils at their feet.

Afterward, guests gathered at tables amid the overgrown columns for a dinner of swordfish niçoise, pepper-crusted fillet of beef, and pear and endive salad. Several of those present were self-described "flower people." One, Patricia Beaman, a modern dancer and floral designer, said, "We have a group of women who are very close in the flower business and we get together for girls' nights." She added: "Cas has been the apple of all of our eyes for years. He's definitely one of the hottest tickets in the flower market. He's so incredibly nice and good-looking, and he has that European *je ne sais quoi*. When we found out about Stacey and Cas, everyone was thrilled. It was the perfect arrangement."

Maryanne Blacker *and* Nicholas Baker

JANUARY 15, 1993

In 1992, 13,126 couples were married in the Marriage Chapel at City Hall in Manhattan. On a recent visit, it seemed as if wedding parties were arriving as often as airplanes do at Kennedy International Airport, one after another after another, all day long.

While waiting, couples sit in a blue room with views of the Brooklyn Bridge until their names are called, doctor's office style. The officials who check couples in are gruff but romantic. When one couple approached the desk to register recently, an officiate asked, "Do you have rings?"

The bridegroom replied, "Not at this time."

"That's okay," the officiate said. "It's not required. It's just the love that matters."

It's possible to find all kinds of twosomes waiting: parents who never got around to marrying, a bride and bridegroom in traditional African wedding robes, two bankers in business suits taking their vows during a lunch break.

On January 15 at noon, Maryanne Blacker and Nicholas Baker walked in, looking whimsical, bohemian and very mischievous. She wore black leggings, a black shirt, bright red lipstick and large earrings shaped like daisies; his outfit included jeans and silver-colored shoes with Captain Cook–style buckles.

"If you can't laugh
on your own wedding day,
there's no hope."

Maryanne, a thirty-four-year-old magazine editor, and Nicholas, a thirty-two-year-old English teacher, had eloped from Sydney, Australia. Their families knew they were in New York, but no one knew about the wedding except for their two witnesses—Margaret Nixon, a friend from Sydney, and Bob Widden, a New Yorker who met the bridegroom while hitchhiking through Australia in 1980.

As the couple waited for their names to be called, they recounted everything from their first meeting in Sydney seven years ago ("Eyes across a crowded room," the bride said) to their decision to elope. "We talked about different places we'd like to get married," Nicholas said. "Europe or South America. Somewhere different and away from family. Weddings are never yours; they're always overtaken by someone else."

Their wedding day up to that point had been thoroughly theirs and "a bit tongue-in-cheek," as the bridegroom said. The couple bought their rings right outside City Hall, from a sidewalk jewelry vendor. The bridegroom chose a plastic bloodshot eyeball in a silver setting. "If you can't laugh on your own wedding day, there's no hope," he said.

Eventually, Lawrence Israel, a member of the city clerk's staff who performs many of the ceremonies in the Marriage Chapel, shouted out their names. He led them into the tiny chapel, which looks like a place for practicing speeches—it has a red carpet and a podium, and little else.

Though the ceremony lasted only about as long as a traffic light, the couple seemed genuinely moved and amused by it. They laughed often, especially when the bride slid the eyeball ring onto the bridegroom's finger.

For their honeymoon, the newlyweds spent three nights at the Paramount Hotel in Manhattan. "It's sleek and modern," Nicholas said. "Just like us, really."

The couple then planned to travel to Santa Fe, New Mexico, and Hawaii before returning to Sydney. They intended to tell their families about "it" in person.

"The shock value will be good," said the bridegroom. "Maybe we'll announce it at a casual barbecue. They'll ask, 'What was the best thing about the trip?' and I'll say, 'Well, the wedding was good,' and they'll say, 'I'm sorry?'"

Barbara Smith *and* Dan Gasby

DECEMBER 23, 1993

"You need to be partners in more than just the physical side of love."

In 1986, Barbara Smith, a model and an actress, opened B. Smith's Restaurant at West Forty-seventh Street and Eighth Avenue, next to a boarded-up theater and across the street from a row of burned-out tenements. Until Ms. Smith arrived, the block was one of New York's bleakest.

Some people now consider her corner a landmark. As Edward J. Robinson, an interior designer and a regular customer at the restaurant, said: "Anyone who comes in from out of town, I must take them to B. Smith's, then to the Statue of Liberty. There's always the possibility of seeing someone famous or in the news or in the know."

Barbara, who is forty, met Dan, the thirty-eight-year-old senior vice president of television marketing for Camelot Entertainment, when he had dinner at the restaurant two years ago. He spends most of his evenings there now, doing everything from bartending to putting on a Natalie Cole tape to sweeping the floor.

"They're like two little lovebirds," said Pat Prescott, a friend of the couple. "He cares about her business. He buses the tables. I think that's the way it should be. You need to be partners in more than just the physical side of love." At their December 23 wedding, the bridegroom said, "I'm Barbara's cut man and she's my cut man. A cut man is the guy in the corner of the boxing ring who cleans up fighters and sends them back to battle. We'll always be in each other's corner."

They were married two blocks from B. Smith's at St. Luke's Lutheran Church by another person who wants to turn the neighborhood around: the Reverend Dr. Dale D. Hansen. (Dr. Hansen and Barbara are members of the Times Square Business Improvement District, and after the wedding, the couple made a donation to the soup kitchen that Dr. Hansen runs at St. Luke's.) Before the ceremony, one tall, gorgeous guest after another filed in; it was as if there had been

an exodus from the Ford Model Agency. "I've never been to a wedding that made me feel so short," one guest said.

Afterward, the guests walked back to B. Smith's in a wedding parade led by several police officers from the neighborhood beat, Christmas carolers, the bridegroom and the bride, who wore a champagne-colored ball gown and sparkly sequined gloves.

"This is a real Manhattan wedding!" exclaimed one guest, Abby Auerbach, a senior vice president at Ogilvy & Mather Advertising. "You have the charm of a church setting followed by a police escort to one of the hottest jazz spots in town."

At the reception, held in the Rooftop Café at B. Smith's, guests ate a dinner of pigeon peas, sautéed greens and jerked duckling while the balladeer Wil Downing stood in a single spotlight and crooned one love song after another.

Many of the guests were regulars at B. Smith's, including Voza Rivers, the producer of *Sarafina!*; Dwight Owsley, a concierge at the Hotel Carlyle; and the Reverend Francis Gasparik, the pastor of St. John's Roman Catholic Church on West Thirty-first Street.

"I come to B. Smith's for her wonderful personality and the food," Father Gasparik said. "Not to mention the wine list."

Another regular, the singer and producer Al B. Sure, hugged the bridegroom. "Dan is a real man, point-blank," he said. "And he's got New York's first lady, Miss Barbara Smith!"

Shayna Hendel *and*
Chaim Meiseles DECEMBER 13, 1992

"In my old
world, it's like
you mention
the 'M word'
and the guy is
out the door."

Shayna Hendel is writing a book about why a self-described "chicken-soup Jew" like herself—a Sarah Lawrence graduate, feminist and former Greenwich Village habitué—joined the Lubavitcher Hasidim in Crown Heights, Brooklyn.

Chaim Meiseles, an administrative law judge for the New York State Labor Department, also lived in the Village, hung out in nightclubs and generally behaved like a young American bachelor before becoming a Lubavitcher.

Shayna, twenty-nine, and Chaim, thirty-three, lead very different lives now. They met in Crown Heights a few months ago and dated according to Lubavitch customs: They did not touch each other, go to movies, dance or watch television together. Instead, they talked about marriage. "In my old world, it's like you mention the 'M word' and the guy is out the door," Shayna said. "Here, it's the opposite. Here, dating is about marriage. You talk about it on the first date."

After eight dates, Chaim sent Shayna a bouquet of roses with a card that read, "Will you marry me?" Before their traditional Hasidic wedding on the afternoon of Sunday, December 13, they still had not kissed.

The wedding began with a reception in the ballroom of Oholei Torah, a yeshiva and community center in Crown Heights. The 150 men and women sat separately, as they do at all Lubavitcher gatherings, on opposite sides of a tall, ivy-covered wooden fence dividing the ballroom.

The bridegroom prepared for the wedding ceremony by reciting a discourse in Hebrew on the spiritual significance of marriage to the men, most of whom were Lubavitchers wearing long black coats and fedoras.

The ceremony took place under a *huppah*, or wedding canopy, that was set up on the sidewalk outside, as is the Lubavitcher custom. Guests chanted an eighteenth-century Hasidic wedding song as the bride was led slowly to the *huppah*. She wore a lace veil that completely obscured her face and a modern mermaid-shaped dress. "I'm going to look like a dark-haired Daryl Hannah in *Splash*," she said a few days before.

Alan Goldfarb, Chaim's uncle, closely watched the bridegroom, who rocked back and forth in prayer for most of the ceremony. "Here's a youngster going back to his roots," Mr. Goldfarb said. "Even his grandmother didn't live as orthodox as he. I admire it because I think it's a more meaningful life. You have humanity and belonging and identity."

Married life in the Lubavitcher community is governed by many rules—married women must wear wigs or hats in public, and husbands and wives cannot display affection outside the home. Few Lubavitcher couples at the wedding seemed to view these rules as restrictive. "I think you can walk down the street holding hands without actually holding hands," Rabbi Eli Cohen said.

While some feminists oppose any limitations on a woman's life, the bride said, "My life as a married Lubavitcher woman will be as feminist as any life I can imagine. I'm not going to be home polishing silver."

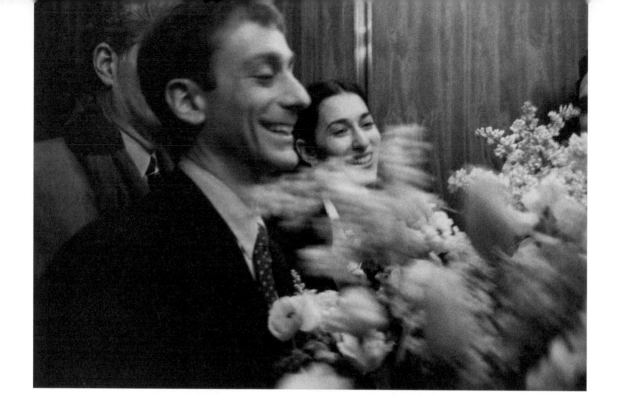

Caroline Ellen *and* Rick Temerian MARCH 19, 1993

Caroline Ellen and Rick Temerian's wedding on the afternoon of March 19 was as simple, nonchalant and charming as a kiss blown across the room.

They were married in Room 300 of the New York State Supreme Court building on Centre Street in downtown Manhattan, a large courtroom with wall murals, Art Deco lamps and old carved wooden benches. It looks like a place where a gangster would be tried in the 1930s. One of the first wedding guests to arrive, Richard Winick, said, "Is this where Rick is getting sentenced?"

Rick, who is thirty-four, is known among his friends as a Renaissance man: He is an architect, a furniture designer,

a surfer, a motorcycle collector and a painter who once worked as Julian Schnabel's assistant. He arrived with the news that Woody Allen and Mia Farrow were battling it out in a nearby courtroom.

"It's one of those wonderful cosmic coincidences that could only happen in New York," he said. "Some people come together; some people break apart. Some people break apart loudly."

Caroline, a twenty-eight-year-old fashion model and jewelry designer, entered carrying a small bouquet of flowers and wearing a black-and-white skintight Norma Kamali dress that she described as "a bathing suit down to the

The bride wore a black-and-white skin-tight Norma Kamali dress that she described as "a bathing suit down to my ankles."

ankles." She looked like Holly Golightly as a nineties bride.

Several of the seventy-five guests were once regulars at Madame Rosa's, a former nightclub in TriBeCa that the bridegroom owned in the mid-1980s. Now closed, Madame Rosa's was known for its resident fortune-tellers, secret unmarked entrance and idiosyncratic deejays, such as the late artist Jean-Michel Basquiat, who often played the same scratchy Charlie Parker record over and over again.

Steven Adams, an art dealer and a guest at the wedding, called the bridegroom "the most glamorous person I know." He added: "Glamour is not velvet gowns and rhinestones. Glamour is that he was able to be in the middle of all this, to associate himself with lots of groovy artists and still not be pretentious."

By that definition, the wedding was totally glamorous. It was as unpretentious and quiet as the entrance to Madame Rosa's. There was no professional photographer, just friends with cameras, mostly Polaroids. Before the ceremony began, the bridegroom turned to the guests and said, "Talk amongst yourselves." It was as if he wanted the wedding to be so low-key that it wouldn't even interrupt conversations.

Officiated by Justice Emily Jane Goodman, the ceremony consisted mainly of promises and poetry. At one point, Justice Goodman read a few lines from a Marge Piercy poem entitled, "Why Marry?" It described a wedding as a public occasion when a couple announces to their guests that they have decided to "continue," to stay together through all kinds of weather, moods and seasons.

A bus waiting outside the courthouse later transported the guests to Alison on Dominick, a small, serene restaurant in TriBeCa that they took over for the night.

Many in the crowd, from the newlyweds to Elaine Farley, a fashion editor at *Glamour* magazine, to Andrea Rosen, a gallery owner, and Brent Richardson, a painter, once hung out in nightclubs like Madame Rosa's every night of the week. For most, especially the bride and bridegroom, the wedding was like their new social lives—calm, mellow and grown-up.

"Caroline's very simple and chic, a classic beauty," said Howard Mindel, an executive at Click Models and a guest. "To have a civil service and dinner in a very simple, beautiful restaurant is what she and Rick are all about."

Allia Zobel *and* Desmond Nolan

MAY 7, 1994

"I wanted to hold up a mirror to single people and say, 'Look, you don't have it so bad. You don't have the responsibility of kids, you don't have diapers.' "

There are two things Allia Zobel fiercely dislikes. One is revealing her age, which she discusses in the style of a street vendor eager to make a deal—she's over forty, around forty, much less than forty. The other is the "What's wrong with you?" stigma that many single women have to endure.

To combat that, she wrote *The Joy of Being Single* (Workman Publishing), a humorous, illustrated book for women *without* wedding plans. In it, she lists dozens of reasons why living alone is a dream come true, such as "You can play the same record over and over again," or "You can eat cold pizza for breakfast, jelly beans and Coke for dinner," or "When it comes to the telephone, you have carte blanche."

Allia, who lives in Bridgeport, Connecticut, where she writes with two cats perched on top of her computer, said, "I wanted to hold up a mirror to single people and say, 'Look, you don't have it so bad. You don't have the responsibility of kids, you don't have diapers. If you want to go to a Chinese restaurant at two in the morning, you can. You're free! Lighten up with this rush to get married.'"

About six months after finishing the book, she was introduced to Desmond Finbarr Nolan, a thirtyish computer software designer who was born in Cork, Ireland. Like Allia, he viewed his single years as an opportunity to live life to its fullest and zaniest. He studied dinosaurs as a hobby, collected electric keyboards and kept few solid foods in his house besides potato chips.

"He had this bed with a mattress that had a weak center so part of it went up and part of it went down," said Ed Gallagher, the best man at their wedding. "The joy of being single for a male is that you don't have to worry about having a mattress your girlfriend or wife feels comfortable on."

Desmond, who is often compared to Lord Byron because of his dark curly hair and rosy cheeks, was happy to date someone who saw herself as a crusader for

single women. "It was very exciting to meet someone who celebrated being single," he said. "It's a philosophy of mine. I'd never sought marriage."

Allia's latest book is entitled *101 Reasons Why a Cat Is Better Than a Man*. It is essentially a long, funny, illustrated list of reasons why a single woman would be better off living with a cat than a man. "A cat doesn't need to go out in the woods with other cats, beat drums, light fires and dance to get in touch with his cathood," she writes. Also, "Cats adore independent women." And, "Cats don't need high-tech toys—a grocery bag will do."

On May 7, Allia and Desmond were married before about ninety guests in a green ballroom at the Gaelic-American Club in Fairfield, Connecticut. There were many resolutely single people in the crowd, including Norma David, a slim London-born columnist for *The Westport News*. Ms. David,

who has been divorced twice, said of marriage: "Never again! I like the company of males, but I like to drop them at the doorstep."

The bride, who danced for much of the afternoon as freely as if she were wearing her most comfortable pajamas, said that getting married wouldn't change her mind about the single life; she still sees it as a time when you're blissfully free to eat cupcakes in bed all day without anyone to bug you about it. In fact, in her married life, she plans to retain as much as possible from her days of living alone, including a private telephone line and her wacky eating habits.

"Singles eat standing up by the kitchen sink even if they have a dining room," she said. "With Desmond and me, we both stand by the sink. He'll be eating a bagel, and I'll be eating Eggo waffles."

53

Stacy Cor *and* Dan Polner APRIL 23, 1994

Stacy Cor and Dan Polner's entire courtship lasted about as long as it takes most people to get to the second date. As a friend of theirs put it, "They ended up at Fortunoff's on the eleventh day."

They met on July 2, 1993, when seated next to each other on an American Airlines flight from New York to Los Angeles. Stacy, a thirty-year-old flight attendant for American based on the West Coast, was in uniform but flying as a passenger. She didn't have a very good first impression of Dan, a thirty-year-old investment banker in New York.

"I was thinking, 'Here is Mr. Too Much Carry-on Luggage,'" she said. "He had tennis racquets, roller blades, a huge duffel bag."

His first impression was more favorable. "I thought, 'Hey, I get to sit next to the flight attendant,'" he recalled. "I'm usually next to the big fat guy who takes my armrest."

As it turned out, they talked nonstop from takeoff to landing, and over the next few days were rarely apart. They went roller blading together, played pool, chose the same songs on the jukebox wherever they went and talked about books, politics, sports and cartoons. Both are Bugs Bunny fanatics and can quote him as extensively and lovingly as some people quote Emily Dickinson.

"It was weird," said Stacy. "We come from completely opposite different backgrounds, from opposite ends of the country. He's Jewish; I'm not. His parents have been mar-

"When someone asks you to marry them, you shouldn't have to make a list of pros and cons. You jump into their arms and say, 'Yeah!'"

ried for thirty-five years; I have musical parents and step-parents. And yet somehow we ended up the same."

Ten days after they met, she visited him in New York, where they became engaged and kissed for the first time—in that order. "The moral is, when you know, you know, and don't believe it any other way," the bride said. "When someone asks you to marry them, you shouldn't have to make a list of pros and cons. You just know. You jump into their arms and say, 'Yeah!'"

The next day, they spread the news of their wedding plans and mostly heard either screams or dead silence on the other end of the line. Susan Bourne, a friend of the bride-groom, remembered, "Dan called me and said, 'Hey, I'm back in town. Are you sitting down?'"

On April 23, they were married before 130 guests at the Alger Mansion, a historic town house in Greenwich Village. A tape recording of several slow, moody songs by Enya, the New Age Irish singer, was played just before the bride appeared, which made her arrival feel as mystical and dreamy as the arrival of a ghost.

Rabbi Ari Fridkis, who officiated the ceremony, began by saying, "I know it seemed to you that the music was very long, but Stacy and Dan were trying to lengthen their courtship."

The spunky bride, who once said she had no doubts she could land a 747 safely, if necessary, was asked afterward what she was thinking about during the ceremony. "I was thinking, 'Where's the part where they let me drink the wine?'" she said. "You're so nervous out there, you need a shot of something."

Valorie Hart, the floral designer who arranged the bouquets and centerpieces, called it the quintessential April wedding. "Their meeting and deciding to marry is like spring itself," she said. "One day the trees are brown, and the next day the world is full of forsythia, cherry blossoms and lilacs."

Gabrielle Brown *and* John Lippert OCTOBER 30, 1993

"We think you can get married and still act like a kid sometimes."

Guests entered Gabrielle Brown and John Lippert's wedding through blue curtains, the kind of glittery, gauzy curtains fortune-tellers like, ones that suggest something very unusual lies on the other side.

Walking through them, the guests were not disappointed. Gabrielle and John, both twenty-six-year-old artists, were married in the TriBeCa loft where her parents live. Working for months, the young couple transformed half of it into a mystical, almost cartoonish, forest.

There were trees with green cotton candy–like tops; murals of white moons, comets and shooting stars; autumn leaves made of paper scattered on the floor; and three papier-mâché creatures hanging from the ceiling like piñatas. A cross between bees and octopuses, the creatures had roly-poly bodies and were as colorful as Fiesta ware.

The Halloween-eve wedding was costume-optional, and about half of the 150 guests arrived in disguise, populating the forest with such characters as Rapunzel, a sunflower, a serpent, Amelia Bedelia and a wood tick. Idelle Weber stood out in her conservative brown suit with black pumps. "I'm an artist dressed up like a real person," she said.

Even the couple, who met as painting students seven years ago at Cooper Union, wore disguises. They looked like bugs in a children's book, with black-and-white-striped legs, polka-dot midsections and big green heads. (Jennifer Reingold, another guest, looked like a traditional bride in a white gown and tulle veil. "I thought *somebody* had to be a bride here," she said.)

The couple, both of whose paintings often include bugs, trees, stars and autumn leaves, also have full-time jobs. John works at the Alan Farancz Painting Conservation Studio in New York, restoring everything from faded WPA murals to damaged Warhols.

Gabrielle, who once was the assistant director of the Helander Gallery in SoHo, recently became the manager of Sammy's, a store downtown that sells Americana-like apple-picking ladders and weather vanes.

Before the ceremony, the couple gave a short performance. They sang "Love Will Keep Us Together," the Captain and Tennille song, while their green heads bobbed in unison and their guests whistled, screamed, clapped and laughed.

Then the couple disappeared to change into their wedding clothes. The bride returned carrying a bouquet of tea roses and wearing a violet raw-silk dress and bunches of artificial red and purple grapes pinned to her sandy blond hair. She had transformed herself from a green bug into a pretty, wholesome-looking bride. The bridegroom joined her in an earth-tone suit and a bright red tie.

They took their vows before the Reverend Darrell Berger, a Unitarian Universalist minister, while standing on a blue and yellow stage surrounded by trees. "It was so sincere," said Trish Milliken, a songwriter and friend of the couple. "It was just the two of them. They didn't have thirteen bugsmaids and bugs-men."

Later, guests helped themselves to a buffet at a long table decorated with silver candelabra, pumpkins and callalillies. During dinner, the music began: a one-man band playing the saw.

All the costumes, zaniness and kooky musical performances actually had a pretty serious point behind them. "There's a stereotype that getting married means you have to become an adult," the bride said. "It means you don't see your friends as much; you become a pill or a blob. We think you can be married and still act like a kid sometimes."

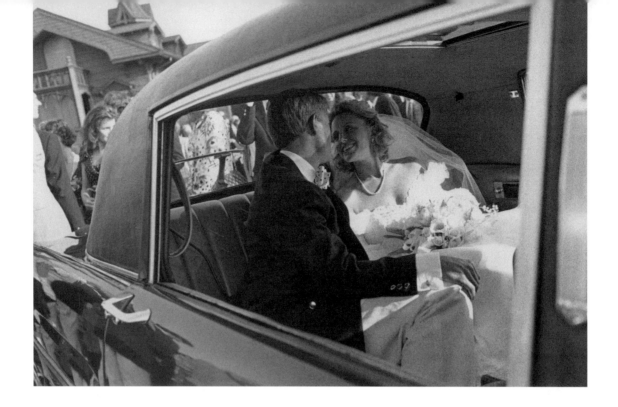

Alison Becker *and* Harry Hurt AUGUST 7, 1993

Harry Hurt III is a tall, blond forty-one-year-old author who grew up in Texas, graduated from Harvard and lives in Sag Harbor, Long Island. In magazine articles and books, he writes about bigger-than-life characters, everyone from Texas billionaires to the Apollo astronauts to Donald Trump to vigilantes who root dealers out of tenements in the Bronx. Many people say he seems bigger than life, too.

"I think of Harry as Dick Diver with a red convertible and a silver flask," said Kevin Wade, a screenwriter who also lives in Sag Harbor and who wrote *Working Girl.* "He's like someone out of a Fitzgerald novel. He's a very presentable bad boy."

Alison Becker, thirty-six, is just as blond, bold and dramatic as Harry. (They're both Scorpios.) The proprietor of Alison on Dominick, a small country French restaurant downtown, she grew up in New York in a literary, theatrical, summers-in-Southampton crowd. The bridegroom grew up in Texas among wildcatters, oil men who lived by "the luck of finding stuff in the ground," as he put it.

When Alison met Harry a little more than a year ago at an art show in downtown Manhattan, she had just returned from shooting clay pigeons in the Dominican Republic. As he recalled, she reminded him of a "can-do, entrepreneurial Texas girl."

He added, "Alison's a lovely lady, but she also has lots of

"I think of Harry
as Dick Diver
with a red
convertible and a
silver flask."

brains and buck and drive and I was seduced by her spirit as well as her skin-deep beauty."

Harry proposed in Sag Harbor in January 1993, over chocolate cookies and champagne, and immediately afterward the couple drove around the deserted summer resort town looking for a jewelry store that had some diamond rings in stock. While nice jewelry is as hard to find as starfish in the middle of winter in Sag Harbor, they eventually found a ring that fit Alison perfectly.

The couple was married on August 7 in Southampton at St. Andrew's Dune Church, a rustic, dark Victorian chapel on the beach that was once a lookout station for ships in trouble. Now it feels like a cross between a lifeguard station, an attic with wooden rafters, a church and a conch shell—sitting in the pews, you can hear the waves crashing outside.

Afterward, the newlyweds rode off in a green refurbished Checker cab to a Gatsbyesque reception held outside the Becker family's summer house. A white tent with six spires was set up on the lawn—it looked like a small snow-covered mountain range in the backyard. Light pink rose petals were scattered on the grass; sea spray was in the air; and a Provençal feast was laid out on a buffet table decorated with bouquets of flowers and dried herbs.

The nearly 450 guests included many literary and social New Yorkers, such as Dominick Dunne, Elaine Kaufman, Terry and Joanie McDonell, Campion Platt, Morgan Entrekin, Jennet and Steve Kroft, Wilfrid Sheed, Christina Oxenberg, R. Couri Hay and the writer Richard Price, who said he was currently working on "two screenplays and a nervous breakdown."

George Plimpton, another guest, commented: "Alison and Harry couldn't be a better match. They both have strong personalities. Imagine starting a restaurant in TriBeCa and having the nerve to name it after yourself! Alison is a confident, strong, powerful, interesting woman. I'm sure they'll have wonderful arguments."

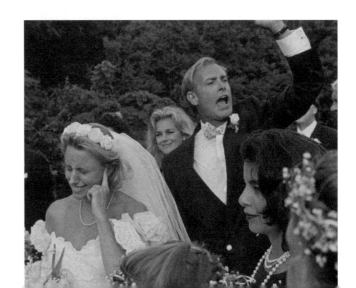

Asha Shetty *and* Steven Cutting

SEPTEMBER 11, 1993

"When we date in India, we're very cautious. We take one step at a time. With Steve, it was like I was being swept away."

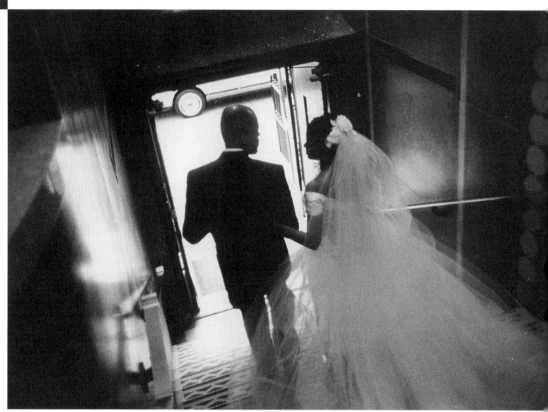

Steven Cutting often begins the day in one city and ends it in another thousands of miles away. In a single week, Mr. Cutting, a thirty-two-year-old fashion consultant and designer based in New York City, might meet with clients in India, shop for fabrics in France, have dinner with a friend in the Netherlands and oversee a fashion shoot in California.

"He's really a gypsy of today," said Arie Vervelde, a Dutch fashion illustrator and longtime friend. "He works and feels at home in a lot of places."

Steven, who grew up in the Crown Heights neighborhood of Brooklyn, met Asha Shetty about a year ago on a night flight from New Delhi to Frankfurt. It was almost as if they had been matched up by the Delta Air Lines computer system: He was one of the few passengers sitting in business class, where she was the lone flight attendant. They ended up talking until the sun came up and European cities began to appear below.

At the time, Asha was living in Bombay, where she was born. She was a self-described rebel against Indian romantic customs, such as arranged marriages. "Everybody in my family has had an arranged marriage, and my parents had kind of given up one me," she said. "I'm very independent. I wanted to seek my own man."

Over the next few months, Steven and Asha met wherever their flight paths crossed—in Singapore, Hong Kong, California, Paris. Sometimes, they rendezvoused just for dinner, often on a day's notice.

"When we date in India, we're very cautious," said Asha, who is thirty-three. "We take one step at a time. With Steve, it was like I was being swept away."

Friends, as well as the couple themselves, flew in from around the world for the wedding on September 11 at Saint Teresa of Avila Church in Crown Heights. Watching the guests arrive was like taking in a global fashion show.

Kevin Pinnock, an African-American artist living in Germany, showed up in a gray loden jacket and lederhosen, looking like a Bavarian rap singer. Mayuri Haldanker, an Indian flight attendant with Delta Air Lines, wore a yellow and red sari and a pearl nose ring shaped like a sea horse.

Mr. Vervelde, who traveled from Amsterdam, stood out in his black spandex pants with fringes. Timothy Dean Lee, a painter from Michigan, wore green jeans and a red airplane pin on his lapel in honor of the way the couple met.

After the Roman Catholic ceremony, everyone gathered in a gallery at the Brooklyn Museum, where there was an exhibition that seemed particularly appropriate for such a well-traveled crowd—art objects from Greece, Rome, Egypt and the Middle East. And the dinner was like a meal served on a plane circling the world; it included everything from Bengali *pakoras* to oysters Rockefeller and was prepared by Movable Feast, a family-run Brooklyn catering company.

Many guests commented on the way the couple met, theorizing that their relationship was preordained, if not by Delta's computers, then by some even higher power.

"It's obvious to me that the way they met was fate," Mr. Lee said. "That's a nice thing to see in this day and age, when so many people unite with someone for career reasons or because it helps their public image."

Ms. Haldankar, who is Hindu, called it "a marriage made in heaven." She added, "We believe that birth, marriage and death are the three things that are not in anyone's hands."

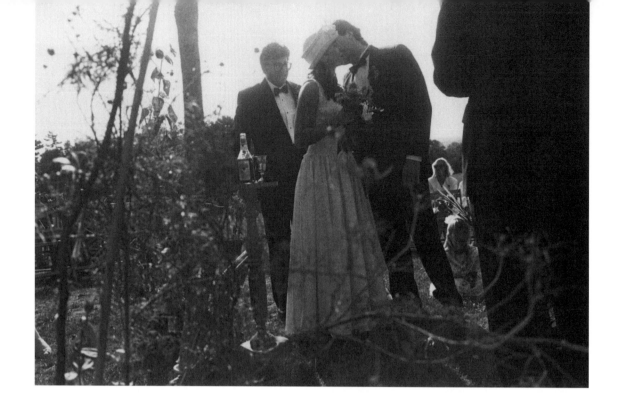

Gale Wolfe *and* Dean Bloch SEPTEMBER 5, 1993

Gale Wolfe and Dean Bloch are "Rokeby alumni," not exactly something you'd put on a formal resume, but definitely an honor of sorts.

"Everybody at Rokeby is wacky and interesting," said Gale, twenty-six, a film and television editor. Dean, thirty-seven, is chief of gynecology and obstetrics at the Neugarten Birthing Center of Northern Dutchess Hospital in Rhinebeck, New York.

They met a few years ago while living at Rokeby Farm, a five-hundred-acre baronial estate on the Hudson River in Barrytown, New York, that more closely resembles a free-spirited commune. Richard Aldrich, whose ancestors built Rokeby, lives in the estate's nineteenth-century Federal-style mansion and rents several outbuildings. Many of his tenants are escapees from Manhattan who are dedicated to gardening, ice boating and recycling.

About five years ago, Dean moved into a cottage at Rokeby after finishing his residency at Columbia-Presbyterian Hospital in New York. A gynecologist who grows basil and always wears tennis sneakers (even in the delivery room), he fit right in. Gale lived next door and her garden abutted his.

"When Dean moved in, there was all this speculation about who would get him," said Ania Aldrich, Richard's wife. "He's this young doctor, and there were all these single women living here. Gale was very low-key about it."

"When I first got to
know Gale, I liked her politics.
She was a feminist and
ecologically minded and
she was her own person."

Dean said, "When I first got to know Gale, I liked her politics. She was a feminist and ecologically minded and she was her own person."

The couple, who recently bought a house a few miles from Rokeby, returned to the estate to be married on September 5. It seemed in keeping with the funny, offbeat Rokeby spirit that Dr. Bloch, who sees women in labor almost every day, took his vows on Labor Day weekend. Many guests were patients of the bridegroom's and either pregnant or nursing their babies. Children ran through the fields and gardens and the mansion, where two busts of Aldrich ancestors had Halloween masks affixed to them.

"Down in the city, it seemed like everyone gets rid of the kids," the bridegroom said. "Adults and children do their own thing. Up here, when we have parties, kids always come. It's part of life."

The couple—she in a white tank-top dress and mules and he in a tuxedo and sneakers—were married outside in a short Jewish ceremony, surrounded by clay pots of tall sunflowers and about two hundred guests.

"I thought we should be seated in sections," said Ann Nicholson, a patient of Dr. Bloch's. "The cesareans, the natural births, the people who delivered two weeks early, the people who got induced.

"My last son was born on January ninth. January eighth is Elvis Presley's birthday and I was hoping to have the baby then. Dean told me if I had it on the eighth, he would come to the delivery room dressed as Elvis and play Elvis tapes."

Like the couple, the wedding was fun and untraditional. During dinner, which was served in a white tent set up in a field overlooking the river, it was announced that the bride was two months' pregnant. The news brought uproarious applause.

"I definitely want Dean to deliver," said the bride. "He's seen so many births and he's cried at people's births and now he gets to have his own."

Cleopatra Meaney *and* Joseph Lindner JULY 25, 1993

"I never felt
nervous with him;
I never felt unsafe.
We were always
laughing and
enjoying
ourselves, and
that's what life is
all about."

In his sunglasses and fadeaway haircut, Joseph Lindner, a twenty-nine-year-old assistant football coach at Fordham University, is known for pacing the sidelines during games, looking competitive, fierce and handsome. (Some call him "the *GQ* coach.")

Off the field, Joseph is an old-fashioned romantic. He eats dinner by candlelight, listens to Vivaldi, believes in chivalry and counts the Knights of the Round Table among his role models. Few of his friends were surprised that he met Cleopatra Meaney in a way that combined the jet age with the Dark Ages.

Nearly two years ago, Joseph traveled with the Fordham team to Limerick, Ireland, for an exhibition game against the College of the Holy Cross of Worcester, Massachusetts. While in Ireland, the coaches and players visited Bunratty Castle, a fifteenth-century castle where Cleopatra had a job singing Irish ballads to tourists. Joseph spotted her onstage, dressed like a damsel in a medieval-style dress. "She sang like an angel," he later recalled.

Determined to meet her, he sent a note backstage, which she ignored; he called her the next day at the castle, and she rebuffed him. One night, he waited outside the castle with a fellow Fordham coach, Frank D'Alessio.

"It's a castle in the middle of nowhere in a forest," said Mr. D'Alessio, now an investment banker at Lehman Brothers in New York. "You hear the flames of the torches, and you smell a swampy, mystic smell from the moat. Joe was like a knight in shining armor waiting for Cleo. If we could have fit a white horse on the plane, we would have. It's just that Fordham doesn't have that kind of budget."

Finally, Cleopatra, who grew up near the castle, agreed to a date with Joseph. She met him after the Fordham–Holy Cross game, which Fordham lost, 24 to 19. "We didn't lose exactly," Mr. D'Alessio said. "We just ran out of time."

Their date was more successful than the game. "From the first time we were

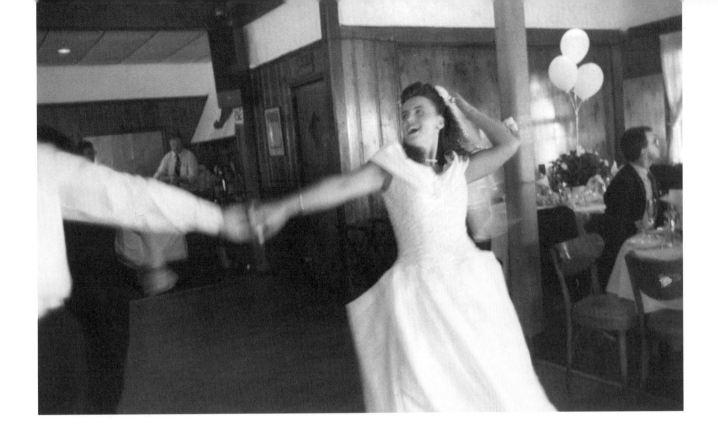

together, we hit it off," said Cleopatra. "I never felt nervous with him; I never felt unsafe. We were always laughing and enjoying ourselves, and that's what life is all about."

After about a year and a half of bicontinental dating, Cleopatra, who is nineteen, moved to New York, and now works as a singer and a waitress at the Tara Restaurant, an Irish pub in Yonkers.

Even their wedding was bicontinental. As a way of including family and friends "on both sides of the water," as the bridegroom put it, they were married in the Ennis Cathedral in Ennis, Ireland, on July 18, and at the Fordham University Church on Sunday, July 25.

After the New York ceremony, the 120 guests found their way to the Morris Yacht and Beach Club on City Island, where the highlight of the evening came when Cleopatra sang. She got up with the Guss Hayes Band, and as she took the microphone, a few guests yelled, "Take us back to Bunratty, Cleo!"

She sang love songs and Irish ballads in a voice so emotional, she sounded as if she were both madly in love and horribly homesick. The couple do not plan to live in New York City forever. "Eventually, we'll go back and retire in Ireland in an old cottage out in the middle of nowhere," said the bride. "The funny thing is, it took an American man to bring an Irish girl to love her own country."

Cricket Telesco *and* Richard Burns

"The waiter came over carrying a tray with a dozen oysters and two glasses of champagne. I'm thinking, 'This is not a typical lunch for my boyfriend.' The ring was in the bottom of my glass of champagne."

Elise Lyn Telesco, who is known to everyone as "Cricket," always wanted to be a fashion editor. But when she started out as an assistant at *Harper's Bazaar* eight years ago, she didn't think she'd survive.

"On my first day, it was winter, and the editor sent me out in a snowstorm and told me not to come back until I found multicolored pastel cotton balls to wrap around the hand model's hand," she said. "I called my mother sobbing from the street." (She finally found them at Boyd's, a pharmacy on Madison Avenue.)

Cricket is now the style and fashion editor at *Avenue*, the *Town & Country*–like publication that covers life, parties, apartments and people on the Upper East Side. She's chic and friendly and glides confidently into the sort of tiny French cafés where you have to be thin just to fit between the tables. Yet, she's also the sort of person who hams it up in karaoke bars or arrives at charity balls wearing a couture gown with a J. Crew sweater wrapped around her neck.

"Cricket mixes high-tech fashion with tradition," said Tina Telesco, her sister-in-law. "To her, everything's appropriate if it looks good. She's someone who goes out on a golf course in the typical Bermuda shorts or a little golf skirt, but then she'll have pink alligator golf shoes. She puts funk and pizzazz into totally traditional outfits."

Cricket, who has also been spotted wearing rubber boots with a Chanel suit, mixes styles just as fearlessly in her Upper East Side apartment. "She has everything going, from leopard skin to Diana Vreeland deep-red walls in the den," said Julie Dannenberg, a publisher of *Manhattan File* magazine and a friend of the bride. "It's wacky and beautiful."

Three years ago, Cricket met Richard Burns, a director and writer for film and television, at a small dinner party in Greenwich, Connecticut, where they both grew up.

In many ways, Richard is her opposite. He is quiet and mellow and wears jeans, T-shirts and sneakers most of the time. They started dating right away. Now she takes him to fashion shows and parties she covers for *Avenue* and, occasionally, he persuades her to stay at home and order Chinese take-out. "Richard is Cricket's anchorman," said Gordon Pennington, an advertising consultant in New York and a friend of the couple.

Richard proposed over lunch at the old-fashioned Oyster Bar in Grand Central Terminal where you can hear trains arriving and departing in the station. "The waiter came over smiling from ear to ear and carrying a tray with a dozen oysters for each of us and two glasses of champagne," Cricket recalled. "I'm thinking, 'This is not a typical lunch for my boyfriend.' The ring was in the bottom of my glass of champagne, and I drank it very quickly to get to the treasure, the goods."

Their wedding, on September 23 at Saint Catherine of Siena Church in Greenwich, was like a fashion show and an Old World European wedding at once. As 350 guests watched and a choir sang, the bride walked down the aisle, which was lined with burning candles. She wore a Grace Kellyesque gown with a pink and white glittery Chanel jacket over it, white gloves and a short veil that looked like a birdcage around her head.

"Cricket is a cross between Babe Paley and Lucille Ball," Ms. Dannenberg said. "She was the most stunning bride—the gown was as chic as you could be—but later in the evening she got up and sang 'Crazy' with the band."

The bridegroom was dressed in black tie with velvet shoes that had a red devil embroidered on each toe. "He's a little devil," said Cricket, who chose the shoes. "Just the look in his eyes is devilish."

During the reception at the Westchester Country Club in Rye, New York, Claire Smithers, a bridesmaid, caught the bouquet. "Usually, I get totally nervous when I catch the bouquet," she said. "I drop it and run away, but this time it was like, 'Wow, if Richard and Cricket can be this happy, I'm going to go out and start catching bouquets.'"

Janet Wickenhaver *and*
Tom Allon OCTOBER 10, 1993

"One week,
I had seven blind
dates in six days.
I had two in
one day—lunch
and dinner."

Four years ago, Janet Wickenhaver was working as a freelance crime reporter and living alone in a railroad flat in Hoboken, New Jersey. She jokingly called her apartment "the penthouse exercise suite" because you had to climb four flights of steep stairs to get to it.

When she wasn't covering murders or drug busts, her night life consisted mainly of playing poker with a close-knit group of other female journalists. "I was militantly pursuing my singlehood," she said. "But it was beginning to crack."

She met Tom Allon, then the editor of *The Manhattan Spirit*, a weekly newspaper, when she called him with a story idea: a single woman's survival guide to Valentine's Day. (Advice from the guide: "Do not let any question resembling 'What's wrong with me?' stick in your head. Do not call any ex-boyfriends and ask them that question. Do not call your mother and ask her that question.")

Tom not only bought her story but he also hired her as an associate editor, and they essentially put out the small West Side paper together. For a year, they were friends and colleagues, critiquing each other's headlines and stories, drinking beers after late nights in the office and talking about their love lives.

His love life was, he said, overactive. "One week, I had seven blind dates in six days," he recalled. "I had two in one day—lunch and dinner. I used to meet them at Caffè Dante on MacDougal Street between Bleecker and Houston. I remember I was there six consecutive nights and I was getting weird looks from the waitresses." After a year, what was clear to almost everyone who knew the pair became clear to them—they were falling in love.

Now they live together (in a building with an elevator) but work separately. Tom, thirty-one, is the publisher and editor of both *The Manhattan Spirit* and

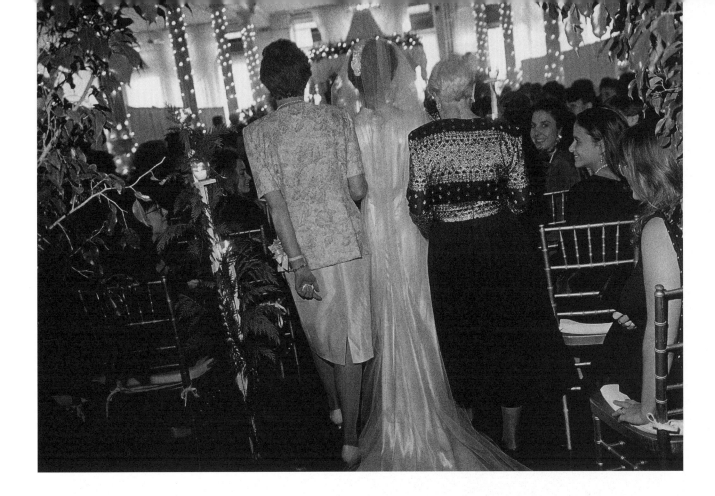

Our Town, a quaint neighborhood paper for the East Side. Janet, thirty-three, is the editor of *Street News,* a biweekly paper that covers homeless issues and has included features on everything from surviving as a street musician to antipoverty legislation. The paper is distributed mainly on New York subways, by jobless and homeless people.

"It is true that a lot of street people have ancillary mental, drug and other problems," Janet said. "But they still have stuff to offer, and we shouldn't give up on them."

Tom and Janet were married on October 10 in the grand ballroom of the Puck Building in SoHo. Long, gauzy curtains covered the tall windows, white Christmas lights were wrapped around the room's many columns and the couple stood under a large, white tentlike *huppah* surrounded by planted trees and flowers; it looked like an elaborate Victorian gazebo in the woods.

During the ceremony, Rabbi Avi Winokur quoted everyone from religious figures to George Bernard Shaw; he talked about love in New York and love in general, and commented that between a husband and wife, it's as important to have a down-to-earth friendship as it is to have romance and chemistry.

"Tom and Janet became good friends long before they made this serious decision and I think that bodes well," he said after the ceremony. "I think passion remains with couples who have more than passion to begin with."

Jillian Nelson *and* Peter F. James SEPTEMBER 22, 1995

Jillian Nelson, an underwater archeologist whose nickname is "Splash," also works as a waitress at Docks Oyster Bar on the Upper West Side. She is tall and lithe and has long, wavy blond hair. More than once, customers have asked her, "Are you a mermaid?"

Jillian, who is thirty-four, usually answers, "Well, I spend a lot of time underwater."

She met Peter Francis James, a classical actor and director, ten years ago in Minneapolis, where he was a resident actor with the Guthrie Theater. She had just graduated from the University of Minnesota and was working as a hostess at a restaurant called Le Peep. He went in

for breakfast one day and she won his heart instantly, from behind the cash register.

"I asked her for change for cigarettes," recalled Peter, thirty-nine. "I asked her what time they open and what time they close. I asked every civilized question I could ask other than 'Who are you and will you be my wife?'"

The two ended up going out after her shift was over that day and sat in a Woolworth photo booth posing for pictures together. "I regaled him with stories about my last romance and told him I'd probably never love anyone again," Jillian remembered.

But she was wrong about that. A year later and very much

"Peter reads and explains
Shakespeare to me,
and to have that done
in a beautiful voice is
one of the reasons
you want to live."

in love, the couple moved to New York City, though not exactly together. "I knew he was going to move back here, and by God if I'll follow a man, so I moved here two weeks before he did," the bride said.

The couple, who have lived together practically since they met, now reside on Pomander Walk, a block-long, gated community of small Tudor row houses that is like a slice of rural England on the Upper West Side of Manhattan. The houses have brightly colored doors and little flower gardens outside and neighbors gather in the evening for cocktails on the stoops.

Jillian is known on "The Walk" as someone who loves roses, cats, strong coffee, talking and candlelight. Peter, who appeared as Aeneas in the 1995 New York Shakespeare Festival production of *Troilus and Cressida*, is known for his knowledge of Old English and his incredible voice, which is so powerful, it sounds amplified.

"Peter reads and explains Shakespeare to me, and to have that done in a beautiful voice is one of the reasons you want to live," Jillian said.

The couple, who said they had been married emotionally for a long time, finally got around to having a real wedding on the night of September 22. The one hundred guests included many members of the close-knit Pomander

community—actors, editors, an opera-singer-turned-psychotherapist and an Episcopal priest, the Reverend Allen Newman. Mr. Newman performed the ceremony on the steps of the couple's house as dozens of candles flickered among the roses and daisies in the gardens nearby.

The bride looked like an underwater creature in her white fishtail dress, with a long strand of pearls braided through her hair. It seemed perfect, if not uncanny, that it started to rain during the ceremony.

The couple barely noticed the downpour. "The hardest thing for us was to keep from laughing during the ceremony," Peter said afterward. "There were actually moments when we couldn't look at each other for fear of bursting out laughing. We have ten years of private jokes and a word can just send us. That was the most trepidatious part of it."

After the couple kissed, guests stationed on the rooftops dropped rose petals on them, while others blew soap bubbles that drifted through the gardens, up the Tudor façades and around the bride and bridegroom under their black umbrellas. Later, the bridegroom passed out raw oysters and whole bottles—not glasses—of champagne. It really did seem like a sweet, funny, offbeat and magical mermaid's wedding.

Catia Z. Mortimer *and*
Schuyler G. Chapin SEPTEMBER 15, 1995

"I've seen my
mother in love,
but I've never
seen her sure,
which is very
different."

As New York City's commissioner of Cultural Affairs, Schuyler G. Chapin is out almost nightly at performances, ribbon-cutting ceremonies and openings held anywhere from the Tibetan Museum on Staten Island to a sculpture garden in Harlem. He is not just a figurehead; he talks about art the way Bill Gates talks about the Internet.

"Art is what marks a civilization," Schuyler said. "Do we know who controlled the grain markets in ancient times, or who, in fact, was the richest person in Rome at the height of the empire? No. But do we know Greek poetry and Roman art? Of course we do."

Schuyler, seventy-two, is like a character from a John Cheever short story, reserved, gentlemanly and wry as the old *New Yorker* magazine. He met Catia Z. Mortimer, who is fifty-seven, when they were seated next to each other at a benefit dinner for the Glimmerglass Opera six months ago.

"I turned to talk to the lady on my left, and here was this exquisite creature," Schuyler recalled. "I thought she was startlingly beautiful. She's elegant, cool but warm at the same time, mysterious and enormously attractive."

He also likes to describe her as "the best thing since steam."

When they met, Schuyler had been widowed for two years, and Catia had been divorced for sixteen. She said she never expected to fall in love again; in fact, she had recently bought a new apartment and was designing it solely for herself—the bedroom carpet was bright pink, her favorite color.

"I find most men lacking," she said. "I have met a lot of gentle and kind men and a lot of interesting men, but never one who combines both. When I met Schuyler, I realized I was dealing with a phenomenon."

The two quickly discovered that they both liked music, the theater, reading, walking on beaches, talking about their children, making simple spaghetti dinners and watching good movies. About five weeks after they met, he suggested marriage.

Catia recalled, "He told me, 'We can take all the time in the world, but I just want you to know I'm going to court you until you say yes.'"

For her part, Catia knew she wanted to marry Schuyler on one of their earliest dates, when she was moved to butter his bread at a gala in honor of Jacqueline Kennedy Onassis.

"I have a very simple and old-fashioned philosophy, but I do feel the way you really know if you're in love with someone is if you want to take care of them," she said. "At my age, when you've had children and an interesting life, you'd remarry only if he was so special you just couldn't stand not being with him to look after him."

After they decided to marry, she totally changed the decorating scheme in her new apartment, where the couple will live. "The day after Schuyler suggested marriage, I called Betty Lee Knorr, who was helping me decorate the apartment," Catia recalled. "I said, 'We've got to change the carpet in the living room. It's pink, and I'm not going to be living there alone.'"

On Friday afternoon, September 15, they were married in a ceremony that took place on the lawn outside Gracie Mansion but felt as if it were happening on a Mediterranean island. The sky was a clear blue, and the white chairs on the grass caught the yellowy light like whitewashed houses in Greece.

But it was undeniably a New York event. Mayor Rudolph Giuliani officiated, and the 160 guests included everyone from Louis Auchincloss to David Rockefeller to Pat Buckley in a tangerine suit.

Liza Mortimer, the bride's daughter, who gave her mother an engagement party where everyone was required to wear a funny hat, said afterward, "I've seen my mother in love before, but I've never seen her sure, which is very different."

Sam Chapin, one of the bridegroom's four sons, commented: "There are very few things in life that seem to be all good, but this marriage is one of them. You know the saying 'Every cloud has a silver lining'? Well, this is all silver. There's no cloud here."

Katherine Kamhi *and* Tony Coghlan MAY 30, 1993

"On the soaps, love is never simple. There are always other people involved, or upsets. But when I fell in love with Tony, it couldn't have been easier."

Tony Coghlan and Katherine Kamhi met two years ago in one of the most hard-core aerobics classes in New York City: Fernanda's class, as it's known, at the Jeff Martin Studio on West Seventy-sixth Street.

"It's the class from hell," Tony said. "The instructor's name is Fernanda Chandoha. She is like a marine drill sergeant. She does not let you take it easy. She knows everyone by name, so that saves you asking people's names because you hear them shouted out during the class."

Fernanda's class, which meets at noon on Mondays, Wednesdays and Fridays, has a loyal following of actors, singers, novelists, models and Broadway dancers. When the heartbeats allow it, they talk about their plays, upcoming auditions, book parties and problems with writer's block or stage fright.

Both Katherine, twenty-nine, and Tony, thirty, fit right in. She is a down-to-earth, friendly actress who has appeared in horror movies (they are "a lot of fun," she said), repertory theater, soap operas (*All My Children* and *Guiding Light*) and, most recently, a Pizza Hut commercial.

In *All My Children*, she played the part of Pamela Kingsley. "I was having an affair with Erica's brother, Mark," she said. "She was having an affair with my father on the show. That didn't work out, so I tried to kill myself with pills. And then I was in a coma."

She added: "On the soaps, love is never simple. There are always other people involved, or upsets. But when I fell in love with Tony, it couldn't have been easier or simpler."

Tony is an athletic, gregarious freelance correspondent for Australian television in New York. He's covered everything from city elections to robot bartenders to luxury hotels for dogs, and he contributes his craziest segments to *Tonight Live with Steve Vizard*, Australia's equivalent of *Late Night with David Letterman*.

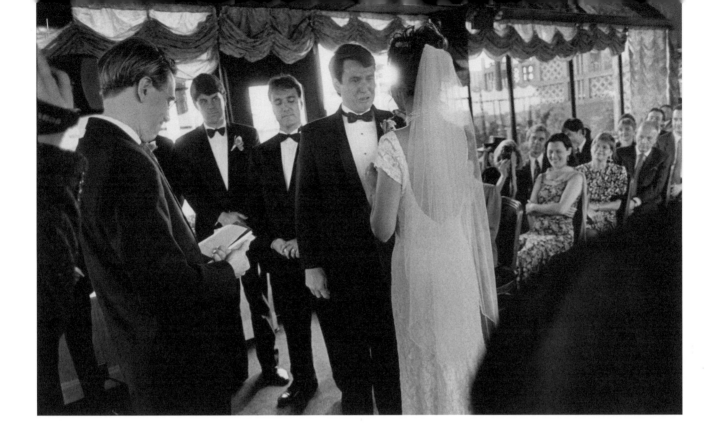

"I never thought I'd get married," Tony said. "It was not high on my agenda. But when I met Katherine, I thought, 'Yeah, this is the girl I would like to spend the rest of my life with.' I suddenly was the marrying kind."

When asked to describe the Australian national character, the bridegroom said, "We'll go anywhere for a drink, basically, which is why so many friends of mine are coming from Australia for the wedding. They'll travel thousands of miles for a free drink."

About eighty guests watched the couple's wedding on Sunday, May 30, at the Terrace Restaurant located on the rooftop of an apartment building on West 119th Street. The bride, who grew up on the Upper West Side, looked Victorian, romantic and zany all at once, wearing a pearl choker and a white lace Betsey Johnson dress with a low scooped back. Closer to a slip than a ball gown, it was the sort of dress that could be folded up and carried in a purse, if necessary.

Although Australian men are better known for wrestling alligators than for weeping in public, the bridegroom cried openly throughout the ceremony. As tears steadily streamed down his face, Ms. Kamhi wiped them away with her handkerchief, sweetly laughing and occasionally saying, "It's okay; it's okay."

Terry Willesee, an Australian friend of the bridegroom and a reporter for the television show *A Current Affair*, said afterward, "Tony broke as soon as he saw his bride and he didn't try to hide it. I was so proud of him."

Peter Heap, an Australian cameraman who often works with the bridegroom, commented, "It's ironic that a man who can perform flawlessly on television, can address himself to millions of people with ease, sort of got all choked up addressing one other person, Katherine."

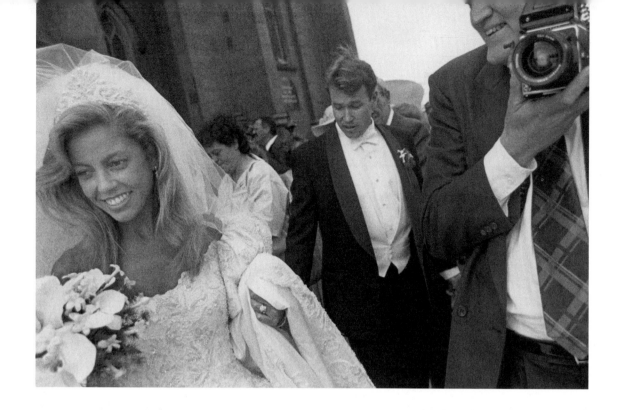

Madeline Cuomo *and* Brian O'Donoghue JUNE 12, 1993

Even as high school sweethearts, Madeline Cuomo and Brian O'Donoghue were more interested in public service than in partying or glamour. They met at the Saint Francis Preparatory School in Bayside, Queens, and spent many Saturday nights working together in places that were not exactly popular teenage hangouts, like a nursing home or a shelter for the homeless.

Madeline, a daughter of Governor Mario M. Cuomo and his wife, Matilda, is now twenty-eight years old and a lawyer specializing in matrimonial law. Brian, thirty, just finished his first year of law school at Fordham University and worked until recently as a firefighter in Manhattan and as a lifeguard at Jones Beach on Long Island.

"He's one of the true good-doers in the world," said Chris Greene, a high school classmate of the couple and a guest at their wedding. "Most guys our age are out to make money and have a good time, but not him. He's looking to save lives."

Like Madeline, Brian is family-oriented—he has fourteen brothers and sisters and thirty-nine nieces and nephews, and he is close to all of them. "Brian had a long reputation in our family as a guy who was unlucky," said one brother, Thomas O'Donoghue. "When he was younger, he would get into minor car accidents and scrapes. We used to call him 'the Luckless Wonder.' As you can well guess, as soon as he got engaged to the governor's daughter, that title changed quickly."

> "Friends are
> one thing,
> but family is
> everything."

On June 12, the couple was married in Albany at the Cathedral of the Immaculate Conception, next door to the governor's mansion, where the reception was held. The cathedral, which looks like a small brownstone version of Saint Patrick's Cathedral in Manhattan, has carved domed ceilings, statues of saints set in the walls and an aisle that is so long, it could serve as a practice track for sprinters.

As many guests expected, the wedding party of twenty-four was made up entirely of sisters, brothers, sisters-in-law, brothers-in-law, nieces and nephews of the couple.

"I asked Brian if he considered having any friends in the wedding and he said, 'My family is my friends,'" Thomas O'Donoghue said. "Neither of them would even consider going outside of their families. Friends are one thing, but family is everything."

As about three hundred guests watched, the bride walked down the aisle wearing an Eve of Milady wedding gown with embroidered lace sleeves, a sparkly crown holding the veil in place and a long satin train decorated with pearls, sequins and crystal beads. Like lingering perfume, the train continued to swish and slide down the aisle long after the bride had passed.

"She looked gorgeous!" said Larry King, the television host, who's an old friend of the Cuomos. "It was the longest dress I've ever seen in my life."

Shortly before the wedding, the couple talked about starting their own family with almost giddy excitement, as well as deep awe. "I think there are some things in life that are so mysterious, so inexplicable, that the only answer is they're close to godly," said the bridegroom. "Bringing life into the world is without a doubt one of them."

Meryl Blackman *and* David Singer NOVEMBER 12, 1995

"I thought,
'It's going to be all
right because
there's someone
who wants me
and I have
a feeling I want
them, too.'"

Meryl Blackman, forty-three, is a fixture in Cobble Hill, Brooklyn. She has worked there for ten years as a real estate broker and can tell you exactly which brownstone apartments are recently renovated, reportedly haunted, seriously underpriced, cold in the winter or close to good Indian restaurants.

She met David Singer, forty-six, in 1986, when he moved into a one-bedroom apartment (he found it through another agent) directly across the street from the offices of Barbara d'Erasmo Realty, where she was working. It was a storefront business, and Meryl sat near the front window, as close to passersby as the mannequins in the Barney's windows. It was hard not to notice her, and David did right away.

At the time, he was newly divorced and living with his daughter, Laura, who was five. Meryl was single and beginning to think she would never marry. The two sometimes spoke on the street, as neighbors do in Cobble Hill, but they became acquainted mainly by watching each other behind their respective windows.

David, a co-principal clarinetist with the Orpheus Chamber Orchestra, would practice for hours each day while standing at the bedroom window that overlooked the street. Meryl often watched him from her desk, imagining that he was funny, smart and unavailable. "I kept waiting for the girlfriend's boxes to arrive," she said.

Meanwhile, he often watched her rushing in and out of the real estate office with clients or shopping bags. "From my window, I saw this very beautiful, very busy young woman scurrying around doing errands in her long, flowing coat," he recalled. "I didn't think there was any way she'd be interested in me. I was a single father, a struggling musician."

In 1988, they both married other people. He moved out of the neighborhood;

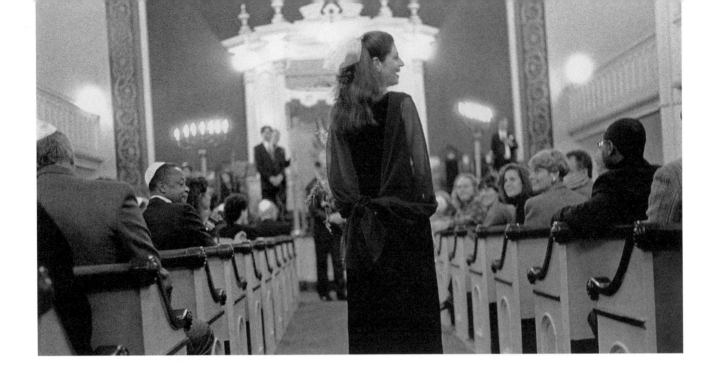

she stayed. Years passed. His daughter became a teenager. The rental market went up and down. He continued to play for Orpheus, which became a popular orchestra with gigs all over the world. Eventually, both of their marriages ended.

In May 1995, he was walking in his old neighborhood when he passed Cobble Hill Realty, where Meryl now works. She was sitting by the front window, and he remembered her instantly. "I thought, 'Well, why not now?'" he recalled. When he knocked on the window to say hello, she recognized him right away. "It had been nine years, but this entire sensation went through me," she said. "He's so pleasing to my eyes. There's something about his presence that takes the breath out of me."

This time, things between them progressed much more quickly. The next morning, he left a message on her work telephone saying that he was leaving for a concert tour in Europe but hoped she would have dinner with him when he returned.

"Then I got a postcard from Paris," said the bride. "When I read that postcard, I thought, 'It's going to be all right, be-cause there's someone who wants me and I have a feeling I want him, too.'"

The couple, both longtime yoga students who like clean, uncluttered, spare apartments, had their first formal date—dinner at an Indian restaurant in the East Village—on June 4. Within weeks they decided to marry.

"Whatever compatibility is, whether it's chemical, whether it's personality, whether it's being the same age, we have it on every level," Meryl said. "I'm hyper; he's calm. Where I lack creativity, he's creative and soft. Where he lacks business drive, I've got it. Our compatibility goes right down to the fact that we both have astigmatisms in our eyeglass prescriptions."

Last Sunday, they were married in Cobble Hill, where they will live, before about one hundred guests at the Kane Street Synagogue. During the afternoon ceremony, Rabbi Debra Cantor told the bride and bridegroom, "The miracle of your coming together can only be described in three lit-tle words: location, location, location."

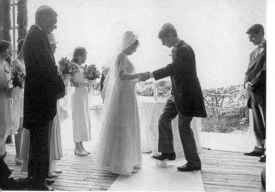

Heather Arak *and* Nathan Kanofsky MAY 28, 1995

"He would walk
to the end of
the earth for
her, literally.
He's the
walking man."

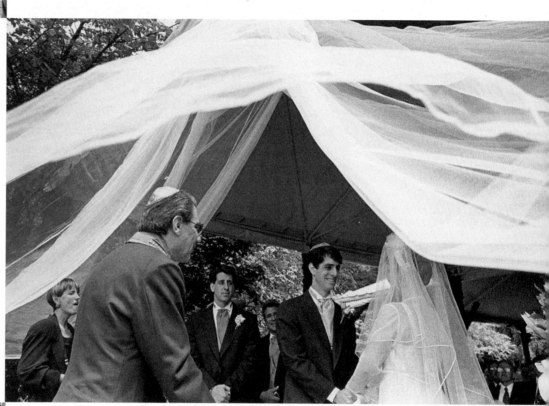

Heather Arak, twenty-four, and Nathan Kanofsky, twenty-five, met as fellow art majors at Syracuse University, where they were best friends until one night in their senior year, when he suddenly kissed her in the printmaking studio.

She said she had two different reactions: First, she wanted to run out of the studio, forget they had ever kissed and go back to being friends; second, she wanted to keep kissing.

The next day, Nathan left a single white rose and a single red rose on her doorstep, composed as carefully as a still-life painting.

"The red was for love and the white was for friendship," Heather said. "He was saying it was my choice."

It took her a while, and many long telephone conversations with friends, but eventually she chose the red rose.

They now live in Hoboken, New Jersey, and own a printmaking business, Arak Kanofsky Studios, that specializes in turning etchings, paintings, photographs and woodcuts into prints. Like printmaking, an old, labor-intensive art form in which everything is done by hand, the couple's life together is almost religiously low-tech.

Nathan, who is known among friends as "the walking man," travels by foot whenever possible, sometimes covering six or seven miles a day. In the couple's apartment, everything, from the furniture to the kitchen utensils, sketchbooks, bed covers and candlesticks, was made by them or by friends.

"All of the paper they write on is handmade," said Kate Ryan, a friend. "The post office hates them because their letters are always undersized or oversized and they always want everything hand-stamped."

Like the letters they send out, the couple's wedding, on May 28 at the Loeb Boathouse in Central Park, was completely unstandardized. Nearly every detail was handmade by the couple or, as Nathan put it, "touched" in some way by them.

The couple spent months on the invitations—creations that involved waxed string and several different layers, colors and textures of paper. The envelopes were transparent; the cover of the invitation showed a Monet painting superimposed over a photograph of Central Park, so that the park took on a dreamy, Impressionist look in periwinkle, yellow and green.

When the ninety guests arrived at the boathouse, they found the tables decorated with paper fans made by the couple and printed in colors that matched the invitations. The tables were named after the bridegroom's favorite places for walking in Central Park—Strawberry Fields, the Ramble—and each had a wedding cake as a centerpiece. Like a series of handprints, the cakes all looked alike, but had slight differences and idiosyncrasies.

Even the bride's outfit was inspired by the arts of printmaking and papermaking. She wore a hand-sewn medieval-style gown with an embroidered apron and a transparent silk organza overcoat that looked as if it were made out of Japanese rice paper.

The couple was married beneath a tulle *huppah* tied to the roof of the boathouse in a spot overlooking the lake. They were surrounded by ushers in black tie and bridesmaids who wore fishnet gloves, short white dresses and voluminous tulle shawls. At times, their shawls billowed and flapped in the wind, making them look like bridesmaids wrapped by Christo.

Of the four bridesmaids, Holly Ward, an artist, cried the hardest during the wedding ceremony, mainly from watching the bridegroom's face. "Nathan did not take his eyes off Heather for a minute," she said afterward. "He is so dedicated to her. He would walk to the end of the earth for her, literally. He's the walking man."

Jean McFadden *and*
Edward Layton APRIL 15, 1995

"At the end
of the night,
I said, 'Hey, I'd
like to continue
talking,' and
he handed me
his phone
number."

Jean McFadden is a funny, talkative woman, the sort of person who bakes bread from scratch and wouldn't hesitate to help someone push a car out of a snowbank, even if she were wearing a silk dress and high heels. She is a premed student at City College, with plans to become a general practitioner in a small American town one day. On weekends, she cooks for God's Love We Deliver, the organization in New York that prepares and delivers meals to home-bound people with AIDS.

Jean, thirty-five, whose first husband died of cancer five years ago, fits in well at God's Love We Deliver. The kitchen there is filled with volunteers making hearty soups and breads, and in many cases getting over the death of a lover, coworker, friend or sibling.

"It's a huge range of ages and stories, but most people in the kitchen have lost a friend or family member to AIDS," said Greg Cartwright, a soup cook for the organization.

Six months ago, Jean met Edward Layton, thirty-six, a student of acupuncture and Chinese herbal medicine, at a party. "We talked about Oriental medicine versus Western medicine," she recalled. "At the end of the night, I said, 'Hey, I'd like to continue talking,' and he handed me his phone number."

A week later, she called and asked him out. They took a long walk through the gardens of the Cloisters in upper Manhattan and, unlike other men she had dated, he didn't seem spooked by her life story.

"I tended to really scare men off," she said. "I'm a premed student, which terrifies a lot of men, and I was married before and my prior husband died and I work for an AIDS organization. Most of the men I met went screaming into the night, but Ed looked at all that and said, 'Cool.'"

Ed, who had been through a difficult divorce, recalls thinking, "Wow, I've met somebody who has a story at least as tumultuous as my own history.

Here's somebody who had a real slice of life thrown in her court. And she maintained a positive attitude at the end of it, too."

On April 15, the couple was married on the Upper West Side in the chapel at the American Youth Hostel, where God's Love is based. The chapel is a simple, no-frills space—it's easy to imagine backpackers marrying there in jeans and hiking boots on their way across America.

The couple spent the morning of their wedding in the God's Love We Deliver kitchen cooking lasagna, soup and ham for their one hundred guests, then changed into their wedding clothes—an antique lace dress with a celery-colored underslip for her and a sage-colored suit for him.

"She looks like someone out of a Victorian storybook," said Adria Quinones, a guest and God's Love volunteer.

"He looks like someone out of a Chekhov play with his goatee and thin build," said Elizabeth Gee, another volunteer.

The ceremony, which was officiated by the Reverend Re-bekah Eisele of the Movement of Inner Spiritual Awareness, reflected the couple's belief in the power of gems, colors, herbs, the healing professions and positive thinking.

They exchanged ruby wedding rings because, as Rev. Eisele put it, "Red rays cut through negativity." The bride wore a wreath made of herbs and other plants that, according to *The Complete Book of Herbs* by Lesley Bremness, were appropriate for the day. She wore thyme, which represents eternity, and variegated ivy, a plant that naturally clings and symbolizes fidelity.

Many among the guests were still mourning the loss of lovers, children or friends to AIDS. Roz Gilbert, a God's Love volunteer, simply said, "I lost my son," when asked why she worked for the organization.

"You are lucky I haven't started crying yet," she added. "I'm holding it in right now but ordinarily I go to pieces. It's inspiring to see Jean. She's going forward with her life. She's a survivor."

Brett Savage *and* Ryan Baker July 1, 1995

While some weddings are as quiet in spirit as an Edward Hopper painting, Brett Savage and Ryan Baker's wedding was like a parade, a Super Bowl celebration, a light show, disco dance and black-tie dinner all at once.

Everything about the wedding was oversized, beginning with the invitations, which were so large they could have been used to mark the bases in a softball game.

The couple, who love cities, jokes, sports, dinner parties and nice shoes, met two years ago in central Illinois. Both were working as anchors at small midwestern television stations, he at WCIA in Champaign and she at WICS in Springfield.

"There was nothing to do in Springfield," said Brett, who is twenty-eight and grew up in Westchester County, New York. "And I mean nothing. I was surrounded by cornfields."

Ryan, twenty-five, grew up in Chicago and first saw Brett on television one day. "I thought, 'Wow, that's a fine-looking sister for central Illinois,'" he remembered. As soon as he could get up the courage, he called, introduced himself and asked her out on a date—lunch in a nearly deserted diner in Springfield.

A year later, when they became engaged, they promised each other that their wedding would be the antithesis of a quiet ceremony in a cornfield. The bride even quit her job to plan and coordinate an extravaganza that included everything

> "In life, you don't have
> to search for bad things—
> they find you without
> a problem. But the good
> times, they're hard
> to find, and this was
> one of those truly
> spectacular times."

from a light-and-smoke show to a four-foot-tall wedding cake.

On July 1, they were married at Saint Catherine A.M.E. Church in New Rochelle. Afterward, the couple and their wedding party traveled in a fleet of eight honking limousines to the Pierre Hotel in Manhattan. Motoring down East Sixty-first Street, they looked like a school of giant white sharks.

As they rode, the bride and bridegroom stood together in the open sunroof of their car. Ryan, who is now a sports anchor at WCPX-TV in Orlando, Florida, wore sunglasses and waved a foaming champagne bottle; the bride's veil flew in the wind like a flag on a speedboat.

"People on the sidewalks were screaming and clapping," said Rob Baker, a brother of the bridegroom and a grooms-man. "It was like we'd won the world championships."

Inside the Pierre, drinks and shrimp as large as ankle weights were served in a room with paintings of formal English gardens on the walls. While the atmosphere was staid, the spirit was not, especially when everyone was invited to enter the ballroom for dinner.

It was like walking into a hot new nightclub. In the nearly dark ballroom, bright purple spotlights lit the bride and bridegroom's table while the wedding party's table was colored with pink lights and glowed like a tropical sunset.

After the 250 guests were seated, the bridesmaids and the groomsmen were introduced like contestants in a beauty pageant, to dance music and crisscrossing spotlights. Just before the newlyweds appeared, the entrance filled with smoke, and they burst through like two stars in a music video.

"What a night!" exclaimed one guest. "It was exquisite, funky and soulful. I don't think the Pierre has ever seen anything like it. You normally see those things at a discotheque or an extravaganza show with Michael Jackson."

The bridegroom was so jubilant during the reception that he was seen somersaulting on the dance floor at one point.

"It was like a dream," he said from his hotel room the next day. "It was surreal. In life, you don't have to search for bad things—they find you without a problem. Disasters always seem to know your address, even if you move. But the good times, they're hard to find, and this was one of those truly spectacular times."

Ayun Halliday *and* Greg Kotis

NOVEMBER 4, 1995

"She loved
the fact that
her wedding
dress cost the
same as four
Northwestern
sweatshirts."

Greg Kotis, twenty-nine, and Ayun Halliday, thirty, are members of the Neo-Futurists, a small alternative theater troupe that started out in Chicago and recently moved to New York. Among troupe friends, they are known as Greggy K. and Princess Annie.

The group appears Thursdays through Saturdays at Here, a performance space in SoHo. While it strives to debunk the conventions of theater, and life in general, its members seem more like lighthearted pranksters than performance artists.

There is no fixed price for admission. (Guests roll a dice and pay whatever number comes up, in dollars.) Once inside, the audience receives a list of skits on such subjects as hairstyles, budget cuts, grandmothers, war and pretzels. Each play is numbered, and viewers pick what will be performed by shouting out numbers, like countermen in a busy deli.

Greg and Ayun, graduates of Northwestern University and the University of Chicago, respectively, met four years ago when he auditioned for the troupe. At the time, her roommate was Stephen O'Rourke, a playwright who was often afraid she'd burn down their apartment because she liked to light candles everywhere.

Mr. O'Rourke recalled that after Greg became a Neo-Futurist, Ayun began to return from rehearsals looking as if she'd just heard a great joke. "She could not stop smiling," he said. "I have never seen anyone more visibly in love."

Greg and Ayun are very different. He is intense and intellectual, a person who reads *Moby-Dick* on the subway.

She is ethereal, a trained massage therapist who never wears makeup and travels around Manhattan by bicycle, sometimes in a long, flowing skirt. Describing her relationship with Greg, she said, "We have a nice yin-yang. Greg often sees the dark scenario, and I refuse to see the darker side of things."

Growing up in Indianapolis, Ayun was full of artistic ambitions. "I never thought she would get married," said Cynthia MacCollum, a childhood friend. "Ayun and I, in our boredom in Indianapolis, would draw future cartoons, where we would draw ourselves in the future. Invariably, Ayun was an actress in New York living in a loft with her boyfriend. All of us were married, but Ayun was never married."

Ayun proposed to Greg eight months ago, upon his return from a trip to Paris. She met him at the airport with a hand-painted sign that read, WILL YOU MARRY ME?

"Ayun is a really strong, forward woman," said Karen Christopher, a troupe member. "She has a very robust attitude about what it means to be a woman. She's proud of how big her hands have gotten since she became a masseuse, because it shows how strong she is."

The couple was married in a SoHo loft, rented for the evening of November 4. It was a quintessential downtown space, with exposed brick, enormous windows and paintings-in-progress on the walls. Ninety or so guests gathered for the ceremony, which was nondenominational and included a reading of Chapter 114 of *Moby-Dick*, in which the description of constantly changing weather at sea reminds the couple of marriage.

Ayun, who cooks a vegetarian feast for the troupe every Sunday, looked like Pomona, the Roman goddess of fruit. She wore a sleeveless silk dress (just sheer enough to show her striped knee socks) and a headpiece made of purple fabric grapes.

The reception was not unlike the troupe's Sunday night get-togethers—a lot of the people there were funny, naturally good-looking and dressed inexpensively, including the bride.

"I was with Ayun when she bought her wedding dress," Mr. O'Rourke said. "That same day I paid fifty dollars for a Northwestern sweatshirt, and she loved the fact that her wedding dress cost the same as four Northwestern sweatshirts."

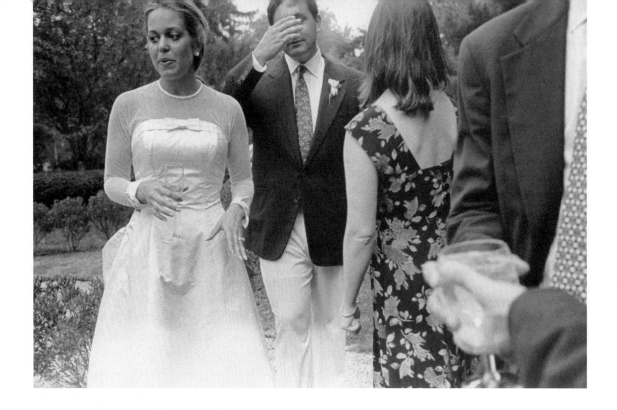

Katherine Zipser *and* Hew Crooks JULY 22, 1995

Katherine Ernest Zipser, twenty-five, and Hew Dalrymple Crawford Crooks, twenty-six, discussed marriage for the first time only two months ago, while sitting in a field of yellow and white daffodils in Litchfield, Connecticut. The next day, they started planning the wedding.

"I hate long engagements," said the bride, who is known as Kate. "I have friends whose engagements have been like a Wagnerian opera—they go on forever. I think fast and furious is better."

Friends compare Kate to a Brazilian or Italian aristocrat because of her olive complexion and dark brown eyes and because, when she's wearing a bikini and smoking a ciga-rette, she evokes the island of Capri, even if she's in a back-yard in Connecticut. Until recently she worked as a sales-person in the corporate sales department at Tiffany & Company in New York.

She is also known for being as adventurous and wild as she is glamorous. Before she met Hew, she dated a wide variety of men, from blue-blooded lawyers to strange, tortured poets. She met Hew, a squash and rugby player, banker and skier, on a blind date a year and a half ago. He is a principal in Stanton Capital Advisers, an investment firm in Lima, Peru, that he named after his favorite ski area, St. Anton in Austria.

At first, Hew thought Kate was the sort of woman who ex-

"I have friends whose engagements have been like a Wagnerian opera—they go on forever. I think fast and furious is better."

pected to be taken to fancy restaurants like Lutèce at least once a week. "Kate was raised in Bedford, New York, and went to Miss Porter's boarding school and worked at Tiffany's and her sister worked at Christie's," he said. "Her résumé suggested that she was pretty but probably high-maintenance. It took a while for me to realize how laid-back she is. On our fourth date, I was trying to think of some chic place to go down in SoHo, and she said, 'What I'd really like to do is go get a cheeseburger and watch the Knicks play.'"

He added, "I knew I definitely wanted to marry her when I bought a little Italian sports car and we broke down in it for the third time on the New York Thruway in the pouring rain. It was a convertible that leaked anyway, just a hopeless thing, and never once did she say, 'Why did you buy this stupid car?'"

According to their many friends, they are not exactly a typical 1990s couple who hang out in cyberspace or watch *Seinfeld* every Thursday night. "Kate and Hew are very old-fashioned," said Erik Oken, an old friend of the bridegroom. "Our parents' generation had a great appreciation for the value of a good cocktail party, and that's something Hew and Kate appreciate. They enjoy being at close range with people and being forced to entertain and be entertained rather than going to a place where the entertainment is provided for you."

Their wedding was definitely old-fashioned—it could have been in a novel by Thackeray or Alcott. On July 22, they were married before eighty guests in Milton, Connecticut, at the Trinity Church, a tiny white wooden chapel with windows as colorful as Hermès scarves. The church is on a country lane surrounded by a village green, an old schoolhouse and mountains. When the bride reached the altar, she discovered there was a cricket caught in her veil.

It was a simple ceremony, with sunlight shining through the windows, flute music, traditional vows and a long kiss.

As in a Victorian novel, the bride's parents, Mary and John Zipser, spent weeks in their kitchen preparing the wedding dinner that followed, using mainly old family recipes. The wedding meal was served at home, as it traditionally was in the 1800s, among the evergreens and English flower gardens behind the Zipsers' colonial house in Litchfield.

A few days later, the father of the bride was asked to recall his favorite moment of the wedding. "I loved the way Kate and Hew kissed each other at the end of the ceremony," he said. "It was so natural, and then Kate threw her arms around his neck, and I thought, 'Well, this looks good to me.'"

Catherine Contopoulos *and* Apostoles Lambropoulos MAY 29, 1994

"I asked
Catherine if she
had a boyfriend
and she said
no, so I said,
'From now on,
you have me.'"

Catherine Kalliopy Contopoulos, twenty-nine, and Apostoles Pericles Lambropoulos, twenty-six, met two years ago at the Thiasos, a Greek Café in Manhattan that looks like a country restaurant, with a rough timbered ceiling, yellow plaster walls and blue window frames the color of Mediterranean fishing boats.

Seated at different crowded tables, they spotted each other across the room and flirted, without meeting or speaking, for hours. Apostoles, a freelance computer programmer who grew up in Athens, sent over a bottle of champagne. She smiled and accepted it. He winked. She waved. He sent dessert.

"Finally, the waiter came over and handed me a check with his name and all of his phone numbers on it: two offices, his home number, his beeper number," Catherine recalled. "Then he gave me a pen and said, 'You should write down yours, too,' so I wrote down my name and *one* phone number."

Eventually the two started a conversation and ended up staying in the café until daybreak. By then, they were the only customers left, along with Vangelis Sampos, an owner of the café, who played guitar as the couple talked and danced among the empty tables. "After we danced, I asked Catherine if she had a boyfriend, and she said no," said Apostolos, whose nickname is "Laki." "So I said, 'From now on, you have me.'"

Catherine, who grew up in New York, is a soft-spoken writer at work on a murder-mystery novel. She also works as an editor and reporter for *The Orthodox Observer*, a national newspaper published by the Greek Archdiocese of New York.

On May 29, they were married in a traditional Greek Orthodox ceremony at the Archdiocesan Cathedral of the Holy Trinity on the Upper East Side. It was the opposite of a modern, custom-made, personalized ceremony: There were no readings of the couple's favorite poetry, or love letters they wrote to each other. There were no homemade vows or guitar playing. The liturgy and rituals of Greek Orthodox weddings have not changed for fifteen hundred years, and watching the couple follow them was like visiting a piece of architecture left intact from an earlier civilization.

The three officiating priests chanted Byzantine hymns while leading the couple through one age-old symbolic act after another. In honor of the Holy Trinity, each act was repeated three times. The couple said their vows three times, exchanged rings and flower crowns three times and walked around the altar, through thick incense smoke, three times. The repetition and chanting made it seem as if all the people involved in the proceedings were mesmerized and being led by an ancient voice.

"I felt like I was watching something that was timeless," said Alexandra Levinsohn, an actress who met the bride when they were classmates at Vassar College. "A lot of people now get married and it's like boom, boom, boom. The big thing is the short ceremony: Let's just get to the party. But if you're going to spend the rest of your life with someone, you deserve a ceremony, something more than 'I do. I do.'"

Afterward, everyone headed down to the Thiasos Café for a reception that echoed the night the couple met. Guests sat at long tables laden with flowers, bottles of wine and platters of everything from marinated octopus to spinach pie. While they ate, the window curtains of the café billowed like sails on a boat. Mr. Sampos even played folk songs on his guitar.

Before he played, he described the night the couple met and lingered in the café. "It was very romantic," he said. "The candles were burning but the place was closed. It was a very Greek night, but it dawned in New York."

Kareene Nahas *and*
John McCarus December 30, 1994

"I called my
best friend and
told her, 'This is
the man I'm
going to marry.'
She said, 'Have
a cocktail.
You're insane.'"

John McCarus, thirty-five, and Kareene Nahas, twenty-nine, are not people a dating-service computer would ever match up.

He is a nine-to-five advertising account manager at *Gourmet* magazine in New York who used to wake up to an alarm clock every morning and stores fancy cigars and coffees in the freezer.

She is a nocturnal trompe l'oeil artist and interior designer who until recently planned to move to a tropical island with only her paints, candles and bandannas.

Shortly after they met, at a party in February 1994, he visited her apartment. His first impression wasn't positive. He thought she was "definitely from another planet," as he put it.

Her apartment was filled with a fleet of motor scooters (Kareene rides them around the city) and very little furniture. When John opened the freezer to get some ice cubes, he discovered her collection of "freezer art"—miniature figures, like Batman and Wonder Woman, caught in webs of frozen spaghetti.

"I was thinking, 'This is very strange, but I'm just going to let it fly,'" he recalled. "Every once in a while in New York you run into a situation like that. You close your eyes and say, 'You know what, I better ride this one out.'"

Their second date was even more peculiar—they ended the evening, which went spectacularly well, by proposing to each other.

"I called my best friend and told her, 'This is the man I'm going to marry,'" Kareene remembered. "She said, 'Have a cocktail. You're insane.' And I said, 'No, you don't understand. This is the one.'"

Soon afterward, he moved into her apartment, which altered his living habits dramatically. For one thing, he no longer needed an alarm clock. As Kareene, who uses the walls, ceilings and counters as her canvases, said, "Everything in the apartment is painted, including John, on mornings when he sleeps late."

And he never knows what might disappear from the apartment during the day. Kareene uses everything from his belt buckles to cheese graters for her interior-design projects.

"When I come home and the candles are on, it means she's in a creative mood and dismantling things," John said. "She takes silverware and puts it on the wall as coatracks. I do the cooking, and I'll make pasta one night only to find there's no strainer—it's hanging in the closet as a lamp."

They were married on December 30 at the Cathedral of Saint John the Divine. His wedding party was conventional; hers included two bridesmaids and four "bridesmen," all wearing their own interpretations of black tie. Brian Lilly, one of the bridesmen, accessorized his mandarin-style black suit with a colorful Hermès bow tie, hoop earrings and black motorcycle boots with polished silver heels.

Friends expected the bride to wear anything from cutoff blue-jean shorts to a tuxedo with paintbrushes in the pockets, but she chose a silk fishtail gown with a cathedral-length train. "I wanted to save some beautiful, classic things about weddings and put others in a blender on the frappé level," she said.

During the reception, at the opulent James Burden Mansion near Fifth Avenue, ninety guests sat at one long table that snaked through a room with marble floors and tall French windows.

Jane Veronis, a guest and the national fashion manager of *Spin* magazine, said, "John's from the Midwest, and he always thought he had to go out with these Suzy Homemaker types. He even dated the Wheat Queen of Kansas at one point. But I always knew he was saving himself for some wildness."

Seth Levenson added, "People search for someone with whom they have a lot in common, but John and Kareene are two people enormously in love who don't have that much in common. They prove my theory that when the right two people meet, everything else becomes meaningless."

Sophie Chapuisat *and* Kenneth Smith JULY 31, 1993

"Two mates
without a
captain—
I thought
that was a great
analogy
for marriage."

For many people with unusual schedules and serious passions—ice-water swimmers, doctors, currency traders, ballet dancers—it helps to marry a like-minded soul.

Kenneth Smith, thirty-seven, and Sophie Chapuisat, twenty-eight, describe themselves as rowing fanatics. Both rowed as undergraduates at Columbia University (she was a member of Columbia's first women's crew in 1983) and now belong to a small group of die-hard rowing enthusiasts in New York City.

For over a year, Sophie has been training with four women for the Canadian Henley, a regatta. Before dawn almost every morning, the tight-knit group rows on the Harlem River, which connects the East and Hudson rivers. They talk about everything from Greek philosophy to their love lives as they glide past the river's strange flotsam (automobile parts, dolls, refrigerators and, once, a school of watermelons). The bride rows as much for the sport and the workout as for what she calls "women's talk."

"I'm marrying someone who understands the commitment I have to rowing, but, more important, to my girlfriends," said Sophie, who works as a banker at Citibank when she's not out on the water.

Kenneth, a training coordinator for paralegals at the law firm of Skadden, Arps, Slate, Meagher & Flom, referees all of Columbia's home crew races and rarely misses a regatta on the East Coast. He can compare the currents, wind patterns and banks of various rivers the way palm readers can distinguish among the tiny lines and crevices of various hands.

Their July 31 wedding in Saint Paul's Chapel at Columbia was athletic black tie. The bride wore a wedding dress that was perfect for someone more accustomed to sweats and T-shirts than tulle, bows and taffeta. It was designed by Lisa Hiley, a British dressmaker who works out of the back room of One Night

Stand, a shop in Manhattan. After the ceremony, Sophie shed the detachable skirt, veil and train and appeared at the reception in a short version of the outfit. Alison Spear, an architect and a guest, called it "the rip-off dress."

The reception was held at the Columbia University Boathouse, a white neoclassical building on the Harlem River near West 218th Street. To show her support for women's endeavors, the bride chose an all-female band—the Kit McClure Band—to play swing music while cocktails were served under the willow trees on the riverbank.

George Freimarck, the chairman of the Rowing Committee at Columbia, was among the guests, dressed like an Englishman attending a regatta at Oxford University. On the subject of two rowers setting up house together, he said, "Sophie probably gets up at four A.M. each morning to practice. It takes someone else who rows to understand why anyone would do that. One reason is the aesthetic feeling of rowing in a boat. It's a continuous rush if you're doing it properly. It's like a big bird taking off on the water."

A few days after the reception, the bridegroom recounted one of the evening's most memorable toasts. "My father-in-law gave a little talk at one point," he said. "He wanted to use nautical metaphors, so he said we should undertake to be two mates in a boat without a captain. No one's in charge, but we're both equally relying on each other. Two mates without a captain—I thought that was a great analogy for marriage."

Mary Collins *and* Tony Yarborough APRIL 23, 1994

Mary Collins, a forty-three-year-old agent with the Triton Agency, a theatrical talent company in New York City, often arrives at work wearing a fuchsia Chanel suit, pearls, black stockings, black high heels and a beat-up black leather jacket. A singer and an actress herself, she grew up in Texas, lived alone in Paris when she was in her twenties and never believed in marriage.

Everything from her spiky hairdo to her thinking about long-term commitments softened after she met Anthony Yarborough, a private investigator who grew up in North Carolina. They were introduced at the christening of a mutual friend's baby three years ago.

"We talked the whole time," she remembered. "It was completely nonstop and fantastic. So often when you meet people you get the feeling that the door is shut or you've got to kick it open or it's stuck or you don't want to open the door. With Tony, I thought, 'This might lead somewhere.'"

Tony, thirty-one, looks and speaks more like a sensitive downtown poet than a hard-bitten detective. He wears a jean jacket rather than a trench coat and is often hired by clients to trail spouses they suspect are having affairs. He has tailed illicit lovers through Central Park, watched them kiss in movie theaters and eavesdropped on them in four-star restaurants. Still, he was not prepared for how love would actually feel.

"I always thought
when I fell in love
it would be like bricks
falling on my head.
But I just liked
being with Mary."

"I always thought when I fell in love it would be like bricks falling on my head or rockets going off," he said. "But I just liked being with Mary. I remember on the third date, we were walking down the street and she said, 'I like you,' and it just went to my heart."

Their afternoon wedding on April 23 was as down-to-earth and openly heartfelt as a Patsy Cline song. The Reverend Molly McGreevy officiated at the Church of Saint Luke in the Fields, a small, pristine Episcopal church in the West Village. The bride wore a knee-length summer dress and had yellow buttercups woven through her hair. The bridegroom wore a Paul Smith suit with a band-collared shirt and no tie.

Afterward, the 130 guests walked to a party in a private loft filled with sunlight and terra-cotta pots of daisies arranged by Avi Adler, a Brooklyn-based gardener and flower designer. Like a backyard barbecue in Texas or North Carolina, there were red-and-white checkered tablecloths, a keg of beer in the corner and a pickup band made up of friends of the couple who played rock-and-roll songs. Reggie Young, an event planner in the West Village, served picnic food—ribs, corn on the cob, stuffed jalapeños, quesadillas and grilled chicken sandwiches.

At one point, the bride grabbed the microphone and sang "Baby, I'm Yours" to her new husband. "Every time Mary sang the line 'Baby, I'm yours,' the crowd would go, 'Yeah!' and applaud and scream and yell, and then it would die down," said Alice Gordon, the maid of honor. "It was like being in the cheering section at a football game."

John Davidson, a writer who met the bride in the early 1970s at the University of Texas in Austin, said: "It's a sign of the times that everybody's happy Mary is getting married. Back then, we would have thought it was a cop-out to get married. If you really were an adventurer, you wouldn't do it. Now, it seems like one of the bravest things you could do."

Gabriela Power Porto *and*
Peter Castaldi <small>DECEMBER 20, 1995</small>

"She was
like this
incredible
panther
walking
toward me."

Gabriela Power Porto, thirty-four, a professional flamenco and ballet dancer, and Peter Castaldi, thirty-four, a baritone with the Magic Circle Opera Company in New York, are the sort of people you often encounter in the Lincoln Center neighborhood, where the streets are filled with singers, ballerinas, flutists and costume designers. Gabriela and Peter have perfect posture and such beautiful voices, they sound as if they are reciting poetry even if they are just giving directions to the nearest subway station.

They met through a mutual friend a year and a half ago, and their courtship, like flamenco dancing and opera, was filled with formalities, drama and roses. After they began dating, Gabriela, who grew up in the Peruvian jungle and now teaches ballet in Carnegie Hall, would often walk out of class—sweaty, with towels wrapped around her neck and no makeup on—and find Peter waiting for her with a single pink rose in his hand. (Pink roses, Peter will tell you, have more perfume than red ones, which are as odorless as Styrofoam.)

"Men don't usually pick up women after work, but I didn't want to wait for her to go home and get 'ready,'" said Peter, who grew up in France, Italy and the United States. "I was in love with her and it didn't matter if she was dressed, not dressed, overdressed or underdressed. I wanted her to know, 'I'm here to see you as a human being in your totality, not as a porcelain antique to be put on a shelf or hanging on my arm like an ornament.'"

Six months after they met, he got down on his knees one night and presented her with a simple ruby engagement ring. "When he gave me the ring, he said, 'It's not a big stone you can't carry around. This ring won't put you in danger on the subways,'" Gabriela recalled. "He said, 'This is a solid ring, like my promises.'"

The couple chose to be married on December 20, the eve of the darkest day of the year, as a way of expressing that they would stick together through any period of darkness, no matter how long. Many of the two hundred guests entering the Landmark on the Park, a Unitarian Universalist church on Manhattan's Upper West Side, appeared dressed for flamenco dancing, in floor-length velvet gowns, with tropical flowers or sparkly pins decorating their hair.

The bride was forty-five minutes late, causing everyone to stare at the front door the way people stare at telephones when they're waiting for an important call. "Gabriela's fiery," said Deirdre Towers, a professional flamenco dancer, as she waited for Gabriela to appear. "You hear a lot about cool elegance these days, but she has a hot elegance. She's added a little intensity, a little spark, by being late. That is what's meant by hot elegance."

When the bride finally arrived, she walked down the aisle slowly while a lone musician sang a flamenco wedding song, which sounded like a long, soulful wail. "She was like this incredible panther walking toward me," the bridegroom said later. "It really captured that element she has, which is very jungle cat."

As part of the vows, the bridegroom sang a Renaissance song. "When he sang to her, it touched every romantic bone in my body," said Valerie Boehme, a guest. "It reminded me of those fabulous singers in old cowboy movies who would break into songs to their sweethearts."

During the reception at the Manhattan Penthouse in Greenwich Village, Tito Puente's salsa band played and the flamenco dancing went on until three A.M. At one point, the bride got up and danced all alone, her own way of celebrating the marriage. "She was dancing for herself, my dear," said Liliana Morales, a flamenco dance instructor in New York. "Flamenco is a very introverted dance form. You dance what you feel inside, and she was ecstatic."

Ann Pluemer *and* Christopher Barber

December 10, 1994

"When they're mingling at a party, they can be completely separated, but you can see them having that eye language."

Ann Pluemer, thirty-four, and Christopher Barber, twenty-nine, are proof that office romance doesn't always lead to lawsuits or awkward breakups in which one person will climb twenty-five flights of stairs to avoid getting in the elevator with the other.

The two met six years ago at Prudential Securities in Manhattan, where they worked as investment bankers. Against their friends' advice—dating colleagues is frowned upon in many Wall Street offices—they started seeing each other.

Ann, who has the wholesome looks and tomboyish manner of Katharine Hepburn, initiated things. She invited him to dinner. "It would be nice to be old-fashioned and get asked out, but if the guy doesn't do it, you've got to do it," she said.

In the office, they communicated by notes, knowing stares and phone conversations full of their own private codes. "We had a lot of funny episodes and romantic times because we had to sneak around," Christopher said. "We were afraid to hold hands on the sidewalk because we never knew who we'd run into. We'd leave work separately and meet up later on a street corner or a subway platform."

Although they no longer need to conceal their relationship—he is still at Prudential, but she now works as an equity research analyst at Cowen & Company—they still enjoy the romance of hiding their romance.

They still go on exotic vacations where they won't run into any fellow human beings, let alone coworkers—deep-sea diving in Costa Rica, for instance, or sailing in the West Indies on their own private boat. And they communicate with their eyes as soulfully as couples in silent films.

"They have wonderful eye contact in public," said Monroe Lenay, a guest at

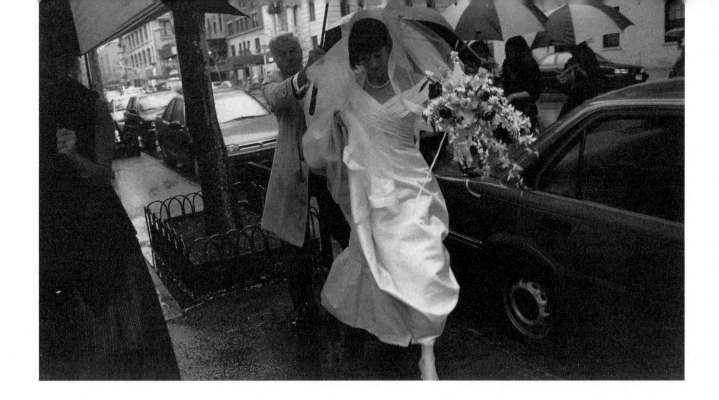

their wedding on December 10. "When they're mingling at a party, they can be completely separated, but you can see them having that eye language."

The couple was married in Greenwich Village at the Church of the Ascension, which is filled with paintings and sculptures of angels ascending into the skies like helium balloons. While many couples pose for pictures in the church before the wedding, they chose not to.

"I thought the whole idea was you don't see your bride for a day and then you see her coming down the aisle," Christopher said. "If you've chitchatted and had a beer and taken photos together beforehand, it ruins it. Otherwise, the ceremony is just to make it legal versus a magical ceremony."

Afterward, guests gathered at the St. Regis Hotel for a reception that felt like a Christmas party—even the Sylvia Weinstock wedding cake was shaped like a pile of colorfully wrapped Christmas presents under a tree.

While sipping cocktails, a few guests discussed the pros, cons and confusions of romance in the workplace. Philip Tsiaras, an artist who has sold paintings and sculptures to the newlyweds, said: "For Wall Street, office romance is taboo, but it's a *requirement* in the art world. The art world is like Hollywood, full of crazy romance and decadence. There are no rules, no time zones. Anything goes, and then some."

While time zones will always be respected on Wall Street, Christopher predicted that office romances will soon be as common among bankers as cellular phones. "A lot of firms have come out in the last few months and said, 'If we think our employees aren't having romances, we're crazy. We need to come up with a productive way to deal with it,'" he said. "To say this can't happen is ignoring the reality of men and women."

Drew Shotland, a friend of the couple, agreed. "If men are around women and women are around men, something's going to happen," he said. "I would hypothesize that in the end, love is really just a chemical reaction."

Angela Gomez *and* Wayne Sinhart DECEMBER 5, 1992

The Reverend William G. Kalaidjian, the pastor of the Bedford Park Congregational Church for the last thirty-nine years, is one of the best-known clergymen in the Bronx. People call him "Mr. Bronx," "Reverend Bill" and "the good-vibes pastor."

He's the kind of pastor who invites neighbors—as well as couples who plan to be married in his church—to sit on his porch and discuss everything from baseball to poetry to the matrimonial commitment. "I tell each couple, 'Keep thee unto her or him, and that means no fooling around,'" he said. "I'm a navy guy. I don't tie any slipknots."

On Saturday, December 5, at twelve-thirty in the afternoon, he tied the knot between Angela Gomez, twenty-two

years old, and Wayne Sinhart, thirty, who met two years ago when they were working at the Hayden Planetarium on the Upper West Side. Wayne runs the laser show at the planetarium; Angela sold tickets there until recently. For them, working the laser show together was an idyllic experience—it was like being under a beautiful night sky filled with stars every day. "The planetarium was a great place to court," Wayne said, adding that a travel guide recently named it "one of the ten best places to kiss in New York City."

About fifty guests gathered in the church for their wedding. Built in 1891, when the Bronx was farmland, the church still resembles a country chapel, with lanterns overhead and hand-carved wooden candlesticks at the end of

"When all is said and done, the flowers die, the dress gets sent back to the rental shop, everything material is gone. The strongest memories I have are of the way Reverend Kalaidjian said our vows."

each pew. Like many couples who seek out Reverend Bill, Angela and Wayne had trouble finding a church in which to be married. They are of different faiths—she's Roman Catholic, he's Methodist—and neither belonged to a congregation. Reverend Bill's policy toward couples like them is, "Come on in!"

"One thing I can't stand is a sanctimonious attitude," he said. "Who are we to say a couple isn't marriageable?"

During the ceremony, Reverend Bill was far more soulful than sanctimonious. A few days later, the bride said, "When all is said and done, the flowers die, the dress gets sent back to the rental shop, and everything material is gone. The strongest memories I have are of the way Reverend Kalaidjian said our vows. The tone and rhythm in his voice, it was like he understood love. That will stay with me for a lifetime."

Like many weddings, this one was tinged with nostalgia and memories of all kinds. The best man was the bridegroom's father, Nicholas Sinhart, who until recently ran Nick's Barber Shop in the Bronx. During the reception in the New York Botanical Garden, Nicholas Sinhart said that Reverend Bill was the only man there with a true, old-style Bronx haircut.

There is much that's old-style about Reverend Bill. He knows everyone in his neighborhood by name; he cooks pancakes every Sunday morning for the congregation, and anyone else who wants to stop by; he knows the score of New York baseball games dating back to the 1940s; and in the age of digital timepieces, he collects old clocks, everything from beautiful antique ones with hand-painted faces to an old schoolhouse clock he salvaged from a trash can on the sidewalk.

"I like to hear the tick, tick, tick of clocks," he said. "I always tell couples I marry, 'Take time before time takes you.'"

Maureen Sherry *and*
Steven Klinsky APRIL 22, 1995

"My first

reaction was

'Get this guy

away from me.'"

Steven Klinsky met Maureen Sherry on a rainy night six years ago. He was riding down Second Avenue in a cab and saw her walking along the sidewalk, crying as openly as if she were alone at home with the shades pulled down and the answering machine on.

"She's very attractive and she was crying, and it was a strange misty evening, and I said to the driver. 'Stop the cab here,'" recalled Steven, now thirty-eight and a general partner at Forstmann Little & Company, a New York investment firm. "I was in a melancholy mood, and to see this woman walking up the street triggered something in me. So I ran after her and tapped her on the shoulder and introduced myself."

Maureen, now thirty-one and a managing director at Bear, Stearns & Company, had moments before broken up with a longtime boyfriend. She is six feet tall, a triathlete and not the type to hide anything, whether it's a run in her stockings or a broken heart.

"She's the sort of person who would roll up her wedding gown, put it in a backpack and show up at her wedding," said Sara Hawes, a friend of the bride. "She goes to work with her hair wet. It's never a dull moment."

After introducing himself, Steven followed Maureen for several blocks. "He kept saying, 'Doesn't the city look cool tonight?'" she recalled. "My first reaction was, 'Get this guy away from me.' I remember looking at the WALK and DON'T WALK signs flashing and thinking, 'I'm going to lose him on one of these corners.'" She added, "The only thing I told him was my name and where I worked, and finally I just said, 'Look, I don't want to talk to you.'"

Over the next several weeks, he persistently sent flowers and letters to her office until she finally agreed to go out with him. On their first date, that winter, he arrived at her door holding a five-foot-tall Christmas tree as if it were a dozen roses. They went to dinner at Bistro du Nord on Madison Avenue and ended up

talking for five hours while watching snow fall outside the windows. "It was so amazing, because he didn't turn out to be a weirdo," Maureen said.

Instead, he was a banker who composed music and poetry, played chess on street corners in Times Square and asked her to teach him to drive a stick shift, which charmed her completely.

Together, Maureen and Steven are not the kind of Wall Street couple who talk about their Impressionist art collection or polo ponies. They often spend weekends working on an after-school tutorial program Steven founded at P.S. 149 in Brooklyn. They try not to talk on cellular phones in public. For wedding gifts, they registered at Paragon Sports, for surfboards and new roller blades.

"Working on Wall Street, you're so used to guys who are kind of showy and flashy, and Steve is so different," said the bride. "Our backgrounds are pretty simple, and that's never

changed for us. A lot of times, we come home from work and have a bowl of cereal. I don't think we've ever been caught up in a real fancy life."

They were married on April 22 at Our Lady of Good Counsel Church, on East Ninetieth Street. Wearing a gown by Penny Babel, a New York designer, the bride stood in the back of the church with her bridesmaids—all of them tanned and athletic and looking like skiers dressed up after a sunny day on the slopes.

At the reception on the rooftop of the St. Regis Hotel afterward, many of the two hundred guests commented on the fact that Steven actually had enough nerve, coordination and heart to jump out of the cab and introduce himself to a total stranger—a *sobbing* stranger—on the sidewalk. Colin Cooke, a professional photographer, simply said, "Steve is very shy and soulful but obviously brought to his knees when he sees a woman crying on Sixty-eighth Street."

Andrea Perlbinder *and* Garth Stein OCTOBER 16, 1993

"I always cry at weddings. They're beautiful and amazing and then you put yourself in that position and you cry more."

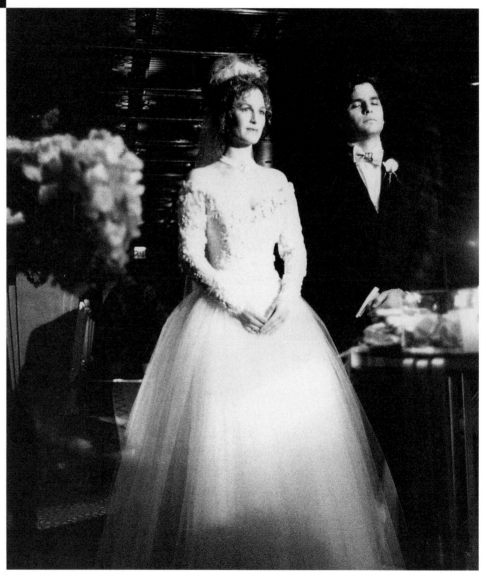

Andrea Jo Perlbinder and Garth Ferguson Stein met five years ago at Columbia University, where both were studying for master's degrees in film. He caught her attention by singing loudly in the editing room and by offering to play the role of the boyfriend in a short sixteen-millimeter comedy she was making called *Papaya Smoothie.*

They are now, as she put it, "a filmmaking couple" who write, produce and direct movies, usually together. The two, who share everything from career goals to their taste in shoes, are working on a documentary about three civil rights workers who were killed in the sixties, as well as an adaptation of *Green Grass, Running Water,* a comic novel by Tom King about four elderly American Indians who escape from a hospital to solve the world's problems.

Andrea, twenty-nine, and Garth, twenty-eight, also play in the Zero Band, a rock group whose members regularly rehearse but rarely perform. He plays the bass; she is the drummer.

They were married on October 16 in a romantic and visually lush wedding at the Pegasus Suite, a gold and burgundy Art Deco ballroom on the sixty-fourth floor of 30 Rockefeller Plaza. The bride looked like a classic nineteenth-century beauty with her porcelainlike skin, long hair in ringlets, pearl choker, tight lacy bodice and tulle skirt.

"Andrea truly looked like a Victorian princess," said Janice Feldman, a guest. "She has a waist of another era altogether. Her waist probably fits the hatband of my riding hat."

During the ceremony, the couple stood with Rabbi Joseph H. Gelberman, surrounded by gold columns decorated with fuchsia orchids that hung like large rubies on a rope of green smilax vine. There was no video cameraman present. Instead, Mark Zero, a filmmaker and Zero band member, was making a black-and-white film about the wedding, which he said would look like a Calvin Klein commercial.

Watching the bride and groom say their vows was in many ways like watching a movie—guests cried even though the scenery was beautiful and the ending happy. "Andrea was standing next to him and she had one tear coming down her face," said Henry Hershkowitz, a lawyer and a friend of the couple from Columbia. "I always cry at weddings. They're beautiful and amazing, and then you put yourself in that position and you cry more."

It was hard to find the color white anywhere in the room, except the bride's dress. For the reception dinner, the tables were decorated with iridescent burgundy silk tablecloths, tall silver candlesticks and bouquets of yellow, pink, orange, maroon and champagne-colored flowers. Designed by Preston Bailey, a New York floral designer, they could have been tables in *The Age of Innocence.*

The bride's mother, Sandy Perlbinder, fit in perfectly with the Victorian *Age of Innocence* decor. A film producer who looks like the actress Jane Seymour, she wore a Morgane Le Fay dark brown velvet gown with a scooped neck and a nineteenth-century–style train.

"We're all in film," she said. "The thing that pleases me most is that Andrea chose a life in the arts and didn't rebel and become a lawyer."

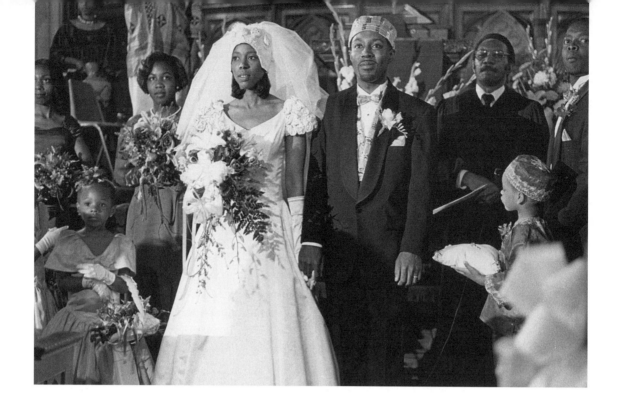

Cheree Rumley *and* Delmar Gillus JUNE 24, 1995

Cheree Nicole Rumley, twenty-six, grew up on the Upper West Side reading African-American authors like Langston Hughes and Toni Morrison; taking flute lessons at the Harlem School for the Arts; singing in the choir at the Convent Avenue Baptist Church; excelling in math at Horace Mann High School; and attending meetings of Jack and Jill of America, a social organization for young African Americans.

As a teenager, she was very organized. She even kept a frequently updated checklist of qualities she wanted in a future husband. Among other things, he had to be handsome, outgoing, knowledgeable about black history and good at math.

Cheree, who is now an electrical engineer in Arlington, Virginia, met Delmar Lewis Gillus in 1992 at the National Society of Black Engineers conference. Delmar, a mechanical engineer, fulfilled every item on her list except "outgoing." Like her, he is shy and quiet.

Delmar, who is twenty-six, doesn't call Cheree "sweetheart" or "honey." He calls her "my go-to person." As he explained it, "Whenever I'm sad or confused about something, I go to Cheree."

While planning their June 24 wedding, Cheree thoroughly researched African wedding rituals, using her personal library of black authors as well as Afrocentric wedding guides, like *Jumping the Broom*, by Harriette

"We wanted to give people
the feeling that they
were attending the wedding
of two very important families in
an African village."

Cole. "We wanted to give people the feeling that they were attending the wedding of two very important families in an African village," said the bride's mother, Sharon Rumley.

Although the wedding took place in the Convent Avenue Baptist Church in Harlem, there was a feeling at times that everyone was gathered in a rural village in West Africa. Montego Joe, an Afro-Caribbean percussionist, began the ceremony by drumming and chanting a greeting song from Sierra Leone. While he played, the bridegroom and Lorenzo Taylor, his best man, entered the church and walked down the aisle together, swaying from side to side to the drumbeat.

"Rather than have Delmar waiting at the altar, we wanted to have this whole feeling that he was walking into the village with his best man or best soldier, who was his protector," Mrs. Rumley said.

The bridesmaids wore deep purple gowns, the color of royalty according to African tradition, with long matching gloves. The flower girls appeared in lavender dresses, and the groomsmen wore black suits with glittery gold and purple bow ties and cummerbunds.

In the couple's minds, the bridesmaids and groomsmen made more than a fashion statement. "Ninety percent of the wedding party are black engineers, and blacks aren't supposed to be mathematicians or scientists," the bride said.

"Here you have a wedding party defying the odds. It's important for youngsters to see us and even for the older generation. My great-grandmother is eighty-nine and college wasn't even an option for her."

Several moments in the ceremony evoked the slave period of African-American history. At one point, Montego Joe sprinkled water near the couple's feet as a way of honoring their ancestors who crossed the ocean involuntarily. After the couple kissed, a friend swept the aisle with a broom, symbolically chasing away evil spirits, a tradition practiced at slave weddings.

During the reception dinner, held in the grand ballroom of the Puck Building in SoHo, such dishes as African fish stew and Nigerian codfish cakes were served and the guests were seated by "village"—the bride's friends and family sat on one side of the room and the bridegroom's on the other.

"We see family as a tree that just keeps branching off," the mother of the bride said. "You're not just marrying an individual, you're marrying a community, a village. That's the concept of family for us African Americans. Delmar now becomes an integral part of our network and structure."

Ruth Allen *and* Jonathan Cox

AUGUST 19, 1995

"He asked me to call him. I was so nervous. All I knew about him was his name and what he looked like."

The first thing Jonathan William Cox, twenty-eight, noticed about Ruth Barnett Allen, also twenty-eight, was her hands—they were petite and delicate and they fit perfectly into his.

The couple met in a ballroom-dancing class at the gymnasiumlike Dance-Sport studio on the Upper West Side in February 1993. Jonathan, now a graduate student in business at Columbia University, had enrolled with an old friend from high school, Darby Harper. They signed up for the class together because, as Darby recalled, "We were both going through a real dry spell at the time, love life–wise."

Ruth, who is now the assistant director of development for Lincoln Center Theater, signed up for the class mainly to improve her dancing. "At the time, I was working for the American Ballet Theater," she said. "So I was totally immersed in dancing. Ballet is very romantic and it's all about partnering, so here I was in my dance class, trying to be the next ballerina in my mind."

The twenty or so students in the class regularly switched partners while learning classics like the fox-trot, the merengue and the rumba. The bridegroom's friend Darby described the mix of students this way: "A lot of the men were in their late forties and early fifties, but the women were all young urbanites—sophisticated, gorgeous women. And, of course, Ruth was one of them."

Ruth remembered that Jonathan was not the most impressive dancer in the class. He occasionally stepped on her toes or turned her hand as if it were a stubborn doorknob. But he quickly became her favorite partner. "He had these really beautiful blue eyes and he wore a suit, which I always think is handsome," she remembered.

Jonathan also developed a crush on Ruth, who many describe as a formal person—she reads Amy Vanderbilt, wears pearls and gets dressed up for every-

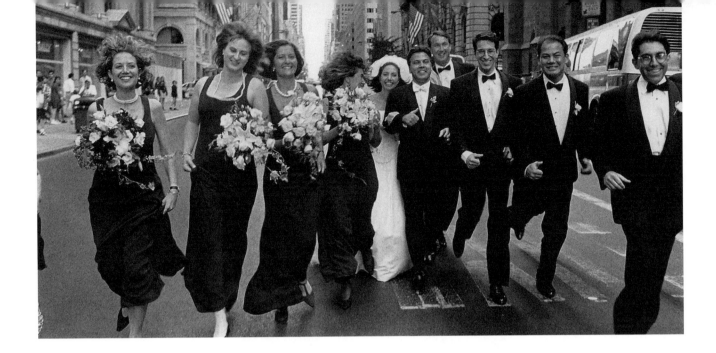

thing from lunch with her parents to airplane trips. "She struck me as incredibly beautiful and also a little bit old-fashioned," he said.

Because students rarely speak while dancing, except to mutter things like "quick, quick, slow" or "one, two, one, two," the couple didn't actually talk for a while. In the fourth class, he finally got up the nerve to hand her his business card.

"He asked me to call him," Ruth recalled. "I was so nervous. We were strangers. All I knew about him was his name and what he looked like. Finally, I called and his secretary asked, 'May I tell him who's calling?' And I said, 'It's Ruth Allen from ballroom-dancing class.' It was an exercise in total humiliation."

A few days later, they went out for margaritas; four months later, they moved in together; and a year after that, he proposed over dinner at the Breakers Hotel in Palm Beach, Florida. They celebrated by ordering ice cream sundaes from room service, calling all their friends and dancing around the room.

Then, for the rest of the vacation, they celebrated their engagement in their own ways. "Jonathan spent the weekend on the golf course," Ruth said. "And I spent it on the beach reading bridal magazines."

They were married on August 19 in another hotel, the St. Regis in Manhattan. Like the bride, the wedding was formal and classic in style—the men wore black tie and many of the women wore pearls.

"Ruth is very good at culture and ideas," said Audrey Allen, an older sister of the bride who is a graduate student at the London School of Economics. "If I had to predict how she would meet someone, it would have been at an opening of some big exhibit, but it's so sweet that they met ballroom dancing. She wasn't in a great dress holding a pose; she was tripping over her feet, which is what ballroom dancing is all about."

On the wedding program, there was an illustration of a couple dancing and a letter to the guests from the bride and bridegroom, telling the story of how they met. The last line read, "While we are not great dancers, we have become wonderful partners."

Lynda Hughes *and*
Stephen Thomson MARCH 19, 1994

To mark the
beginning of
married life, the
ribbons were cut
by a friend of the
groom who was
listed in the
wedding
program as "the
transformer."

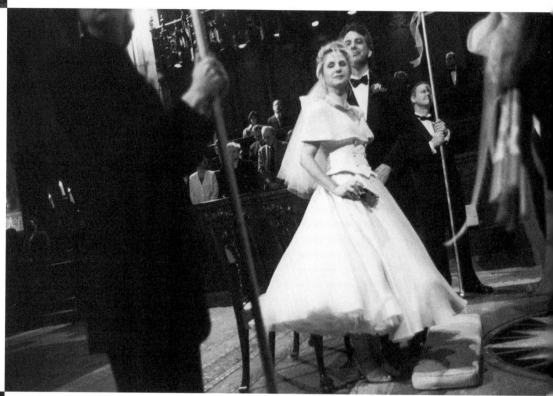

Lynda Hughes, a forty-two-year-old professional photographer, almost always has cameras hanging around her neck like necklaces. Her photographic subjects have ranged from prehistoric cave art in France to baboons in Ethiopia to brides in New York. She shoots several weddings a year and says of marriage, "I never expected it to happen to me. It's like, 'Never the bride, always the photographer.'"

Lynda, like many photographers, has occasionally used her Nikons as a way of meeting people. Looked at in one way, cameras make great flirting tools—they allow a photographer to observe people discreetly, ask total strangers to smile and, if all goes well, invite them into a darkroom.

Lynda employed a few of those techniques six months ago when she met Stephen Thomson, a forty-four-year-old architect. She was photographing a wedding in Larchmont, New York, and spotted Stephen among the guests. "The bride will tell you I took approximately 465 photos of Steve," Lynda said.

A few days later he called to ask her out and suggested they go to the Cooper-Hewitt Museum to see an exhibit of household appliances, like dishwashers, that freed the modern woman from kitchen drudgery. But their second date was the real icebreaker. "We sat down to dinner at Lola's," Lynda recalled, "and even before we ordered anything, he pulled out these two pieces of paper and said, 'I thought you could get to know me a lot better from these.' One was an astrological readout for Gemini and the other was his HIV test result." (It was negative.) "That night was the first night we necked," she added.

On March 19, they married, both for the first time, in the Great Choir area of the Cathedral of Saint John the Divine. One hundred forty guests gathered in seats that were like rows of carved wooden thrones, surrounded by the cathedral's walls, which are as high and craggy as the walls of a Colorado canyon.

The transformation from "singlehood into mutualhood," as the bride put it, was expressed symbolically throughout the wedding, beginning with her bachelorette party. Ms. Hughes invited her closest girlfriends for an evening of purification at a Russian bathhouse in Manhattan that was meant to rid her of the past and ready her for marriage. The women spent the evening taking hot saunas followed by cold water baths, massages and shots of vodka that would transform anybody.

During the wedding ceremony, which was performed by two Episcopal priests, the couple stood under a tentlike structure made of four gilt poles tied together with white iridescent ribbons. Afterward, to mark the beginning of married life, the ribbons were cut by Gino Cionchi, a friend of the bridegroom who was listed in the wedding program as "the transformer."

Even the wedding cake, by Cheryl Kleinman, expressed change. Since the nuptials took place on the eve of the vernal equinox, she pressed spring flowers, pansies and daisies among them, into the white frosting—it looked like flowers coming up through the snow.

The guests traveled downtown to SoHo for a reception at the T Salon, a stylish tearoom with a long, curvy copper bar, tea tins covered with stamps, like a veteran traveler's suitcase, and a chandelier made of teapots.

Many of the guests were photographers, who snapped at each other as they talked. Flashbulbs went off regularly, like summer lightning. Even the bride carried a camera, a tiny silver one, tucked in the pocket of her tea-length vintage dress.

Napua Davoy, a jazz pianist and an old friend of the bride, described the couple's six-month courtship as "firecrackers the whole way!" She added, "They swept each other off their feet and they knew they were right together and there was absolutely no conservative weighing it out. I'm really impressed, because it took me five years to decide to get married."

Alexandra Tierno *and*
Francois Payard APRIL 24, 1993

"For the French,
the cake is
the focal point
of the wedding,
the heart
and soul of it."

Many say that Francois Payard makes the best desserts in New York—coffee parfait with seaweed, chocolate baked with tarragon and other concoctions that sound more like accidents in the kitchen than delicious and famous treats. Formerly the pastry chef at Le Bernardin, he has just been hired at Restaurant Daniel on the Upper East Side.

A native of France, Francois, who is twenty-six, does not fit the stereotype of a pastry chef. He is neither overweight nor hot-tempered. He is, however, sweet. Even his art collection is sweet: He owns a "painting" of an American Indian made entirely out of sugar.

He met Alexandra Tierno, twenty-five, a year ago at Au Bar, a nightclub where European chefs, maîtres d'hotel and waiters frequently congregate and where Francois is known among regulars as "the cookie monster." Alexandra is a media planner at Sudler & Hennessey, an advertising agency, but she loves cooking and restaurants. Two nights a week, she works as maître d'hôtel at Cité restaurant, and for as long as her friends can remember, she has carried a Zagat guide in her pocketbook.

To her delight, their first dates took place in the city's best restaurants, places like Bouley, Jo Jo, Provence, Le Cirque and Park Bistro. One night at Luxe six months after they met, a waiter served Alexandra a large pastry shaped like a box and surrounded by fresh berries. She remembers thinking before she opened it that her dress was too tight and she didn't want to eat dessert. It was one of her last rational thoughts for some time. Inside the box she did not find custard or chocolate mousse, but a diamond ring.

At their wedding on April 24 in the United Nations Chapel, the bride looked like a spunky princess. She wore her black hair in ringlets, a rhinestone-studded veil and a luminescent satin dress by Arnold Scaasi.

The seven bridesmaids wore short black dresses with scoop necks and pearl chokers. Together, they looked like a great all-girl band that could start performing at any time. When they entered the packed chapel, the organist played "Thank Heaven for Little Girls."

After the ceremony, guests gathered uptown at the Westbury Hotel for a reception and dinner. Like many of those present, the bride's mother, Josephine Tierno, was elegantly dressed, tearful and funny at once. Mrs. Tierno, who owns a vintage-clothing store, recounted the first time she met the bridegroom. "He came up the stairs, kissed me once on each cheek and handed me a beautiful, beautiful chocolate cake," she said. "I've never tasted chocolate cake like that, and I've tasted chocolate cake in my day. He could've been the loony of the world, but the two kisses and the chocolate cake won me over. That was it!"

There were many well-known French chefs among the guests, all of whom stopped to admire and analyze the wedding cake. The bridegroom worked for five days on the six-tier cake, with the help of his father, Guy Payard, and brother, Charly Payard, who are pastry chefs in France. It was decorated with pink sun hats, white swans, peach-colored roses, light green seashells and white umbrellas, all made of sugar and appearing as fragile as handblown glass ornaments.

"For the French, the cake is the focal point of the wedding, the heart and soul of it," said the bride's father, Dr. Philip Tierno, a microbiologist. "The umbrellas symbolize protection against all things evil. The swans express beauty and nature. The entire cake is hieroglyphics."

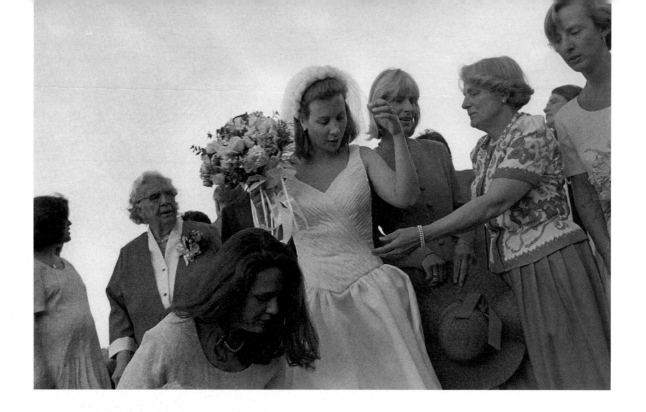

Margo McGlade *and* Dave Epprecht MAY 14, 1994

In the summer of 1993, at a barbecue in Darien, Connec-
ticut, Margo McGlade and Dave Epprecht were among
the last guests left on the lawn as the beer ran out and
the sun began to set. They started talking and a week later,
he called and invited her out for an afternoon of waterskiing.
While wearing a bathing suit and water-skiing on a first date
might intimidate some women, Ms. McGlade fearlessly
showed up in her bikini, figuring, "Hey, this is who I am."

The two got along so well they were rarely apart after that
and a few months later they decided to get married—as
soon as possible. Their thinking was, "We're madly in love,
let's just do it!"

Dave is a thirty-five-year-old businessman who sails Hobie
Cats, drives a 1977 Toyota Land Cruiser and wears John
Lennon–like wire-rim glasses. He proposed to Margo in
March, and they set the date for seven weeks later: May 14.

At first, Dave didn't have an engagement ring or even an
idea about a ring, but that didn't matter to Margo, thirty-
six. Friends describe her as a no-frills person with a high-
powered career and no time to think about ring settings,
diamonds or whether platinum is prettier than gold. After
fifteen years as a retail analyst at Paine Webber in New
York, she recently joined Charter Oak Partners, a money-
management firm in Westport, Connecticut.

The couple pulled off "the seven-week wedding," as they called it, by using Federal Express, mail-order catalogs and twenty-four-hour toll-free telephone numbers.

The couple approached their wedding the way Ernest Hemingway approached prose: They cut out all but the essentials. There was no time for showers, cake tastings, bridesmaids' teas, cocktail parties or long deliberations over details. Margo chose her wedding dress in exactly an hour. "I had an appointment at eleven-thirty at Vera Wang," she said. "Found the dress. Left at twelve-thirty."

The couple pulled off "the seven-week wedding," as they called it, by using Federal Express, mail-order catalogs and twenty-four-hour toll-free telephone numbers. "One morning, I got up at six A.M. and called Talbots and ordered all the bridesmaids' dresses," Margo said. "Then I called American Airlines and made the reservations for the honeymoon and called Avis for the rental car, and then I took a shower and went to work. It's amazing what can be done with modern technology."

Before the wedding, she did her own makeup and hair and could barely wait to get to the church. "When she had her wedding dress on, she picked up her suitcase, flung it over her shoulder and walked to the car," said Melanie McGlade, the bride's sister-in-law. "I said, 'Watch out, you're wearing a wedding dress!' She didn't care. She was just so psyched to be married to Dave."

The bridegroom was also visibly excited. A few minutes before the ceremony, he sped up to the church, skidded to a stop on the grass, jumped out and ran through the back door pulling on his dinner jacket.

They were married in the evening at the First Congregational Church in Darien, a spartan white church on the inside, with beet-red rugs and clear glass windows.

After the ceremony, the newlyweds headed to the reception at the Wee Burn Country Club in the Land Cruiser, the bride waving her bouquet like a sparkler on the Fourth of July. "I told her, 'You need to go away in a limo,'" said Katherine McGlade, the bride's sister and maid of honor. "But Margo said, 'No way. I want to go in the jeep with no top on it.' That's her and Dave."

At the reception, guests gathered on a terrace overlooking a golf course lined with tulips in Easter egg colors. The sky was as blue as a Connecticut license plate. Jon Sweet, an actor and a friend of the bride, gazed into a crystal ball–like ring he wore that changed color in the sun. "This is my mood ring," he said. "If it's blue, it means happy love. There's maximum love here. It's the richest blue I've ever seen."

Stacey Regent *and* Robert Eskenazi MAY 23, 1993

"I think children are what love and marriage are all about."

All year long, the first-grade students at Public School 6 on the Upper East Side were talking about the wedding of Stacey Regent, twenty-seven, their redheaded, softhearted and funny teacher.

While some teachers leave their personal lives outside the classroom, Miss Regent, as the students call her, made hers very much a part of it. In the months before the wedding, she passed out photographs of her dress to the class, occasionally taught while wearing her tulle headpiece, made scroll-like invitations for each student and referred to the wedding as "our special class trip."

Miss Regent met Robert Eskenazi, who was known among her students as "the fiancé," on a blind date five years ago. He graduated a couple of weeks before the wedding from Columbia University with a joint J.D.-M.B.A. degree and will soon join Merrill Lynch & Company as an associate in investment banking.

Robert, who is twenty-eight, said there were some great advantages to marrying a schoolteacher, especially for a banker. "I could be working on some language in a securities registration statement," he said. "And I come home, and Stacey is making a space project with cotton balls, glue and sparkles for the kids. It kind of brings you back down to reality."

On Sunday, May 23, they were married outdoors at the Sleepy Hollow Country Club in Scarborough, New York. Like dignitaries watching a parade, about twenty first-graders, and a few of their parents, sat in a special private section that was cordoned off with white ribbons and bows. They added playfulness, misbehavior, giggles and handfuls of caterpillars to an otherwise formal event.

"The children gave the wedding a much more celebratory mood," said Paul Lentz, one of two hundred adult guests. "They were the cheerleading section. They kept screaming, 'I see Rob!' and 'I see Stacey!'"

Toward the end of the ceremony, several children, including Olivia Katz, in a polka-dot party dress, ducked under the ribbons and crept across the grass toward the *huppah*. "They're all trying to see the kiss," said David Katz, Olivia's father. "That's what they're focused on."

After the kiss, which almost unanimously grossed out the first-graders, the adults headed for cocktails. The children gathered separately to eat "mini wedding cakes" (cupcakes) baked by one of the parents, Arlene Reckson, who owns Kids Kitchen, a Manhattan bakery.

Each child saw the wedding in his or her own unique way. "I think it would be very fun to be a bride, for a little while," said Margot Goldblum. "Then it would get kind of boring. My legs would start to hurt, and I would be listening to all that language I don't know."

Dakota Arkin was most concerned with capturing and protecting the many caterpillars on the lawn from guests. "I don't think caterpillars should be around here," she said. "There are always lots of people at weddings, and I don't feel they should get stepped on."

Lori Klein, a makeup artist, attended the wedding with her daughter, Jenna, another student in Miss Regent's class. "Most people do not want children at weddings," Ms. Klein said. "They associate them with annoyance and misbehavior. But I think children are the epitome of what love and marriage are all about."

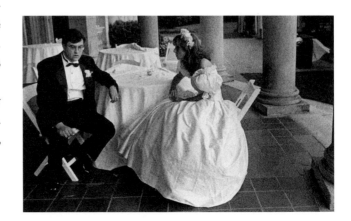

Karen Yamauchi *and* Jeffrey Eugenides DECEMBER 9, 1995

> "We became engaged when we started talking about what it would be like to be old together."

Karen Yamauchi, a shy, soft-spoken sculptor, met Jeffrey Eugenides, a funny, intense novelist, a year and a half ago at the MacDowell Colony, the artists' retreat in Peterborough, New Hampshire.

At any given time at MacDowell, there are about thirty composers, painters, poets and others living and working in studios hidden in the woods. If you take a walk there, you can usually hear piano playing or spot a poet leaning against a tree or a painter in splattered clothes riding one of the colony's old three-speed bicycles. It is known as an ideal place to work as well as to fall in love.

"A lot of my friends had gone to MacDowell, and they all got involved or had flings, and I was intent not to do that," said Jeffrey, the author of *Virgin Suicides* (Farrar, Straus & Giroux, 1993). "I just didn't want a stereotypical event to happen to me."

His studio at MacDowell was the master bedroom of a large white wooden farmhouse. "There was a big fireplace, with a Persian rug," Jeffrey said. "It was like having a country house suddenly, like going from being a starving artist to a landowner."

Karen lived a short walk away in a stone cottage, at the end of a path she decorated with plastic bugs and fake flowers, objects she sometimes uses in her sculptures. "I was interested in impostors and artificial things," she said.

The couple, both in their mid-thirties, met at one of the colony's nightly dinners.

Jeffrey recalls thinking Karen was beautiful, reclusive and surprisingly knowledgeable about trucks, tractors and other machinery. (She also uses parts from model airplanes and trucks in her work.)

One late afternoon, the two went for a walk together and ended up in the colony's rose garden. "She told me this amazing story about her grandfather," Jeffrey said. "There were all these dragonflies overhead. She told me her grand-

father would catch dragonflies and tie a string to them and give them to kids, and they'd fly the dragonflies like kites. It seemed amazing and incredibly fanciful but true, the kind of story I like."

After their return to New York City, they met at the Empire State Building for their first real date. A few weeks later, she moved into his apartment, arriving with all her belongings in paper bags. Although he cleared a drawer in his dresser for her, she didn't use it for four months. "It was so romantic and free with the bags," Karen said.

Jeffrey never got down on his knees and officially proposed to Karen; they became engaged in a more symbolic and intuitive way than that. Jeffrey said he first felt they were engaged when Karen finally agreed to use the drawers. She said, "I think we became engaged when we started talking about what it would be like to be old together."

The couple set December 9 as their wedding date, and a few weeks before the date went to City Hall to get their marriage license. "It was like boarding Noah's Ark," Jeffrey said. "You get in this long line of people walking up to the

computer two-by-two, and there's every kind of person—a couple of Hasidic people, two Norwegians, an under-age couple. Because of the budget cuts, the lines are slower, so you're inching up to the ark."

On December 9, at the First Presbyterian Church in Greenwich Village, the bride inched down the aisle in Japanese platform shoes, wearing a stiff kimono that looked like a painting of bamboo trees, cranes and pink flowers.

After the ceremony, about sixty guests gathered at Ithaka, a Greek restaurant on Barrow Street. The crowd was filled with writers and editors; even the wedding cake was literary. Designed by Gail Watson, it was a replica of one described in *Madame Bovary*, which Jeffrey recently read aloud to Karen in nightly installments.

Mark Plesent, an old friend of the bridegroom, offered this description of the bride: "She's a tough cookie. She's not intimidated by anything, not by Jeff's friends, or his intelligence or his verbosity. I've known a lot of Jeff's girlfriends, and out of all of them Karen is the one girl man enough to handle him."

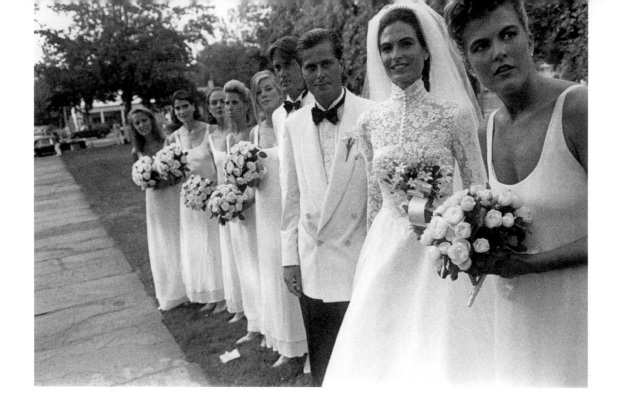

Whitney St. John *and* James Fairchild AUGUST 27, 1994

Many people cite Whitney St. John, twenty-eight, and James Fairchild, thirty-eight, as proof that high style is not yet dead in New York City.

The two met at Ralph Lauren, where she is the fashion director for Ralph, the new lower-priced women's line, and he is the creative director for gentlemen's clothing.

Both ride horses and play tennis in whites, collect walking sticks and silver cigarette cases and are the sort of people who would instinctively know how to dress for any occasion, even afternoon tea in the Antarctic. On their first date, he cooked a soufflé for her in his apartment, which is full of orchids and English antiques.

Whether they are walking down the sidewalk or into a charity ball, they are known for wearing clothes that "create a small explosion," as one friend of theirs put it. Whitney has been seen at parties in everything from cat suits to headgear the size of lobster pots.

"At a leather-and-leopard party at Doubles, she arrived in a leopard-print pants suit straight out of *The Flintstones,* with a matching pillbox hat, and he wore leather," said Jim Brodsky, a guest at the couple's wedding, on August 27. "With Whitney and James, it's never a dull moment. He had a party at his apartment for Whitney's birthday, and in the middle of his living room, the plates were put aside, the music went up and everyone was dancing on the furniture."

Cricket Telesco, another friend of the couple, added: "It's

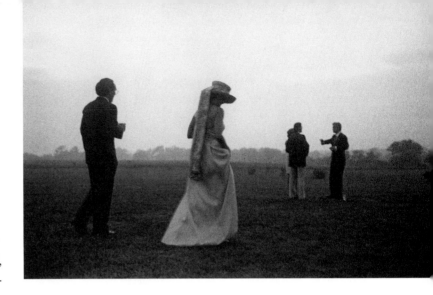

"It's like they're from the 1930s,
like Zelda and Scott Fitzgerald,
when people went all out."

like they're from the 1930s, like Zelda and Scott Fitzgerald, when people went all out. People just don't do that anymore. It's a dying craft."

James proposed last Christmas Eve over dinner at Sapore di Mare restaurant in Wainscott, Long Island. "He was acting very strange," Whitney recalled. "I held his hand and he had sweaty palms, and the next thing I knew, he ordered a Scotch. Then he whipped out a little navy velvet antique box with a sterling silver top. At the same time, he asked me to marry him. I was thrilled and practically fell off my chair."

They were married in Bridgehampton, Long Island, at the Presbyterian Church, which has a tall white steeple that is like the North Star of town: It can be seen from every porch and back road around.

The clothes for the couple and the wedding party were designed by Ralph Lauren. The ushers wore white jackets, black dress pants, no socks and black velvet slippers, each pair with a different emblem embroidered on the tops. Peter Melhado, an usher and the bridegroom's brother-in-law, wore slippers decorated with fly-fishing lures.

"I chose these because James is getting hooked today," he said.

Walking down the aisle, Whitney looked like a nineties version of a demure Victorian beauty. She wore a dress that had a Chantilly lace bodice, a high neck and a row of satin-covered buttons down the front. Over it, she draped an ethereal floor-length veil that made her look like a bride you

might see in the distance on the beach, half-obscured by mist and haze.

At the reception, held at the bride's family house in Bridgehampton, waiters offered arriving guests glasses of champagne from silver trays and held wicker baskets full of Chinese paper parasols to provide shade from the sun.

Everyone gathered in an apple orchard by the house, underneath a light blue sky that had pink streaks across it like smudged lipstick. Guests in colorful clothes and hats held their parasols up and gazed out at the views of potato and corn fields. The entire scene looked like a Monet painting of Bridgehampton.

Contemplating the event a few days later, Melanie Seymour, a guest and an old friend of the couple, said, "You look at a good-looking couple like Whitney and James, and you know glamour is going to stay around New York City for a while."

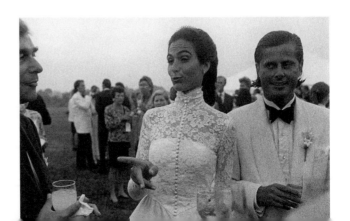

Devonee Loretta *and*
Mitchell Banchik DECEMBER 19, 1994

"Loretta is
married to a
guy who's
married to his
old friends."

When Mitchell Banchik, thirty-two, was a student at New York University, he was a member of the Psi Upsilon fraternity. His friends say that he has tried to relive and re-create his fraternity days ever since.

About two years ago, he opened Down the Hatch, a bar that could take anyone back to their college days. Located in the basement of a historic town house in Greenwich Village, Down the Hatch has inexpensive beer, football games on the television and Christmas lights strung everywhere all year long. Mitchell also recently opened Mo's, a Caribbean restaurant on the Upper East Side that has the ambience of spring break in the islands.

He met Devonee Loretta, who is now thirty, almost five years ago when she applied for a job as a waitress at Boxers (Mitchell's first restaurant, named after men's underwear, which he no longer owns). A folksinger who grew up in New Jersey, she was looking for steady work to save enough money to move to Los Angeles and, in her words, "get discovered one night in an obscure little club off Sunset Boulevard."

Mitchell was crazy about her from the moment she walked through the doorway, and he hired her after only a cursory interview. "It was a very strange interview," she recalled. "He didn't ask me the usual questions."

He said, "I asked things like, 'What's your phone number?' and 'What are you doing tomorrow?'"

Although she was moving to California, he courted her tirelessly, occasionally resorting to a few tricks from his college days to impress her. "Soon after they met, Mitch brought Devonee to Central Park, where we used to play touch football on the Great Lawn," said Peter Karshold, one of Mitch's fraternity brothers. "Toward the end of the game, he came into the huddle and we were discussing plays, and he said he wanted to impress Devonee by catching 'a bomb'—a long throw into the distance. So he ran down and

I threw the ball into the air and Mitch leaped and caught it. It all worked out; he became her football hero."

Devonee moved to California anyway, but Mitch flew to the West Coast a few weeks afterward and persuaded her to come back. A year and a half ago, he proposed as they rode through Central Park in a horse-drawn carriage. "It was bubble-gum pink with a heart-shaped window," said Devonee, who is now a full-time nursing student. "At first, I said, 'I am not going in it!'"

On December 19, they were married at Tatou, a supper club in Manhattan that looks like an 1850s jewel-box theater in New Orleans. A harpist played as the wedding party entered the ornate dining room through a heavy red brocade curtain. To no one's surprise, there were almost three times as many groomsmen as bridesmaids. Most of the groomsmen were the bridegroom's fraternity brothers, and as they walked down the aisle in pairs, it looked like a black-tie ceremony at Psi Upsilon after a football game.

Afterward, Brian Smith, one of the groomsmen said, "Devonee's married to a guy who's married to his old friends. She doesn't mind because she's so secure. We all look at her as one of the guys. She's played poker with us. She goes out drinking with us. She's one of the boys."

Overhearing this, Andrea Green, another friend of the couple, added, "But she's still a woman who gets her nails done."

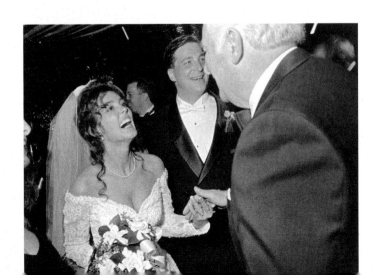

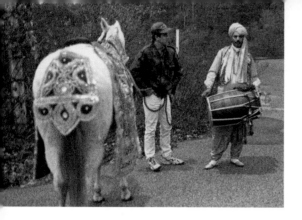

Divya Gupta *and* Pankaj Gupta

NOVEMBER 24, 1995

"As I was
growing up,
I wanted
one thing in life,
an arranged
marriage."

❝❝I grew up in this country, but as I was growing up, I wanted one thing in life, an arranged marriage," said Pankaj Gupta, twenty-nine. "I really adore and respect Indian culture and I believe in the arranged-marriage concept."

On November 24, he entered an arranged marriage with Dr. Divya Gupta, twenty-five. (While they share the same last name, they are not related.) Friends describe Pankaj, who grew up on Long Island, as sensitive and smart, a perfect doctor; Divya, who grew up in New Delhi, combines gregariousness, even zaniness, and grace.

Like their parents, all of whom are doctors, both are passionate about medicine. She is a resident at St. Mary's Hospital in Rochester and he is an intern at Maimonides Medical Center in Brooklyn. By the time they married, they had seen each other only about seven times.

In January 1995, their families were introduced by a mutual friend, and in April, a date was arranged for the couple to meet. When they met for the first time, their parents were not only present, they were as much a part of the courtship and selection process as Pankaj and Divya.

Before the meeting, each family had carefully studied the other's financial, educational, astrological, religious and social backgrounds. "We look at everything," said Dr. Asha Gupta, the bridegroom's mother, who is a gynecologist. "For us, love is not blind."

When asked why he thought the couple would make a good match, Dr. K. K. Gupta, the bridegroom's father, who is a pediatrician, said: "They are both physicians, they both belong to the same section of society. The families are both well-to-do, respected and there are no skeletons in the closet."

During the first meeting, the bride and bridegroom talked easily. "I thought Divya was a true gem in a vast ocean, honestly," said Pankaj. "She was so understanding and mature. There was an initial magnetism, and from that mo-

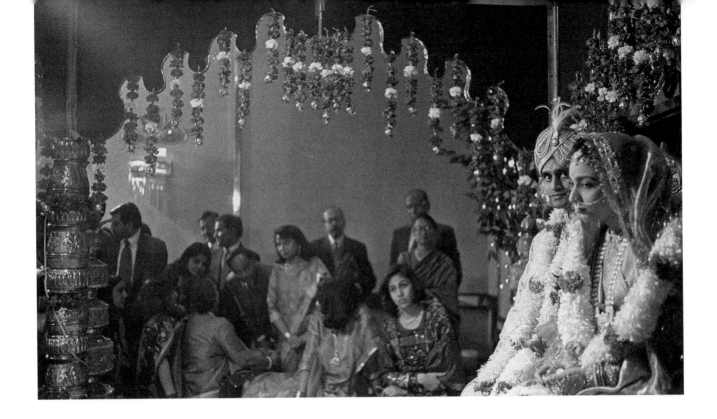

ment on, I've only seen her once a month for twenty-four hours."

Unlike the bridegroom, Divya never wanted an arranged marriage. "She always felt you have to know a person before you marry them," said her younger brother, Saurabh Gupta. "But this thing just clicked so well."

Following the tradition of arranged marriages, the couple decided to marry after only a few dates, before knowing such things as how the other spends vacations, tips taxi drivers, likes their coffee or behaves at dinner parties. "Once you meet someone and the marriage is made, you work hard to find common ground," said a wedding guest, Vino Luthra. "It's a spiritual thing. You say, 'This is my destiny for the rest of my life.'"

The couple was married in a traditional Hindu wedding at the Radisson Hotel in Hauppauge, Long Island. As is the custom, the bridegroom set out for the wedding on a white horse, actually a friend's polo pony that he mounted nervously in the hotel parking lot. "I want you to know, I've never ridden a horse," he said. "Is this an old one? Holy smokes!"

Wearing white pants, a matching knee-length jacket and a red turban, Pankaj rode about two hundred yards to the entryway as some of the 450 guests danced around him, the men in black suits, the women in saris the color of tropical drinks.

During the ceremony, the couple sat with their parents and a Hindu priest, Dr. Anand Mohan, under a red gazebo that had strings of carnations hanging from the roof. It made perfect sense that their parents, who had been a part of their romance from the start, went through the wedding rituals alongside them.

"In the Hindu tradition, marriage is not a personal contract between two people and forget the rest of the world," said Dr. Pratap Gupta, a guest who is unrelated to the couple. "It's between families."

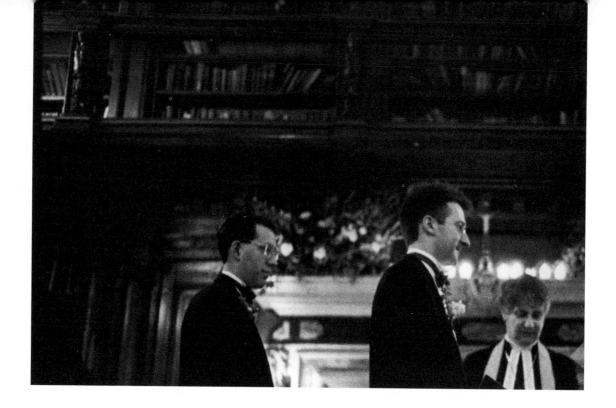

Jane Perlov *and* Robert Maas JANUARY 26, 1996

Inspector Jane Perlov, the first female commanding officer of the police department's 30th Precinct in Harlem, grew up in a sprawling Upper West Side apartment filled with oil paintings, Oriental rugs, bookcases and overstuffed armchairs comfortable enough to read long Victorian novels in one sitting.

No one would have predicted that Jane, the middle of three daughters, would become a cop. As a girl, she was known for screaming when she saw daddy longlegs or frogs and for spending hours locked in the bathroom, curling her hair. All three daughters were encouraged by their intellectual parents, Norman and Dadie Perlov, to pursue professional careers in fields like medicine, social work or law.

Law *enforcement* was not exactly what they had in mind. When Jane announced in her late teens that she wanted to be a police officer, her mother wept. "I told her, 'One, Jewish girls don't do that. And two, you have to finish college,'" Mrs. Perlov remembered. "The third thing was, we must never, ever tell Grandma, and we didn't. She thought Jane was a lawyer."

The inspector, now thirty-nine, joined the department in 1981. Friends say that, while she rose steadily through the ranks, she never lost her humor or her habit of spending hours styling her hair, though she didn't exactly go out on a lot of dates. Jane said that men, especially men outside the department, tended to avoid her. "It's hard for them to think

> "He became a man and I became a woman, instead of inspector and sergeant, and we fell madly in love."

you can be soft or sweet or small or charming or understanding or any other things a woman is supposed to be," she said. "They expect you to be manlike."

She met Robert Maas, a fellow officer who is now a sergeant, soon after joining the force. Robert is athletic, drives a Jeep and is more inclined to spend weekends fishing in the wilderness than going to dinner parties. Over the years, they occasionally worked together—in the same precincts or at the same crime scenes—but never dated.

She said it wasn't until they went out for sushi after work a year ago that "he became a man and I became a woman, instead of inspector and sergeant, and we fell madly in love."

Sergeant Maas, who is forty-two and works in the Department of Investigations, described their romance this way: "We fell in love on the first date, after crossing paths for fourteen years."

He proposed several months after their sushi dinner while they were mountain climbing in Wyoming. On January 26, the couple was married in Jane's parents' current home, an apartment in a prewar building overlooking Gramercy Park. The apartment is filled with the Perlovs' various collections of everything from Victorian sepia photographs to celluloid billiard balls to wire rug beaters that cover a living room wall. "When people first come in, they say, 'What goes on in this apartment?'" Mr. Perlov said.

One hallway was covered with family photographs, including a 1916 picture of the bride's maternal grandmother wearing a three-piece men's suit and a newsboy's cap, smoking a cigarette and squinting like a gangster.

"We come from a long line of strong women," said Nancy Rosenbach, a psychologist and the bride's older sister. "All my mother ever really wanted us to be was powerful and successful, and Jane's done that. She's very powerful."

The couple was married before about fifty guests in a civil ceremony in the parlor, a room decorated with oil paintings, a grand piano and a glass case filled with old novels by Charles Dickens.

The bride wore her loose curly hair up, and appeared in a billowy chiffon dress with an uneven hem and low-cut back. "I wear pants, jackets and black shoes every day," she said. "I really wanted to look like a princess."

A few days before the wedding, the bridegroom said, "I am forty-two years old, and I have never been happier in my whole life. Jane's my soul mate. We both love sushi. We love biking and hiking. We have a wonderful garden with wildflowers and tomatoes. We love to go fishing. My rod cost two hundred dollars, and hers is worth about forty-nine cents, but she's always the one who catches the bigger fish."

Darinka Novitovic *and* Andrew Chase DECEMBER 2, 1995

"She's the one
who owns the
power tools in this
relationship,
which I love,"
he said.

Friends describe Darinka Novitovic, an artist and a hostess at Restaurant Florent in Greenwich Village, as a downtown Babe Paley. Her closet is filled with color-coordinated haute couture from the 1960s; she often wears long gloves, some long enough to serve as protective sleeves for golf clubs; her pocketbook always matches her shoes; and she never swears.

Like the late Mrs. Paley, she is a muse to many people, including the artist Alex Katz, who has a series of paintings titled "Views of Darinka."

"She wears a conservative, upper-class sixties look," said Tim Zay, an actor in New York and a close friend of the bride. "She's not going for the hippie-girl look at all. She's cruising the uncharted lands of the sixties."

Darinka, who, like many ladies of the fifties and early sixties, doesn't reveal her age, finds all her clothes in thrift shops. "She doesn't go into Bergdorf Goodman and get dressed," said Florent Morellet, the owner of Restaurant Florent, an all-night diner with offbeat waiters and waitresses, including many drag queens. "It's work, it's research, it's fighting. It's an art. It's not shopping."

The bride met Andrew Chase a few years ago at a party in the East Village, where they both have lived for a long time. The couple became, as the bride put it, "friends in passing" who often saw each other around the neighborhood.

"I was always struck by how beautiful she was, by her grace and poise," remembers Andrew, the chef of Contrapunto, a restaurant in Manhattan. "She's very ladylike, very proper. Her hair is always done perfectly. I remember running into her on the street one night and she was wearing a shimmery silver pants suit. This is eleven-thirty at night and here was this stunning apparition."

His courtship of her was gradual, gentlemanly and caloric, beginning with

their first real date, when he baked chocolate madeleines in her apartment.

"His tastes are very elegant," Darinka said recently. "He'd much prefer to read than watch television. He loves art. He doesn't necessarily like what's popular, and that's how I am, too."

When he visited her apartment for the first time, he was very impressed. French brioche molds hung from the ceiling, and she had recently built bookshelves and bigger closets for herself. "She's the one who owns the power tools in this relationship, which I love," he said. "It's so great, because on the one hand she's very ladylike and proper, but she is not a delicate little flower. She knows how to use a circular saw, and that is an attractive quality in a woman."

They were married on December 2 at Flamingo East, a restaurant on Second Avenue near Thirteenth Street. The wedding felt like a cross between a gathering in an 1800s French salon and a present-day party in the East Village. About ninety guests walked through a heavy velvet curtain into a room with mirrors and moldings as ornate as Victorian petticoats. There were white candles everywhere, even lining the tops of door frames, like Christmas lights.

For the nondenominational ceremony, conducted by the Reverend David Dyson, a Presbyterian minister, the bride wore a new dress, a sleeveless Dolce & Gabbana gown with a big bustled skirt. She looked more like Madame Pompadour than Babe Paley.

One of the best moments came when a friend of the bride, a drag queen known as Ebony Jet, performed a slow ballad from the seventies, "Walking in the Sun." A song about finally getting love right after a long period of darkness, it was perfect for the couple, who both described their prior romantic lives as sometimes disastrous and generally tiring. Now they're in the sun.

Ariane Noel *and* Marco Sodi

JUNE 25, 1994

Friends
call them
"the Electric
Couple."

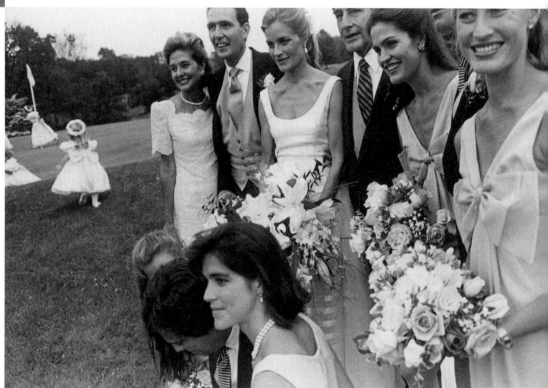

Friends describe Marco Sodi, who was born in Florence, as a "Florentine at heart," someone who appreciates art, beauty, nature, books, water-skiing and power boats.

Marco, a thirty-five-year-old investment banker in New York, met Ariane Noel, whose background is Brazilian, Swiss and American, on a blind date a year ago. She picked him up at his Manhattan apartment building in her bright red Volkswagon.

Ariane, twenty-seven, is a partner with her mother in Monica Noel, a company based in Greenwich, Connecticut. They sell children's clothes and linens that are European in style, the sort of smocked dresses and embroidered tablecloths one might see hanging on a line in a bougainvillea-filled garden overlooking the Mediterranean.

The blind date went well, and now their friends call them "the electric couple." Both are tall, outgoing, beautifully dressed and multilingual; in conversation, they slip in and out of different languages as if they were loose summer shoes.

They are also both fierce athletes. "Ariane has been good for Marco," said David Lamb, a friend of the couple. "The other day we were having lunch, and Marco told me he shot an eighty-six in golf for the first time. She will probably bring him under par."

Six months after the couple met, Marco proposed as he and Ariane stood underneath the brightly lit Christmas tree at Rockefeller Center. "He said, 'I love you more than anything in the world and I've never been happier,'" Ariane recalled. "I sort of let him go on. I wanted to hear it all. Then he opened his dinner jacket and said, 'Pull on this string.' There was a long, beautiful velvet cord hanging out of his inside pocket and I pulled on it and out came the ring. It was tied to the bottom of the cord."

Marco found the ring at the annual Christmas jewelry auction at Sotheby's in New York. It was an antique emerald-cut sapphire, the sort of large, bold ring that Anjelica Huston or Mariel Hemingway might wear.

On June 25, they were married in the early evening before four hundred guests at Christ Episcopal Church in Greenwich in a wedding that was European in spirit. The dark, Gothic-style church was filled with piano music, big hats, bright colors and flowers that were inspired by Impressionist paintings.

The bride wore a long ponytail and a sleeveless ballgown with a big scooped back. The ten bridesmaids appeared in short dresses in different summer colors, like watermelon-pink, lime-green and the bright yellow of new tennis balls. All around them, like shooting stars, ran five flower girls in white Monica Noel dresses and white fabric flowered headbands.

For the reception at the nearby Round Hill Country Club, Dorothy Wako, a New York floral designer, planted a traditional English garden outside the main building. The garden was filled with rambling roses, wild sweet peas, lavender Canterbury bells and white peonies that were as soft-looking as powder puffs and as big as melons.

"Ariane wanted to please all the senses with this wedding," said Tierney Gifford Horne, a friend of the bride who is the fashion director at *Mademoiselle* magazine.

During dinner, guests sat at tables named after the couple's favorite places—Geneva, Aspen, Kloster, Anguilla, Firenze, San Michele. At one-thirty A.M., after a night that included a song-and-dance toast by the bride's four sisters, who called themselves the "Noel Supremes," the couple drove off in an old classic yellow Buick convertible from the 1950s.

"They went off for a three-week honeymoon," said Alix Noel, a sister of the bride. "The first week is in the Great Barrier Reef in Australia, the second week is a week of heli-skiing in New Zealand and the third week they'll spend in a remote bungalow on an island in Fiji. They'll go scuba diving in Australia and skiing in New Zealand. They love the sporting life."

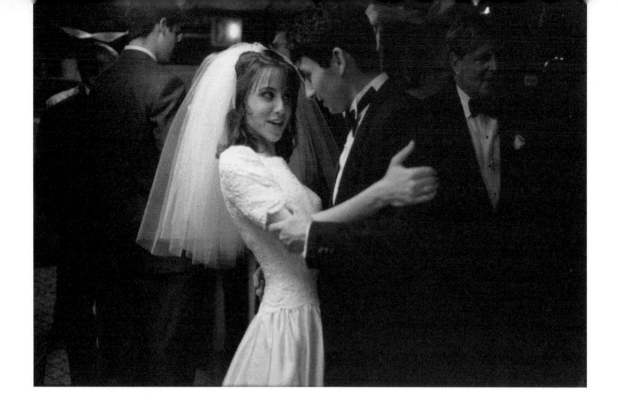

Laura Mason *and* Alexander Khutorsky

DECEMBER 30, 1995

While many young people today dream of marrying rock stars or Internet entrepreneurs, Laura Mason, twenty-four, dreamed of marrying someone who liked chicken soup and chopped liver, knew the Russian ballets and felt comfortable in loud, overcrowded, earthy, ethnic restaurants.

Laura, a former professional ballerina who now teaches English at the Brooklyn Friends School, grew up in Bethesda, Maryland, in a mainstream American household. But she was always fascinated with what she called "the strong Jewish Eastern European spirit" in her grandparents' homes, especially in their kitchens.

When she met Alexander Khutorsky, a twenty-four-year-old law student at Columbia University, she felt that spirit right away. They met in a campus pub four years ago, when he was an undergraduate at Columbia and she was a student at Barnard College. His family emigrated to Miami from the Ukranian capital, Kiev, when he was six. He speaks fluent Russian, and he knew all the Russian poets she'd read and the Russian ballets she had danced.

"With Alex, it felt so comfortable and right," she recalled. "When I visited his home in Miami, his parents were always talking loudly in Russian. One morning, I went into the kitchen to get cereal, and on the counter there were

> "I asked Laura,
> 'Are you getting a florist?'
> And she said, 'No, why have
> flowers when you can
> have chicken fat?' "

two cows' hooves sticking up out of this bowl of water. It was like there was some big cow under the table. His mother was making jellied hooves, a Russian delicacy. It was just like my grandmother's kitchen."

Now Laura and Alexander live in Brooklyn, two blocks from where her great-grandparents first lived after coming to America, and Laura often cooks traditional Russian dishes. "Our home will be filled with the scents and atmosphere Alex is used to and I always craved," she said. "My mother commented on how it's like a circle—the people who immigrated two generations ago were doing everything they could to assimilate, and now my generation wants more ethnicity."

Friends describe the bridegroom as a cross between a Russian philosopher and an American fraternity brother, and the bride as irrepressibly lively. "As a teacher, Laura is so off-the-cuff and unusual," said Judith Solar, a teacher at the Dana Hall School in Wellesley, Massachusetts, where the bride taught from 1993 to 1995. "She would begin a typical class by saying, 'Okay, this is what happened with Alex over the weekend. Close the door.'"

On December 30, they were married at Temple Israel on East Seventy-fifth Street in Manhattan. The reception afterward at Sammy's restaurant on the Lower East Side was loud, unpretentious, soulful and fun. Inside the tiny restau-

rant, the tables were set with unmatched silverware and the centerpieces were dispensers of schmaltz (bright yellow chicken fat) and bottles of Absolut vodka in blocks of ice.

"I asked Laura, 'Are you getting a florist?'" said Melissa Kanter, an old friend. "And she said, 'No, why have flowers when you can have chicken fat?' Laura is outrageous."

Once everyone was seated, waiters in jeans and T-shirts ran up and down the aisles, which are as narrow and curvy as mountain creeks, yelling, "Watch your back! Hot stuff coming!" and "Beep, beep, beep!"

A violinist strolled from table to table, saying, "I'll ruin any song for you. You name it, I'll kill it."

Jennifer Abramson, a friend of the bride from Barnard, said that Laura is the sort of person who likes cramped, down-to-earth, spirited places like Sammy's. "With Laura, anything goes, and with this restaurant, anything goes," she said. "It's a 'kick off your shoes and have a good time' place, and that's how she is."

The irrepressible spirit of the wedding was perhaps best expressed by a member of the restaurant's staff who announced to the crowd, "You may not think there's room to dance here, but there's always room to dance at Sammy's!"

Patricia Durkin *and*
Kenneth Wignall MAY 20, 1995

"One night, a moth was flying around a light bulb and he caught it and let it out the window. I said, 'That's it. He's the guy.'"

Patricia Ann Durkin, forty, is the director of advertising for Tommy Hilfiger, the men's sportswear company whose advertisements are filled with guys wearing jeans rolled up at the cuffs, seersucker shorts with no loafers and no socks, and khakis with dreadlocks. They look like the laid-back, rugby-playing, looser-thinking brothers of the Ralph Lauren models.

Patricia, whose own sense of style is so casual she wore sneakers with her short white wedding dress, met Kenneth Grant Wignall, forty-four, a year and a half ago. They ran into each other at the Tamboo Tavern, a restaurant built out of bamboo and driftwood on the beach in Negril, Jamaica.

At the time, she was on vacation; Kenneth, who is a business executive from Ontario, Canada, was spending part of the winter living on his sport fishing boat, *Adventure.* He often went marlin fishing during the day, then rowed ashore in his dinghy for a lobster-and-goat-cheese pizza at the Tamboo Tavern.

That night, he and Patricia struck up a conversation and ended up eating dinner together, then walking down the beach afterward to an old-boat-turned-bar set up on the sand. Patricia had not dated anyone in a long while. In New York, she usually spent Saturday nights on the phone with Patti O'Brien, a close friend who is the fashion director of *Rolling Stone* magazine, while they sat in their separate living rooms laughing and watching *Sisters* on television.

Over the next several months, Patricia missed almost every episode of *Sisters*. Instead, she got together with Kenneth each weekend—they'd meet to see a New York Knicks game or to look for antiques in Canada or to hunt for a house to buy on the Jersey shore.

Describing Kenneth recently, Patricia said he was unlike any of the men she had known in New York. He knew how to repair car engines and frozen pipes. He could beat her in Scrabble. And he didn't kill bugs.

"One night, a moth was flying around a light bulb and he caught it and let it out the window," she recalled. "I said: 'That's it. He's the guy.'"

Nowadays, he spends the workweek in Canada, she spends it in Manhattan, and on Friday nights they meet at a white ramshackle Victorian house they bought and are renovating together in Spring Lake, New Jersey.

On May 20, after they were married in the Saint Denis Roman Catholic Church in the nearby town of Manasquan, they had a big party at the house. It was basically a wedding reception on a construction site—the house, which the couple call their five-year plan, is still unpainted, unfurnished and essentially unsafe to enter. (For wedding gifts, the couple registered at The Home Depot.)

Guests gathered in the two-acre backyard, still somewhat overgrown, where stereo speakers blared songs by Aretha Franklin and Sting, paper bells hung in the trees and a large white tent was erected.

There were about 130 guests, including Linda and Robert Beauchamp, who recently renovated a turn-of-the-century Tudor-style house with a totally overgrown garden in Wanamassa, New Jersey.

"I know the blood, sweat and tears that goes into clearing a piece of land like this," said Mr. Beauchamp, who is the editorial fashion director of *Esquire* magazine. "We've dug up old seeding areas and walkways and patios in our yard. For anyone from New York City, it's like an archaeological find. They should dig for a tennis court."

Linda Beauchamp, the president of Donna Karan Menswear, saw the house, with its peeling wallpaper, chipped woodwork and dilapidated outbuildings, as a much more poignant backdrop for the couple's reception than any slickly furnished party space.

"It's like they invited us to an empty canvas they're working on together," she said. "We, as their friends, will be able to come back on their fifth anniversary or twentieth anniversary, and say, 'Remember what it was like at the wedding?'"

Audra Avizienis *and*
Jason Duchin JUNE 17, 1995

"When I
visualize them,
I see them in a
sandbox."

Jason Duchin's résumé reads like a run-on sentence. At twenty-nine, he is an actor, a novelist, a film producer, a video director, a screenwriter, a carpenter, a bike messenger and a founder of a nonprofit company, The Dreamyard Drama Project.

Dreamyard is a group of artists who teach everything from poetry to moviemaking in New York public schools with fledging or nonexistent art programs. Jason recently spent several months rewriting and updating *Romeo and Juliet* with a class of eighth-graders at the Wadleigh Secondary School in Harlem.

Friends liken him to a bohemian Hemingway character living in Paris in the 1920s. He rolls his own cigarettes, travels around Manhattan on a bicycle held together by duct tape and forgets to buy new shoes until the leather wears out completely and he hits sidewalk.

He didn't believe in marriage or even think about it until he met Audra Avizienis, who has almost as many occupations as he. Also twenty-nine, she is a former model who is now a screenwriter, film producer and journalist.

"My writing is definitely a reaction against my experience as a model," she said. "I'm interested in female protagonists who are real people, not just wives, girlfriends, arm pieces and sex objects."

Jason and a friend, Laird Blue, introduced themselves to Audra six years ago at a party given by George Plimpton on a boat in the Hudson River. "We were being very sarcastic with her and she gave it right back without hesitation," Laird recalled at the wedding. "Jason and our group of friends would never be with anyone who could not diss you and call you on your lies and jokes and attitude—who wasn't strong. Audra is very beautiful and demure, but she doesn't take grief. Her spine is as thick as a Corinthian column."

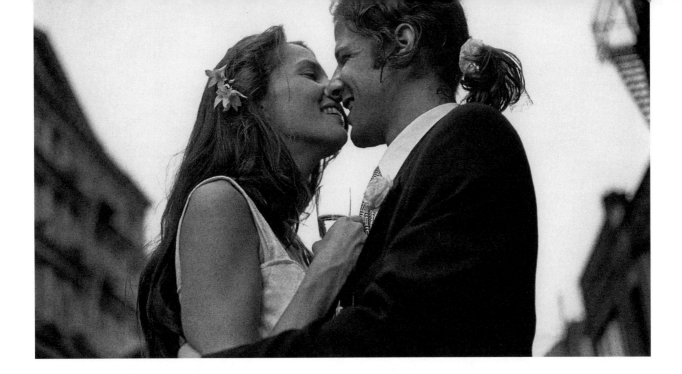

A few days after the party, Jason left on a trip to South America and South Africa. As he traveled, he wrote letters and poems to Audra almost daily.

"A month afterward," he said, "I arrived back with all my worldly possessions, which is exactly one bag, and landed on her doorstep and she took me in and we've been together ever since."

The couple is now working together on several projects—screenplays, videos and a renovation of their downtown loft. During work breaks, they almost always end up at one of the old wooden farmhouse tables inside Il Buco, a restaurant in the East Village.

"When we had dinner there for the first time, we'd been working all day and we looked like hell," Jason recalled. "We sat down and the owner said, 'Are you vagabonds or are you customers?' Over time, we really became friends, and it became important to have the wedding in this place."

On June 17, right after they were married at the Church of the Transfiguration on East Twenty-ninth Street, the cou-

ple pulled up to Il Buco in a cherry-red vintage Thunderbird convertible and jumped out onto the sidewalk.

Seventy-five guests, many of them in long flowered dresses and looking like models, gathered inside the restaurant, a dark, rustic European-style tavern filled with Americana, including Bakelite radios, vintage lunch boxes, wooden tennis racquets, quilts and old red sleds. It's the perfect place for rewriting screenplays, coming up with movie ideas and finding furniture (everything is for sale).

Like the restaurant's decor, the bride's clothes evoked farmhouses, country roads and simpler times. She wore a sleeveless, ankle-length dress she sewed herself and wildflowers tied loosely in her hair. The bridegroom wore a dark suit and a ponytail decorated with a piece of white lace that guests called his bridal veil.

"There's an innocence to them and a purity," said Jason Dietz, an actor among the guests. "They haven't been brought down by life. When I visualize them, I see them in a sandbox."

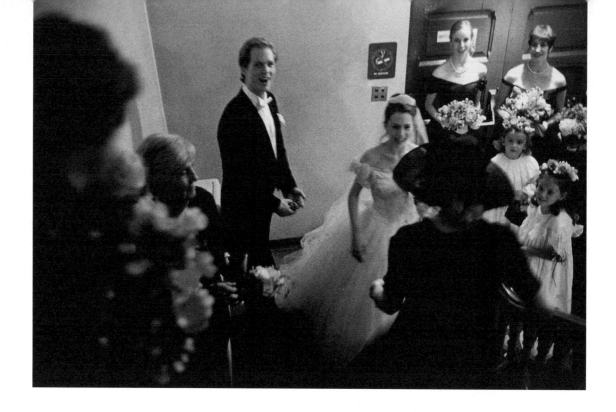

Ashley Tuttle *and* Charles Askegard JUNE 16, 1993

Ashley Tuttle, twenty-two, a soloist with the American Ballet Theater, catches your eye even while dancing in a crowd. She is as athletic as a gymnast and so ethereal, she seems to be made of little more than air and tulle.

Charles Askegard, twenty-four, is also a Ballet Theater soloist. He is known as Chuck and, at six feet four inches tall, looks more like a basketball player than someone adept at jetés and pirouettes.

Many members of the company described them both as dancers who could become major stars, with large crowds waiting for them outside the stage door. "Ashley is one of the real up-and-coming talents," said Lucette Katerndahl, a

Ballet Theater dancer who was a bridesmaid at their wedding, on June 16. "We call Chuck 'the Prince.' To us, Chuck has always been the nicest, tallest, most fantastic partner. No one worries if you have Chuck holding you up."

The couple made most of their wedding plans from a pay phone inside Lincoln Center, in between their nearly non-stop rehearsals and performances. Even the bride's shower took place during a short break from dancing. "We had a shower for Ashley between shows in the women's lounge," said Lucette Katerndahl. "About thirty-five people came, and I never saw so much lingerie in my life. Dancers don't give cookbooks."

The couple was married a few blocks from Lincoln Cen-

The couple made most of their wedding plans from a pay phone inside Lincoln Center, in between their nearly nonstop rehearsals and performances.

ter, at Holy Trinity Lutheran Church on Central Park West at Sixty-fifth Street. Of the 130 guests, most were fellow dancers and beautiful to watch, even offstage: tall, willowy women in sleeveless flowered dresses, their arms as long and thin as calla lilies, and men in perfectly fitting jeans who stood in the turnout position in their cowboy boots.

Afterward, everyone walked to the Dairy in Central Park, a Gothic stone building with ornately carved wooden rafters and columns—it looks like a large gazebo in the woods in a Victorian novel.

The building was decorated to evoke the ballet. Huge baskets of hydrangeas, red lilies, purple roses and pink peonies hung from the rafters. They were designed by a former dancer, Paul Bott, of Paul Bott Beautiful Flowers in Manhattan, and were based on the colors in the ballet *Coppélia.* Like many other guests, Benjamin Pierce moved to Manhattan to study dance when he was barely a teenager. As it turned out, Benjamin's first roommate was Chuck. "When I moved in with him, I didn't know the first thing about living on my own," Benjamin said. "He taught me how to roast a chicken, how to put spices in tomato sauce, which subway to take. Judging from that, I'd have to say

he'll take care of Ashley like no one else and show her the way when she's lost."

During dinner, the couple moved from table to table so gracefully, it appeared they were wearing motorized shoes. It was hard not to stare at them. David Richardson, a ballet master at Ballet Theater who was a guest, commented, "Technique alone is wonderful, but you're not going to be a dancer audiences are drawn to unless you're willing to give up your soul, and your soul has to be interesting. You want to have a conversation with that dancer on the stage. Ashley and Chuck embody that quality, and that's why it's so exciting to see them as a married couple."

Heather Mee *and* Glenn Muscosky DECEMBER 3, 1994

"The whole wedding goes by so fast, you can't really believe it happened."

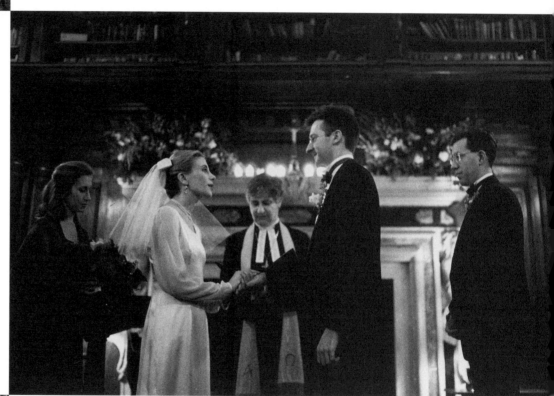

Sometimes falling in love means learning to live with your significant other's cats, pit bull, insomnia or collection of lava lamps. When Heather Mee met Glenn Muscosky, she learned to love his bicycles.

A capital investment analyst with the New York Transit Authority, Glenn is a serious mountain and racing bicyclist. He spends almost every weekend either racing in Central Park or riding through forests in New Hampshire, where trees are as close together as people on a rush-hour subway.

Heather, a partner in the New York advertising firm Frierson & Mee, met Glenn through friends three years ago, and not long afterward, a row of bicycles was hanging like bats from a massive rack on her living-room ceiling.

"I had this pristine apartment in Chelsea with all my antiques, and Glenn had this little studio on the Upper West Side with six bicycles in it," she recalled. "It was like *Caddyshack*. So when we moved in together, I had to make this big leap of having all these bikes in my apartment. It really hurt, but I've gotten used to it."

Heather, who is petite and as delicate-looking as a blown-glass figurine, also took up mountain biking. Following Glenn on old coal-mining trails in Jim Thorpe, Pennsylvania, she learned to ride over boulders and fallen trees, across streams and through knee-deep mud.

"I'd be riding straight up vertical climbs, and Glenn would already be at the top," she said. "But the best part is going downhill. Then you don't hate the guy anymore. You hate him on the way up and love him on the way down."

Before their December 3 wedding, Nancy Smith, a friend of the couple's and the art director of *Ms.* magazine, compiled a list of the top ten reasons they should be married. "One reason was the bike rack," Nancy said. "I said it's way too hard to get down, and it took forever to build, and it would make a great jungle gym for their kids."

They were married in Manhattan at the House of the Redeemer, an Italianate town house on East Ninety-fifth Street. The ceremony took place in the library, which is filled with floor-to-ceiling bookcases (at least one is fake and leads to a hidden passageway), Oriental rugs, antique writing tables and old lamps that give off about as much light as candles.

"Most other rental spaces in New York feel like rental spaces," Ms. Mee said. "This feels like we're all Medicis having our buds over for a fancy party at the turn of the century."

Seventy-five guests watched as the bride appeared in a dress by Jane Wilson-Marquis, a SoHo designer, which was the color of melted coffee ice cream and diaphanous in spirit. It appeared weightless, as if it could be blown across town like tumbleweed.

She and the bridegroom said their vows while standing next to the fireplace. The bride's only fear a few days beforehand was that she might catch on fire during the ceremony. "My dress is made of taffetta so we're going to have someone with a fire extinguisher in the first row, " she said.

Almost every detail of the wedding was like the dress—delicately done and unusual. The couple gave each guest two crocus bulbs as a party favor, hoping that when the spring flowers came up, they would be a reminder of the wedding. The bridegroom called the bulbs, which needed to be refrigerated for eight weeks before planting, "a science experiment for our New York friends."

Although the couple treated the wedding with as much care as they would a twenty-four-gear bicycle, the bride said a week later that she could hardly remember putting on her wedding dress, walking down the aisle or even taking her vows. "The whole wedding goes by so fast, you can't really believe it happened," she said. "All I have to prove it happened are these little contact sheets. I guess I have a whole lifetime for it to sink in."

Annie Zamoiski *and* Steven Yamovsky APRIL 1, 1995

Her friends told her, "You can't marry him! Your name will be Annie Zamoiski Yanovsky!"

While many people in New York avoid, mistrust or simply never see their neighbors, Annie Zamoiski, forty, has almost single-handedly turned her Greenwich Village apartment building into a place where the residents know their neighbors' names, love problems and preferences in movie rentals, and where they sometimes even forget to lock their doors.

Annie, a freelance computer graphics designer known to her friends as "Annie Z.," talks to everyone in the hallways and elevators of the converted warehouse, regularly drops in on neighbors, usually with a bottle of wine, and is always up to date on who's having a baby or moving out or auditioning for a part in a movie or in need of home cooking.

"When I moved in, I'd find notes on my door from Annie saying, 'Want a hot meal? I made some soup. Stop by. Bring wine,'" said Jim Weisse, a neighbor.

Alan Blum, an advertising executive who lives across the hall from her, added, "Annie's always smiling and talking and terribly bubbly and alive. She makes the building a very communal place. There's always two or three people from the building perched in Annie's living room."

She met Steven Yanovsky, thirty-two, an executive at Atlantic Records in New York, in the building. She was in Alan Blum's apartment one night sharing take-out Mexican food when Steven, an old friend of Alan's, dropped by to play some new CDs and talk about his lackluster love life.

When the couple first started going out, friends told her, "You can't marry him! Your name will be Annie Zamoiski Yanovsky!" Nevertheless, he seemed like the perfect man to her. He knew how to cook and arrange flowers and tell great jokes, and he didn't ask her age until they had been dating for months. In fact, he seemed much more interested in her address than the fact that she was eight years older than him.

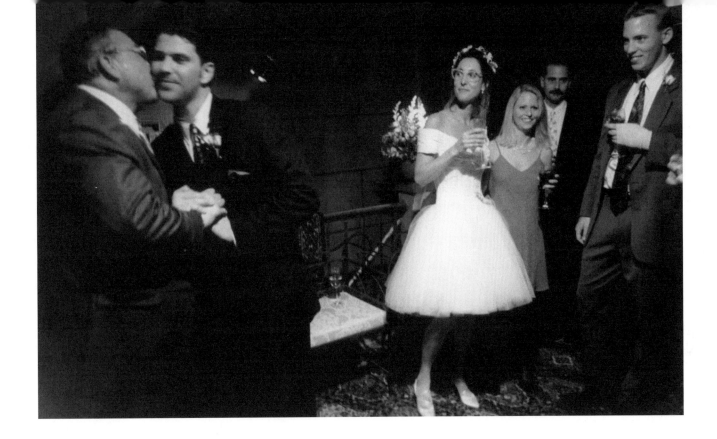

"I'm just so glad I met a woman who lives in the West Village," he said. "All of the women I've met down here are independent and vibrant and free. Women in the West Village aren't afraid to go into a bar alone."

He added, "When Annie and I go to a party, I see her at the beginning of the party and leave with her at the end. She'll be hanging out on one side of the room and I'll be on the other. There's no jealousy in this relationship. People who are jealous end up on *Oprah.*"

Rick Maranian, a friend of the couple and a stand-up comic, calls them "two independent souls who fell in love and decided to be single together."

They were married on April Fool's Day in a private triplex in a converted furriers building on West Twenty-ninth Street. The bride wore white Hawaiian orchids woven through her hair, a wedding gown she cut off at the knee and

pink eyeglasses studded with rhinestones, the fanciest in her extensive collection of glasses. "I can't wear contacts because they feel like potato chips in my eyes," she said.

True to the bride's friendly, communal spirit, the seventy guests sat down together after the ceremony for a family-style dinner at one enormous table that was about as narrow and long as a lane in an Olympic-size swimming pool.

The table was decorated with a row of tall gilt candelabra and medieval-style centerpieces that included everything from lilies and pink roses to pheasant feathers, green apples and purple grapes.

"I always wanted to have dinner at a ridiculously long table where if you say, 'Pass the salt,' you get it an hour later," said Sara Kimball, a guest. "You never see a table like this, except at the White House. It's the ultimate dinner party."

Kim Cochrane *and*
Robert C. Field III <small>APRIL 10, 1993</small>

"Friends describe
Robert as a pacifist,
philosopher and a
daredevil."

Captain Kim Cochrane, twenty-eight, recently returned from Somalia, where she commanded 145 soldiers whose main duty was to escort truckloads of food inland from the port at Mogadishu, past countless bandits and ambushes.

In the Persian Gulf War, her platoon accompanied ammunition trucks from Saudi Arabia to Iraq, often driving secretly across the desert at night with no headlights and subsisting, as usual, on MREs (meals, ready to eat). "They're pretty good for meals in plastic bags that are five years old," she said.

From those experiences, she learned about Somali clans, chemical warfare and what it's like to be as popular among men as a homecoming queen or Michelle Pfeiffer.

"Being in the military, I dated a lot of people because there are so few women," she said. "You get plenty of male attention. It's fun, I have to admit, but it's a false environment. I tell the women soldiers, 'Don't get a big head about this.'"

A year ago, she met Captain Robert C. Field III of the Army Special Forces, an elite group trained to parachute into enemy territory, perform covert missions and get out quickly. Friends describe Robert, thirty-nine, as a pacifist, philosopher and a daredevil who never loses his cool.

On April 10, they were married in the Cadet Chapel at the United States Military Academy at West Point, New York. The Gothic stone chapel overlooks the Hudson River as it winds through the Catskills, affording a view that is serene, strategic and evocative of lost soldiers all at once.

The reception was in Cullum Hall at West Point, in a ballroom big enough to store a fleet of helicopters, decorated with oil portraits of Civil War generals and

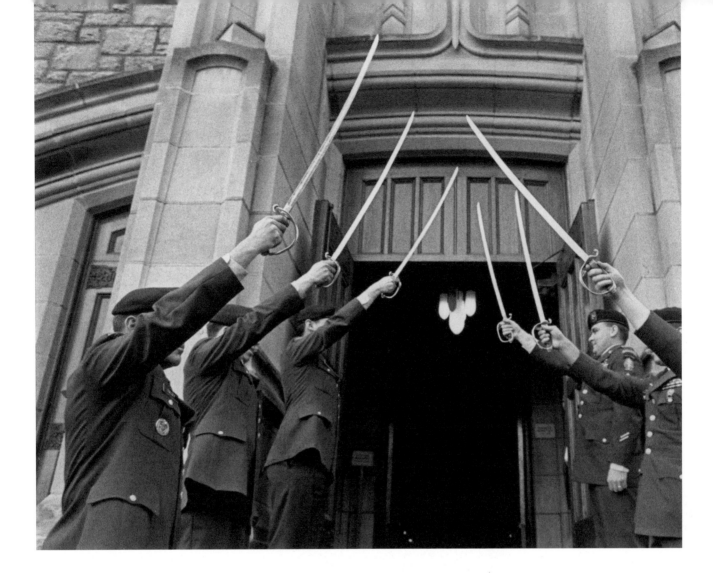

captured enemy cannons embedded in the walls.

Many of the 160 guests wore army uniforms brightened with colorful service ribbons, pins and patches. One, Captain Chuck Williams, described himself as a semireformed male chauvinist. "I've always had reservations about female officers," he said. "But Kim's one of the best commanders I've seen, male, female, whatever. It's been a learning experience for me."

Like the couple, the reception was romantic rather than regimented, more loose than lockstep. They danced their first dance on the ballroom floor, which seemed as wide open as the Saudi desert, to "I Will Stand By You," a slow, easygoing country-western song by Bob Corbin. In spirit, the song's lyrics contradicted the images of generals and war heroes peering down stoically and proudly from the walls.

It was about anti-heroes, everyday people without angel's wings, medals, or shining badges, whose philosophy is, take me as I am.

Susan Wyland *and* Norman Lanes

"It's the heart
of things that
matter."

Susan Wyland, the editor of *Martha Stewart Living* magazine, and Dr. Norman Lanes, an internist in New York, are not at all alike.

He likes to mountain climb in wild, remote places like Alaska; her footwear would not allow it. According to friends, her favorite winter shoes are a pair of black suede thigh-high boots.

At work, she oversees articles on such subjects as painting furniture, arranging peonies and reupholstering armchairs. He has no interest in any of that. He specializes in cardiology and likes to say, "It's the heart of things that matter."

Friends describe Dr. Lanes, whose practice is on Park Avenue, as shy, philosophical and just plain different. "He's a forty-plus bachelor, kung fu student, cardiologist, mountain trekker," said Peter Cutner, a friend.

The couple met three years ago when Susan and a coworker were lingering over a meal and commiserating about their disastrous love lives at Pisces Restaurant in the East Village. Toward the end of the evening, Norman and a friend were seated at the table next to them, and they all ended up talking, sharing a bottle of wine and exchanging business cards.

At the time, Susan was recently divorced and living with her old gray tabby cat, Parker, the only male in her life. Norman had never been married.

A few days later, he phoned her at her office. "He said, 'Can we have dinner?' and I said, 'Sure,' and took my book out and there was nothing, *nothing*, for the foreseeable future," Susan recalled. "So I said, 'To tell you the truth, it could be anytime.'"

For their first date, he picked her up at her downtown apartment in a white Jeep and they drove around the city, talking for most of the night. After that, she cooked him dinner a few times in her apartment, with Parker sitting on the table between them, occasionally burning his whiskers in the candle flames.

"It started slowly," said Susan. "We saw each other once a week, then a couple of times a week. It just got better and better. My therapist likes to say Norman was in the 'Who Knows?' category for a long time."

For him, she was the love of his life at the perfect time in his life. He had entered his forties and was beginning to feel, as he described it, mortal, lonely and suddenly blasé about backpacking. "I realized you can only go on so many wilderness hikes alone," he said.

A few days before the wedding, the bride's coworkers gave her a shower in their midtown office. Martha Stewart gave the bride a present that could be seen as either a blessing or a curse—an ironing board and iron that was so durable, she said, it would never, ever break down.

"It has an attached water bottle with a tube in it for steam, like an IV," Martha said. "Perfect for a doctor's wife."

Darcy Miller, an editor at the magazine, gave the bride a small pink "wish book" containing hand-painted pages. In it, the guests wrote their wishes for the bride. One read, "I hope you make your house into a lovely home—warm, smart, clever and a little funky."

After the couple was married on February 17 at the United Nations Chapel, forty guests gathered for a small dinner party in Susan's duplex apartment overlooking Washington Square Park. The windows were lined with white Christmas lights; the snow-covered park, with its bare trees and antique lampposts, looked like an old black and white postcard of New York.

The wedding was almost entirely designed by Ms. Miller, who made everything by hand, including the JUST MARRIED sign on the newlyweds' new Jeep (it was written in calligraphy and hung from the car by pink satin ribbons).

Parker, Susan's cat and longtime confidant, was not at the party. The day after Dr. Lanes proposed in September 1995, Parker died. "It was Parker saying, 'Okay. You're okay now,'" the bride said. "'There's someone else to take care of you.'"

Mimi Kim *and* Stewart Kim MAY 8, 1993

When Mimi Kim and Stewart Kim met two years ago, they both worked at Merrill Lynch & Company, he in mergers and acquisitions and she in fixed-income research. He saw her across the office cafeteria, looking beautiful and spunky, and immediately devised what he described as "a subtle, roundabout acquisition strategy."

Knowing she was Korean-American, as he is, Stewart pretended that he was the membership chairman of the Korean American Finance Association and called to see whether she might be interested in joining. He suggested they meet for an "informative" lunch. "It was the first and only call I made in my capacity as chairman," he said.

Many guests at their May 8 wedding, held at Tappan Hill, a stone mansion overlooking the Hudson River in Tarrytown, New York, commented on the bridegroom's low-key yet clever courtship strategy.

"This is an example of the sensitive nineties courtship," said Bryan Burrough, a guest and author who has written extensively about hostile takeovers in the business world. "In the eighties, Stewart would have gone by and picked her up in a limo and talked about how much money he makes."

Upon hearing Mr. Burrough's comments, another guest, Steve Swartz, the editor of *Smart Money* magazine, added, "Mimi wouldn't have been impressed. She probably makes as much money as he does."

"This is an example of a sensitive, nineties courtship."

While Mimi, twenty-eight, and Stewart, thirty, may have had a subdued nineties courtship, they both live at a terrifyingly fast pace. A typical Saturday for them includes tennis, basketball, a few business meetings, multiple cocktail parties, dancing and about three hours of sleep.

The only thing to slow Stewart down in recent history was the weather during his bachelor party. On March 12, he and his closest friends arrived in Myrtle Beach, South Carolina, planning to play golf. Instead, they were marooned in a condominium as winds and rain raged outside. Golf was out of the question. So was electricity.

As Stewart recalled, "It was sixteen guys sitting in total darkness. One guy said, 'Mimi has powers we can't even imagine.'"

At Tappan Hill, about 230 guests watched the couple exchange vows outdoors in the much better weather—the afternoon was filled with the kind of balmy breezes that make you think of convertibles, screened-in porches, favorite songs on the radio and first loves.

Later, halfway through dinner, the couple changed from their Western wedding clothes into traditional Korean wedding costumes. The bridegroom appeared in baggy peach-colored silk pants tucked into black boots, a long iridescent blue coat and a black hat that looked like a Viking's helmet. The bride wore a jeweled crown and many layers of clothes—a chartreuse jacket, a fuchsia jacket, a light pink skirt, an embroidered sheer overskirt, long pants. It was as if she were wearing an entire wardrobe rather than a single outfit.

Together, they looked like a Korean couple going through an ancient, sacred ritual rather than New Yorkers who spend their summers in the Hamptons, work out with personal trainers and know every nuance between the eighties and the nineties on Wall Street. As the bride's brother, Steve Kim, put it, "They wanted to show that their blood is still Korean blood."

Holly Corroon *and*
Marc Robinson SEPTEMBER 24, 1994

"My first
impression of
Holly was that she
was a striking, tall
brunette with a
sense of adventure
and a great sense
of humor."

In 1981, Holly Corroon and Marc Robinson both lived on the Upper East Side and walked down the same stretch of Lexington Avenue to work each morning. While he never noticed her, she developed a crush on him, looking for him on the crowded sidewalk every day, walking close behind him sometimes, imagining where he was from, the things he talked about, what he did for a living.

"I thought he was an L.A. movie producer," she recalled. "He always had a tan, and he wore his hair a tiny bit long. It wasn't an investment banker's haircut. I'm still highly insulted he didn't notice me. I keep asking him, 'Are you sure you don't remember me?'"

Eventually, she changed jobs, walked to work a different way and forgot about him. Then, one night in 1984, she was sitting with a friend at the bar in Mortimer's Restaurant, at Lexington Avenue and Seventy-fifth Street, when Marc walked in and sat down nearby.

"We just started talking," he said. "My first impression of Holly was that she was a striking, tall brunette with a sense of adventure and a great sense of humor. I've always thought she should be a stand-up comic."

As it turned out, Marc was not a movie producer from L.A. He grew up in Kansas and is known for being a dapper dresser who carries a pocket watch, collects 1930s Art Deco ties and drives a vintage MG. He now works as a real estate agent at Stribling & Associates in New York.

"On our first date, he took me to a black-tie Boys Club of New York benefit at the Plaza," said Holly, who is statuesque and slim and works as a personal trainer. "We had a wild and fun time. By the end of the night, when he walked me home, he was wearing my high heels and I was wearing his velvet slippers."

In many ways, their courtship was like one from another era. They dated for

ten years but never considered living together before marriage. He always picked her up at her apartment for dates, more often wearing a formal suit with a handkerchief in the pocket than jeans.

"I was more stressed about moving in with Marc than about getting married," the bride said several days before their wedding. "When we were searching for an apartment, we looked at two one-bedrooms in Carnegie Hill that were adjacent to each other. I said, 'Marc, this is perfect. It has two bedrooms, two kitchens. We'll just build a door.' I was seriously considering it. It was like, I'd knock on the door and say, 'Do you want to come to my place for dinner?'"

On September 24, they were married at Saint Vincent Ferrer Church on Lexington Avenue and Sixty-sixth Street, only a few blocks away from Mortimer's. The bride, whose father died not too long before the wedding, was escorted down the aisle by her four brothers, looking like a movie star surrounded by a phalanx of bodyguards.

After the ceremony, the couple and their two hundred guests walked to the Colony Club on Park Avenue for the reception. Wearing a sleek, sculptural gown designed by Bill Blass, the bride resembled a high-fashion angel as she walked, pulling lilies from her bouquet and tossing them at passing yellow taxis, an in-line skater and the evening sky.

"Holly is a hybrid of Ava Gardner and Rene Russo; she's a classic forties beauty," said Craig Natiello, an assistant designer for Bill Blass and a friend of the bride. "No bleached-blond hair. A big face and blue eyes. Her most forties quality is that she has no sense of herself as beautiful. She's shy. Marc, on the other hand, knows exactly how beautiful she is."

Llewellyn Sinkler *and*
Oscar Shamamian APRIL 17, 1993

The wedding cake was modeled after one of the couple's favorite buildings in Europe, a baroque church in Prague.

Oscar Shamamian and Llewellyn Sinkler were introduced while they were both in a hardware store picking out doorknobs. They are the sort of couple who, given a warehouse full of doorknobs—or light fixtures or china cups—would probably end up choosing the same ones.

Oscar, thirty-three, is a partner at Ferguson Murray & Shamamian Architects, a firm in SoHo known for its classical designs that have been said to evoke the grand estates of the twenties and thirties. Llewellyn, thirty-four, is an interior decorator at Bunny Williams Inc. on the Upper East Side. She grew up in Charleston, South Carolina, in what she described as "traditional eighteenth-century houses that were architecturally divided into perfect squares and proportions."

It was Bunny Williams who introduced the couple as the three were choosing doorknobs for a Park Avenue apartment the two firms were working on together. Many of Llewellyn and Oscar's clients live in traditional prewar apartments on Park and Fifth avenues and in places like Aspen, Colorado, or Palm Beach, Florida.

The couple, however, live differently. They reside in an idiosyncratic, trapezoidal loft in the West Village that has panoramic views of the meat market. "It makes a good case for vegetarianism," Oscar said.

Filled with furniture from the thirties and forties, their apartment has almost no interior walls separating the living areas. When asked why they chose an open floor plan, Oscar said, "Since we're so busy, it gives us a good opportunity to see each other."

The couple married on April 17, in a nondenominational ceremony at the Union Club on the Upper East Side, where every room is a paradigm of classical design principles. "The proportions are beautiful, the scale is wonderful, the

color scheme is serene," the bridegroom said.

As about eighty guests watched, the couple spoke their vows tenderly, as quietly measured as a grandfather clock ticking in a hallway. The bride wore a dark plum velvet gown that she found in a vintage-clothing store. "It's a very elegant, forties, cut-to-your-body dress," Bunny Williams said. "For her, it's great fun. For me, a disaster. It certainly depends on your form."

It was a black-tie evening for the guests, who included many New York decorators, architects, painters and writers.

Thomas Nugent, an architect and a guest, praised the choice of the Union Club. "The decor isn't making the event," he said. "That's why people like classicism. It's not like you're in a decorated space where you have to inch over aggressive architecture."

Even the wedding cake was architecturally inspired. Designed by Ellen Baumwoll of Bijoux Doux, it was modeled after one of the couple's favorite buildings in Europe, a baroque church in Prague with half-moon steps and a beautiful clock tower.

"I was told they worked out some of the details of their marriage pact at the church," said Thomas Jayne, a guest who is an interior decorator. "There were other architectural sites where they worked on the resolution of their life together, but this was the most easily replicable in a cake."

He added, "Sometimes, people think traditional architecture means being uptight, but it's not like that. That's what's so great about Llewellyn and Oscar. They understand all the classical formulas, but they also understand how to apply them with style and wit."

Nina Perales *and* Javier Maldonado MAY 20, 1995

Nina Perales, twenty-eight, and Javier Nyrup Maldonado, twenty-seven, both devoted advocates for the civil rights of Latinos, met at a dinner party three and a half years ago.

At the time, Javier was working for Legal Services of New York, helping welfare recipients who needed legal advice but couldn't afford it. "I was really excited to meet him because I knew he was working on behalf of poor people," said Nina.

At the party, they did not talk immediately about their common interests in protecting the rights of migrant farm workers, prisoners, people on public assistance, women and others without the language skills or power to fight for themselves. Mainly, she remembered, they talked about her shirt.

"I was wearing a blouse that had little flowers made of ribbons around the neckline," she recalled. "Javier turned to me and said, 'Do you know how those flowers are made?' He explained that they were made in factories in Mexico that take advantage of cheap labor. I felt absolutely horrible. I thought, 'He must hate me, for sure.' I had bought this shirt—unwittingly—that was made from the labor of exploited women."

In fact, he was enamored with her and soon became a regular visitor to her home, a cooperative household in a Brook-

> "I was really excited to meet him because I knew he was working on behalf of poor people."

lyn brownstone where members shared everything from grocery bills to vacuuming responsibilities. Whenever he came over, the two debated endlessly about everything from labor laws to what they should eat for dinner—she's a vegetarian while one of his favorite meals is barbecued cow's head.

A few weeks before the wedding, Javier graduated from Columbia University School of Law, where he was voted the student with the most potential as a public advocate. Nina is an associate counsel of the Puerto Rican Legal Defense and Education Fund, representing clients in job, housing and language discrimination cases.

As they do with most political issues, the couple debated the terms of their marriage thoroughly and tirelessly. "We had a three-month-long negotiation," Nina said. After extensive talks, usually over Sunday brunches, they agreed they would share the housework equally; he would wear a wedding ring (men in his family traditionally don't); she would keep her name; and they would have three children (he wanted five, she preferred one).

Nina, who loves New York, agreed to move to Texas in September, when the bridegroom begins a judicial clerkship there; he agreed to move back to the East Coast after a few years. They are still debating the subject of how they will educate their children.

"Nina thinks our children should go to private school, and I think they should go to public school," Javier said. "If we are progressive individuals who believe that public schools, public transportation, streets and utilities should be available to everyone at an adequate level, then we should make that commitment by sending our kids to public school."

On May 20, they were married in an English-Spanish ceremony at Our Lady of Lourdes Church in Washington Heights. Afterward, 125 guests gathered at Landmark on the Park, a Unitarian church on the Upper West Side. The space was rearranged for the reception, with tables set up among the stained-glass windows and statues of saints; the altar was cleared to make room for a mariachi band.

Although the bride and bridegroom are committed to changing the status quo and rewriting laws of all kinds, they had a conventional wedding. They did not rewrite or reword the vows. And while they seem like the sort of couple who would take public transportation to their reception, they arrived in a stretch white limousine, surrounded by bridesmaids in pink gowns and ushers in black tie. "Nina worked hard to make the wedding a fantasy for a day," said Gammy Miller, an artist among the guests. "Tomorrow, it's back to real life."

Laura Colin *and* Marc Klein

MARCH 27, 1993

"It was like a
wedding out of
an Edith
Wharton novel,
even down to
the lilies."

"What we really wanted to do was go to Las Vegas and rent a pink Cadillac and find the Elvis Chapel, but we both realized our parents would never talk to us after that," Marc Klein said several days before his wedding.

Marc, twenty-nine, a freelance advertising art director, and Laura Colin, also twenty-nine and a community coordinator for the Teen Outreach Program at the Association of Junior Leagues in New York, met at Harvard University (class of '87). As it turned out, their wedding was nothing like eloping to Vegas in a pink Cadillac.

Instead, it was an ode to New York City—the bride's hometown, passionate interest and permanent address. The bridegroom comes from an outdoorsy family, but the bride and her family are much more comfortable around chrome skyscrapers than redwoods and black bears. Bill Green, the bride's uncle, is a former congressman from New York. Her sister, Ann Colin Herbst, is writing a novel set in Manhattan, and her brother-in-law, Peter Herbst, is the managing editor of *New York* magazine.

The couple was married on March 26 in a civil ceremony at the Old-World Upper East Side town house belonging to the bride's mother, Cynthia Green Colin. The bride, afraid of tripping down the spiral staircase, arrived at the parlor ceremony from the town house's small elevator. Two days before, her office-mate had told her about a woman who was married outdoors and tripped into a hole while walking across the lawn. "That was the story that really scared Laura," said her sister, Ms. Herbst, adding that it sounded like a story John Cheever would have entitled "The Bride Who Fell into a Hole."

The couple took their vows before fifteen guests while standing near a large oil painting depicting two lovers surrounded by birds, clouds and angels. "It was like a wedding out of an Edith Wharton novel, even down to the lilies,"

said Rafe Greenlee, a friend of the couple from Harvard.

"It had the feeling of a piano recital in *A Room with a View,*" added John Dolan, the photographer who shot the wedding.

The next night, 180 guests attended a dinner reception in the Rainbow Room's Pegasus Suite, a sleek Art Deco ballroom on the sixty-fourth floor of the G.E. Building, where the elevator ride is so long, it verges on air travel.

The dinner tables were decorated with handblown glass candlesticks in the shape of calla lilies, and from their seats, guests could see the city of New York as only pilots, Batman and window cleaners can.

While the bride is happiest when surrounded by a galaxy of city lights, the bridegroom and his family are mountain climbers, sailors and back-country campers. The bridegroom's father, Dr. Cornelus Klein, is a geology professor at the University of New Mexico and can often be found in remote, out-of-the-way geological sites; his sister, Stephanie Peponis, is a long-distance runner. Marc even proposed to Laura in the middle of the wilderness, while on a rafting trip in Idaho. Standing in the Pegasus Suite overlooking Manhattan, a city she rarely leaves, the bride said, "This whole wedding is my reward for going white-river rafting."

Heather Drewes *and*
Richard Feldman MARCH 25, 1995

"You have to remember to slow yourself down and have sushi with your boyfriend and rent a movie and pet the cat."

Heather Drewes, a twenty-nine-year-old fashion editor who has worked at *Harper's Bazaar* and *Mirabella* and is now at *Glamour* magazine, looks like a model from the 1950s. She is buxom rather than rail-thin, her hair is platinum blond à la Marilyn Monroe and her skin is as milky white as bobby socks.

Among friends, she is known for her "foot-long eyelashes," as one put it; her habit of wearing gloves and carrying a big umbrella to protect her skin on the beach; and her level-headed presence in a business filled with flamboyant personalities.

"It's such a giddy, crazy world we're in," said Helen Roberts, a friend of the bride who used to work as an accessories editor at *Mirabella*. "You have meetings to talk about whether black and white is over or if red is important for this month."

She added, "Generally, there are two types of fashion editors. There are the ones who live, breathe and die fashion, and those people who go home and have a life. Heather is the second type."

Like many women in the fashion business, the bride lived and shopped exclusively in SoHo and rarely dated anyone above Fourteenth Street, until friends introduced her to Richard Feldman, thirty-six. He is a boisterous, athletic stock trader who lived far from stylish SoHo on the Upper West Side in an apartment decorated with baseball caps hanging on the walls.

"All of the guys I used to date were artsy, groovy guys who lived in the East Village," Heather said. "Not many people in my group had a full-time steady job. Rich was different. At first I thought, 'Oh, my God, he's older than me; he has a stable job; he opens the door for me; he's a gentleman. I'm going to turn into a housewife from hell in four months.' So I ran off to Chicago one weekend to get a tattoo because I thought it was the last time I could be crazy."

The couple recently moved into a loft in TriBeCa, where they laugh a lot together on the futon, the one piece of furniture they own so far. "You have to work extra hard in our industry to keep relationships real, because so much of the other stuff is fantasy," said Lisa Silvera, a fashion and beauty advertising executive and an old friend of the bride. "You have to remember to slow yourself down and have sushi with your boyfriend and rent a movie and pet the cat. Heather and Rich go to Knicks games and howl and scream."

While the couple hangs around the futon most weekends, their wedding on March 25 contained as much fantasy as a Ralph Lauren runway show. They were married at Oheka, a French château in Cold Spring Hills, Long Island, that once belonged to Otto Kahn, the railroad baron.

The guests wore black tie and strolled from room to room—the château has 130 in all. In one, cognac and cigars were served; another was filled with desserts—about forty different tall cakes, each on its own stand, like elaborate hats in a milliner's shop.

The bride looked like a nineties version of Guinevere in an off-white dress that had sheer sleeves, a high waistline made of gold antique ribbon and a square plunging neckline for the "medieval wench look," as Heather put it.

While historical in style, the dress had a modern spirit. "To me, the wedding was about the essence of being a woman," Ms. Silvera said. "It took place in a castle and Heather looked like a princess. Women in fashion nowadays are not walking around in clunky, scary deconstructed clothing. We are celebrating our breasts and our waists and our hips and our eyebrows and our ability to walk in high-heeled shoes. We're finally realizing that being a woman is a privilege."

Kate Connelly *and* Bobby Flay OCTOBER 1, 1995

Kate Connelly, thirty-one, was the cohost of *Robin Leach Talking Food,* a live, quirky show that ran on the Television Food Network until September 1995. Guests on the show included everyone from sophisticated sommeliers to a lady who collects refrigerator magnets to a man who eats glass. Kate often cooked on the air, gamely coping with mishaps like hollandaise sauce that wouldn't thicken or champagne corks that bounced around the studio like Super Balls.

"You name it, I did it wrong," said Kate, who is currently developing a new food show with Mr. Leach. "Once, I didn't put the top on the blender and turned it on—*live.* Everything splattered all over the place—all over me, all over the kitchen—and you can't stop. You just have to go 'Ha-ha-ha,' wipe your face and keep going."

She met Bobby Flay, who is thirty and the chef of Bolo and Mesa Grill restaurants in Manhattan, when he was a guest on the show in January 1995. At the time, he was divorced and living in an apartment with white furniture, white carpets and modern art on the walls; she was a single mother whose apartment was decorated with the kinds of rugs and chairs that camouflage peanut-butter-and-jelly stains. Most of the art on the walls was done by her son, Jonathan, who is now nine.

"For both, there was an instant attraction, yet instant danger signals," said Mr. Leach, a close confidant of the

> "If there's anyone here who knows a reason why this couple should not be married, and I can't imagine there could be, step to the back and be quiet."

bride. "She was warned that he was a real bachelor, and he realized he met the woman he was going to give up bachelorhood for."

Soon after the show, Bobby invited Kate to have dinner with him at the Monkey Bar in Manhattan, and Kate still has the note she left for the baby-sitter the night they went out. "It said, 'I'll be gone two hours, tops,' and I underlined *tops*," she recalled. "I got home four and a half hours later. I've never had such a good time in my life on a date, ever, ever, ever. I don't remember what I ate. There was always something to talk about. He was funny. It was the easiest thing in the world."

Bobby recalled, "I was completely attracted to her, but she wasn't just another beautiful woman. She was a single mother with an eight-year-old son, and I thought, 'Wow, that's an accomplishment.'"

Just a few months later, he gave her an engagement ring as casually as if he were handing her a glass of wine. "Kate is not a 'Take me to the River Café, get down on one knee and tell me how much you love me' type," he said. "She thinks I'm corny as it is, so I wasn't going to give her any more fuel."

They married on October 1 at Bolo in a ceremony officiated by Kristin Booth Glen, dean of City University Law School in Queens. She began the ceremony by saying, "This will be short and sweet, unlike their courtship, which was short and hot." She told the ninety or so guests, "If there is anyone here who knows a reason why this couple should not be married, and I can't imagine there could be, step to the back and be quiet."

During the ceremony, the bridegroom was surrounded by several male buddies, including the ponytailed chef Mario Batali of Po restaurant in Greenwich Village and Tom Valenti of Cascabel in SoHo. "We didn't do the bachelor-party thing for Bobby," said Mario. "We all feel we've had a long bachelor party already."

There was a spicy southwestern wedding feast afterward, with guests sitting at tables throughout the restaurant, where the wallpaper looks like a collage of newsprint cutouts and sparkly Christmas wrapping paper. The whole tone of the night was colorful and spunky, much like the bridegroom himself, who has a pioneering, daring attitude about everything from cooking to love.

When asked how he felt about becoming a new stepfather as well as a husband, he replied, "It's a complicated situation and the odds are against us, but that's what's great about it. If there's no challenge, why do it?"

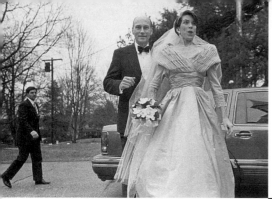

Melissa Burtt *and* Allan Smith

DECEMBER 19, 1992

"The proposal
is the start
of the process
and it should
be the most
exciting time."

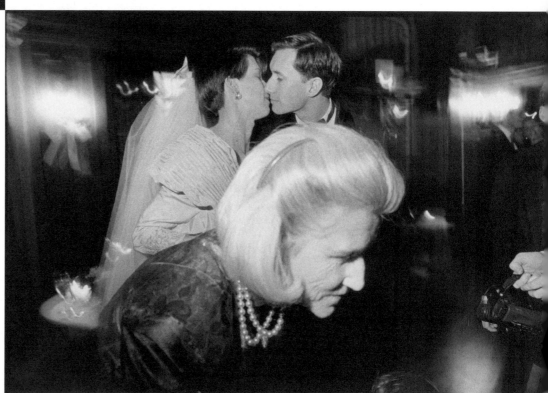

Allan Smith, Jr., planned his proposal to Melissa Burtt for months. A daylong adventure, it involved mysterious envelopes, tickets to the opera, a bit of foreshadowing (that morning, he gave her a new silk handkerchief that was decorated with champagne bottles) and dinner at Café des Artistes on the Upper West Side. After the meal, instead of dessert, the waiter brought Melissa a diamond ring on a silver tray.

"The proposal is the start of the process, and it should be the most exciting time, because after that you're burdened with a lot of preparation and decision making," said Allan, the manager of corporate communications for Designtex in New York. "We laugh because it was election year, and every time we turned on the television, it said, '1992: The Year of the Decision.'"

Deciding when to get married was easy. Both Melissa, who is twenty-four and has a big Julia Roberts–like smile, and Allan, twenty-five, wanted to get married at Christmastime. It is a favorite holiday for their families. Each year, the bridegroom's father, Allan Smith, Sr., draws an elaborate blueprint for the family's Christmas tree, detailing the exact positions of more than one thousand lights. He draws for days and days—the lights are configured differently each year—while listening to Barbra Streisand albums for inspiration.

Christmas weddings run in the Burtt family. The bride's older brother, Forbes Burtt, was married on December 27, 1986, in a small waterfront chapel in Florida, with waves lapping at the steps. "Why marry in May?" asked his wife, Cynthia Burtt, who had to be carried into the chapel to avoid getting her dress wet. "Why June? Christmas is a time when everybody gets together."

On December 19, Melissa and Allan were married in New Canaan, Connecticut, in the Congregational Church, a simple white building with beet-red carpets, wooden benches and evergreen wreaths lining the walls. The best man, Daniel Baker, described the wedding as "nouveau traditional," a mix of the 1990s and Emily Post.

Melissa, who works in the advertising department of *Interior Design* magazine in New York, wore her mother's late 1950s peau de soie wedding gown, redesigned with a stole-like neckline. Although the couple took traditional Protestant vows, they also wrote their own vows and read them to each other in a private ceremony a week earlier. Allan, a serious cook and herb gardener, was given a bachelor party that was more like a traditional bridal shower—friends gave him kitchen utensils as presents. "They step out of standard gender roles," said one older guest at their wedding. "In my generation, it was 'Bring me the slippers.'"

The 150 guests drove up a long driveway to the reception at Waveny House, a Jacobean mansion in New Canaan that on their wedding night looked like a hunting lodge decorated for Christmas. In the wood-paneled rooms inside, fires glowed in the marble fireplaces and it smelled of pine cones and evergreen. Several guests in tuxedos leaned against the walls, smoking cigars and looking as though they belonged in a 1950s wedding album.

Kathleen Smith, the bridegroom's mother, gave the couple a fitting wedding present—a large box of Christmas tree ornaments she had collected for Allan over the years. Wrapped carefully in tissues, they were like charms on a charm bracelet; each had a little story that went with it.

"The year Allan got his first tuxedo, I bought him a man-in-a-tuxedo ornament," she said. "The next year he had his first date, so I got him a lady in this red dress with feathers. She looked like she was stepping out of *Mame*. Last year, I bought an angel from a man who hand-carves ornaments. I thought the angel would watch over them as they go through married life."

Elizabeth King *and*
Paul Farrell FEBRUARY 17, 1996

"Elizabeth was born
a century too late.
She loves all
that Old-World
graciousness."

E lizabeth King, thirty-six, can make topiaries, vinegars or petit fours that look like Wedgwood china as easily as others make instant coffee. She's the cook, hostess, designer and part-owner of King's Carriage House, a four-room restaurant in a former carriage house on Eighty-second Street near Second Avenue in Manhattan.

The restaurant, which opened in 1995, is modeled after an Irish manor house and filled with antique wooden furniture, tartan curtains, murals of hunt scenes and shiny silver teapots. The perpetual feeling there, even on a sunny June day, is that it's raining outside and wonderful to be inside sitting around the fire or eating tea sandwiches in the Hunt Room upstairs.

The decor was inspired mainly by Elizabeth's love life. Seven years ago, while she was traveling through Ireland, friends introduced her to Paul Farrell, who is now thirty-seven. A Dublin native, he plays rugby, laughs easily and told friends the first night he met Elizabeth that they were going to marry one day.

Whenever she visited him over the years, they would drive around the countryside, never with a map or a plan, but always with one of Elizabeth's beautifully packed picnics in the trunk. They would stop whenever possible in manor houses to sip tea or port by the fire, in rooms filled with gilded portraits, old overstuffed couches and flowers in silver vases.

"Elizabeth was born a century too late," said Ursula Lowerre, a friend. "She loves all that Old-World graciousness."

Paul, who moved to New York to help run the restaurant, proposed last July— to Elizabeth's mother, Shirley, in the sitting room of the carriage house. Shirley King, who had been anticipating the couple's engagement for years, accepted, then called out to her daughter, who was in another room, "He proposed! He proposed!"

"To this day, he's never asked me," said the bride.

The couple was married on February 17 at Saint Ignatius Loyola Church on the Upper East Side, in a Roman Catholic ceremony one guest described as "the most aesthetically pleasing wedding I've ever attended."

The wedding procession began with six flower girls, all holding ropes of mountain laurel, heather and white lilacs. The first two girls wore green velvet dresses with lacy pantaloons showing; the next two wore blue velvet dresses; and the last two wore white shirts, black velvet vests and tartan taffeta skirts. They looked like young guests walking into a Christmas party in a Jane Austen novel.

"I brought a bag of Twizzlers and M&M's to lure them up the aisle, like Hansel and Gretel," said Dede Fratt, whose daughter, Isabel, three, was a flower girl.

The reception was held at the Junior League of New York building on East Eightieth Street, where bagpipers met guests at the entryway and violinists serenaded them up to a tea dance on the second floor. The female guests were given hand-lettered paper dance cards with satin ribbons so that they could tether them to their wrists.

Downstairs, in a wood-paneled room, there was the sort of buffet you might find in an Irish country house after a long day of fox hunting. The table was decorated with many of the bride's silver candelabra and platters of everything from poached salmon to rabbit to ginger sausage, pheasant pot pie and Irish lamb stew.

As Elizabeth does for every party she gives, she spent weeks cooking, polishing and shopping for unusual table decorations.

When Mrs. Lowerre's twelve-year-old daughter Lavinia, a tartaned flower girl, was asked if she wanted to be a bride someday, she exclaimed, "Yes! And I want to do it myself, like Liz. If I hadn't been to her wedding, I'd get a really nice cake maker and someone to do the flowers. But now I know the perfect wedding comes from your own heart and your own working and your own doing."

Jennifer Loring Cook *and*
Rudy Vavra MAY 14, 1994

When Rudy
pulled up to
give Jennifer
a ride home,
one former
classmate said,
"Jenny, your
knight in
shining armor
has arrived."

Jennifer Loring Cook, an editor at *Glamour* magazine, was the prom queen of the class of 1969 at Hastings High School in Hastings-on-Hudson, New York. She wore pleated skirts and sweet button-down sweaters and was always with her boyfriend, which seriously disappointed Rudy Vavra, one of the shyer members of the class of '69, who had always admired her from afar.

Five years ago, the two met again at their twentieth high school reunion. "We literally arrived at the front door at the same time," said Rudy, a painter who is now forty-three and lives in TriBeCa. "I put my hand on the doorknob and said, 'Hi, I'm Rudy Vavra,' and Jenny said, 'Who?'"

She looked the way he had always remembered her, but she didn't recognize him at all. "He was six feet three, and he had been much shorter in high school," said Jennifer, now forty-two. "He had become this really tall, thin guy." At the reunion, he got an award for being the most changed person in the class.

While Jennifer had attended the reunion partly to catch up with her old high school sweetheart, she and Rudy ended up talking and dancing together for the entire evening. As happens at high school parties, almost everyone noticed—and whispered about—the obvious sparks between them. At the end of the evening, when Rudy pulled up in a beat-up, borrowed Volvo to give Jennifer a ride home, one former classmate of theirs said, "Jenny, your knight in shining armor has arrived."

When they decided to marry, Rudy, who is known for his large abstract landscape paintings, which often have real rocks hanging from them, decided to approach the wedding as he would a new work of art. He took six months off to concentrate exclusively on it and made everything by hand. Working together in their TriBeCa loft, the couple put together thick wedding booklets for the guests that were like pamphlets accompanying a major art show. Each booklet was held closed by a rice-paper seal and included a postcard of the church, a reproduction of the bride's favorite Pompeian fresco, reprints of the hallmarks on their antique wedding rings and the entire ceremony, word-for-word.

They even made an aesthetic composition out of the stamps on the invitations. "There was a row of postage stamps: a trout, an American Indian, Hank Williams," said Leonard Porter, a painter and friend of the bridegroom. "You could tell Rudy went to several post offices. And the colors were chosen precisely. Everything in the wedding is like that."

The ceremony took place on May 14 in lower Manhattan at Saint Paul's Chapel, which the couple chose partly for its colorful interior—it brings to mind Easter eggs, or Miami architecture.

As bagpipers played, the bride arrived in a deep blue Morgane Le Fay gown with long sleeves that flared at the cuffs like calla lilies and a small, subdued train. "Kneeling there with all that shining blue drapery around her, she looked like paintings from the eighteenth century of the Annunciation of Mary," said Elizabeth Ellis, a guest.

At the reception at Two Eleven restaurant, even the wedding cake, made by Gail Watson, was decorated with works of art: antique hand-painted pewter statues that made a sly reference to the couple's love story. One statue depicted a princess, aglow and carrying a wand; the other, an admiring frog, before his transformation.

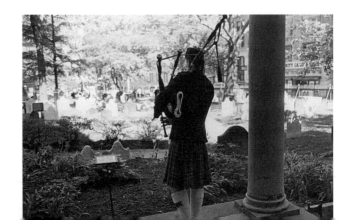

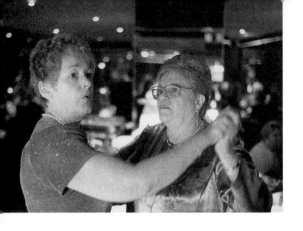

Martha Byrne *and* Michael McMahon NOVEMBER 12, 1994

"Michael got all of my jokes. I'd tell a joke and he'd laugh until he had tears in his eyes."

On the soap opera *As the World Turns*, Martha Byrne plays Lily Grimaldi, a young woman who wears Versace suits and tight-fitting gowns and is married to an Italian millionaire. She lives on a yacht but is about to move into an enormous mansion. Her emotional life is a disaster—she has two competing mothers (one biological and one adoptive) and a former true love who has suffered amnesia because of a car accident and now can't recognize her.

Off the set, Martha is anything but a troubled diva. She is twenty-four and drives a four-wheel-drive Toyota truck, wears jeans and work boots and often spends Saturday nights singing in an Irish pub with friends, few of whom are celebrities. And on November 12, she married someone who is not at all a show biz type—Michael McMahon, a twenty-seven-year-old New York City police officer.

Michael's job is as relentlessly dramatic as the story line of a soap opera. A member of the NYPD's undercover street-crime unit, he spends his days patrolling the Times Square neighborhood, dressed as everything from a construction worker to a hapless tourist. He recently chased a robber down Eighth Avenue whom he later described as a Santa Claus look-alike—the robber was wearing a ski mask and carrying an enormous sack of stolen merchandise. He was also shooting at Michael with a semiautomatic rifle.

Martha and Michael were introduced by friends in a pub one night about two years ago. "Michael got all of my jokes," she recalled. "I'd tell a joke and he'd laugh until he had tears in his eyes. He really, honestly thought I was funny, and it was great. Performers need that."

They were married at Saint Luke's Roman Catholic Church in Ho-Ho-Kus, New Jersey. An entire pew in the church was filled with *As the World Turns* cast members, many of them wearing bright red outfits and talking about the match between a soap opera actress and a police officer.

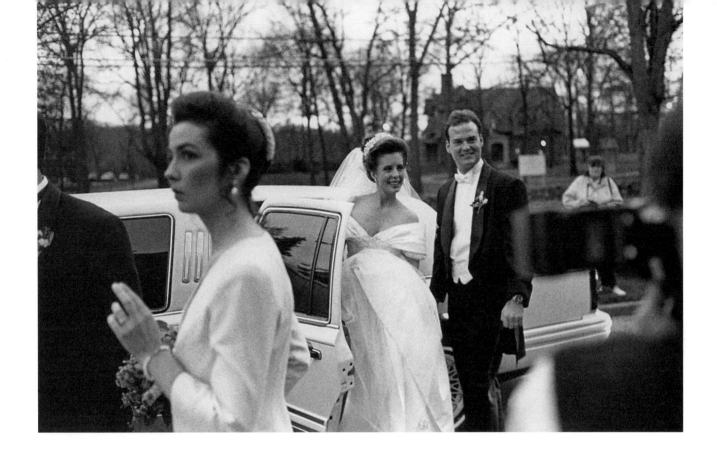

Elizabeth Hubbard, who plays Lily's *adoptive* mother on the show, said, "The obvious question a surrogate mother would ask is: 'He's a cop—have you talked about that?' It's a frightening, dangerous business. But I think they'll make it together. Any policeman comes home with a buildup of emotions and residue from the day, and that's what an actor thrives on."

Other guests noted that the couple seem much older than their ages, not at all the stereotypically conflicted Generation X couple who stay up all night struggling with their relationship as if it were a difficult math problem. Instead, Martha and Michael were both eager to make the commitment and spend Saturday nights cooking, talking and singing Irish ballads in their suburban kitchen.

Allison Smith, an actress and an old friend of the bride, described Martha as an anomaly among young people in soap operas, television and movies today. "More so than a lot of our peers, Martha has been able to balance everything," Allison said. "She hasn't gone off the deep end in any way. She's not a girl who has a boyfriend and no career or a girl with a great career and no one who cares about her. She has an incredible relationship with her family and really close friends, and she's one of the leading ladies of daytime, and she has Michael. She really hasn't sacrificed any side of herself."

Elizabeth Hubbard described the couple as two down-to-earth people with down-to-earth expectations of married life. "They know marriage is not all a blast and a party and sleeping in heart-shaped beds," she said. "Marriage is like a ball of wool you throw out into the world and you follow it."

Terri Cousar *and*
Ed Shockley MAY 27, 1994

"She's starting
on a new
journey, and
may the
first steps of
her journey
be blessed."

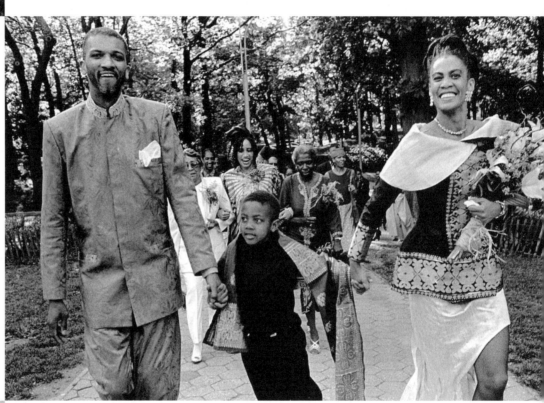

Ten years ago, Terri Cousar met Ed Shockley when they were platonic roommates in a large, old apartment across the street from the Brooklyn Museum. Although he had a crush on her from the moment he moved in, he never let it show.

"Having an affair with a roommate is like being married," said Ed, a playwright who is now thirty-seven. "It's very complicated. And also, if it breaks up, you have to move."

Terri, now forty-two, had just joined Urban Bush Women, a New York troupe of African-American dancers whose performances deal with everything from homelessness to girl talk. The dancers move, as if possessed by ancestral spirits, to traditional West African and Caribbean drumming and chants. Terri, as graceful onstage as a weeping willow tree in the breeze, retired from the company in mid-May, just after its tenth anniversary party.

Ed, who now lives in his hometown, Philadelphia, recently won a New Writers Project award from HBO for *Liar's Contest*, a three-character play about a sharecropper, a moonshiner and the Devil. "I see artists as being priests, which is clearly the way it was in other centuries," he said. "I'm trying to examine the world, hold up a mirror to society, get people to examine their lives."

He waited till he moved out of the apartment five years ago to tell Terri he was in love with her, blurting it out one night when they met for a casual dinner to catch up on each other's lives. "I thought he was just being crazy," she remembered. "I said: 'It's a full moon. I don't know what you're talking about.'"

A few weeks later, the full moon had passed but she found herself thinking about Ed all the time—when she woke up, while riding the subway, during rehearsals—so she wrote him a long letter saying maybe he wasn't so crazy after all.

On May 27, they were married in the woods of Prospect Park in Brooklyn before ninety guests in a spiritual, homemade ceremony inspired by African wedding traditions. Their colorful silk outfits, based on royal African wedding clothes, were designed by a friend, Wunmi Olaiya, who grew up in Nigeria.

Ed was escorted to the ceremony by his six-year-old son, Brandon, followed by the bride, who was accompanied by a banjo player. Before she arrived, several of her female friends formed an aisle for her to walk down. Standing in parallel lines, they wore everything from black leather pants to a canary-yellow gown to red bell-bottoms and construction boots.

As the bride walked between the women, each knelt and placed a small piece of African cloth on the ground for her to step on; by the time she reached the bridegroom, the makeshift aisle looked like a long patchwork quilt behind her. "I felt like she's starting a new journey, and may the first steps of her journey be blessed," said Treva Offut, a dancer.

As the wind blew through the trees, the couple married in a ceremony that they wrote, orchestrated and officiated themselves. They burned sage incense and passed around a conch shell, asking guests to speak into it, as if their words and wishes for the couple would be trapped there forever, like the sound of the ocean. Afterward, the guests escorted the bride and bridegroom to a reception at the Prospect Park Picnic House, a red brick pavilion on a hilltop. As they followed a path through the woods, the guests sang, waved sunflowers, played drums and shook tambourines around the newlyweds' heads.

"They gave themselves license to remake the wedding ritual," said one guest, Marlies Yearby, a founder of the Movin' Spirits Dance Theater in New York. "That's very important to who we are as African Americans, because we constantly have to remake and reinvent our culture."

Kyoko Miyamoto *and*
Tariq Mundiya MAY 6, 1995

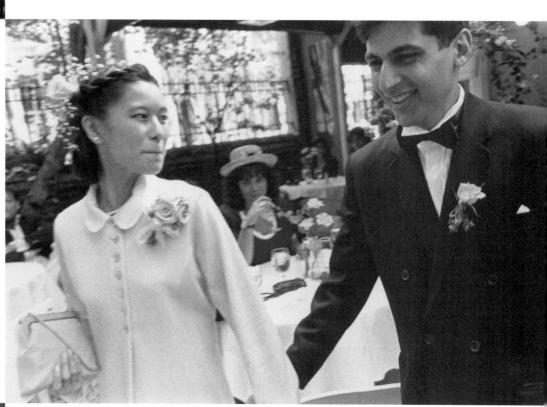

"We were the
only two people
on the elevator.
It was complete
silence. It was
basically me
staring at her."

Kyoko Miyamoto, a classically trained violinist and a Japanese language instructor and translator in New York, grew up in Tokyo, where romance is often as formal as the gardens.

Many of her friends there entered arranged marriages, but her meeting with Tariq Mundiya was as lucky and unexpected as finding a penny heads-up on the sidewalk. One stormy night two years ago, she met him by chance in an elevator in a Wall Street office building.

"We were the only two people in the elevator," recalled Tariq, a lawyer at Sullivan & Cromwell in New York. "It was complete silence. It was just basically me staring at her. I was thinking: 'I've got to ask this lady out. She's very beautiful.' I figured there's only a limited amount of time. These things happen very quickly, and if you miss the moment, you've missed it."

After they got off the elevator, she waited outside under her umbrella for a cab while he stood beside her, without an umbrella, trying to persuade her to walk to the subway station with him. "No cabs came, so eventually she agreed," he said. "She said, 'Would you like to share my umbrella?' And I said, 'That's what I've been waiting for.'"

Tariq, whose family moved from Pakistan to Yorkshire, England, in the early 1960s, added, "As foreigners do in New York, we talked about our respective immigration statuses. Then we talked about sushi. She gave me her business card, and the next day I called her up and said, 'Let's go out for that sushi we talked about.'"

To both, their meeting seemed like something that could happen only in New York City, where strangers often talk to one another and where there are lots of wandering eyes on subways, elevators and buses.

"If you go to Europe, there is no eye contact in elevators," Tariq said. "The same with trains. If you ride the subways or trains in London, virtually everybody has a book."

Kyoko, who played a Mendelssohn violin concerto for Tariq on one of their first dates, added that in Japan, even good friends do not have much eye contact. "If you stare at someone's face while talking, it is considered too aggressive," she said. "We are told the correct manner is to look at the knot of the tie."

The couple had an intercontinental wedding. First, they were married on April 27 in a traditional Muslim wedding in Karachi, Pakistan. At the end of that ceremony, which lasted all day, an entourage of family members and friends followed the couple to their hotel bridal suite. "They checked out the room as we sat there sheepishly," Tariq said. "It's a custom now that the relatives want to see where the marriage will be consummated."

A second wedding reception took place in New York on May 6 on the patio outside Grove, a restaurant in Greenwich Village. The bride wore a knee-length white wool overcoat with a satin underslip, a simple and serene outfit that completely camouflaged her—she looked like one of the guests rather than the bride.

Like the couple, several of the sixty or so people at the reception had met their significant others in unarranged, out-of-the-blue ways. David Schwartz, a labor lawyer in Washington and a friend of the bridegroom, met his wife in the basement of a college library while standing in front of a candy machine. "That proves junk food is good for you," he said.

Rima Fukita, a painter who wore a short lavender dress, black cropped sweater, green leather jacket, red wristwatch and fishnet stockings and stood out like a colorful bouquet of tulips, said she didn't believe in chance encounters. "Every time I see Kyoko, she wears traditional Indian outfits," she said. "She doesn't look weird in them. People think I'm nuts, but I believe in reincarnation and I believe she has a strong connection to India. I think that's why they met. Their meeting was not a coincidence. It was very karmic. They were meant to meet in an elevator."

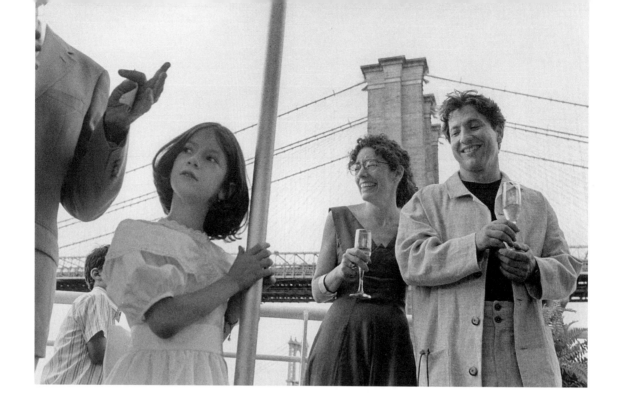

Robbin Silverberg *and* Andras Borocz

SEPTEMBER 4, 1995

Seven years ago, when Andras Borocz moved into a loft on Dobbin Street in Greenpoint, Brooklyn, he assumed very few people lived on his mostly industrial block. Andras, who is thirty-nine and grew up in Budapest, moved to New York City in 1987. He rented the Greenpoint loft so that he could have more space to work on his sculptures, which he makes out of everything from loaves of bread to wine corks, eggs and logs.

About two years after moving in, he began receiving art magazines addressed to Robbin Ami Silverberg. As it turned out, Robbin, a paper maker and book artist, lived on the same block in a converted horse stable tucked between the factories. They met when he knocked on her door to re-turn the magazines, and she invited him in.

To his surprise, Robbin's space was beautiful and serene, completely different from the scruffy streetscape. There was a courtyard that was reminiscent of Europe; a hayloft Robbin had converted into an apartment; and a working paper mill, where she made paper from scratch. He left with a mound of pink paper in his hand that looked like cotton candy.

Soon afterward, she visited him in his studio and was just as surprised at what lay behind his door. "He had just finished carving seventeen life-size figures called 'The Hanged,'" said Robbin, who is thirty-six. "These figures, which were made out of logs he collected in the park, were

"We worked together
so well, both of us thought,
'Why ruin it by
falling in love?'"

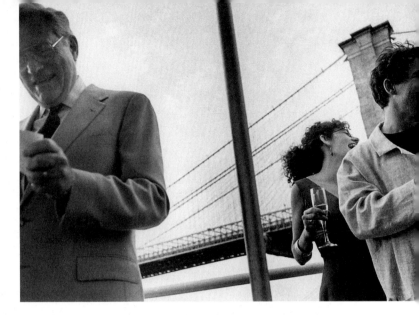

all hanging from nooses under the loft bed. My first thought was, 'I don't think I could ever sleep above those figures.'"

At that time, Andras spoke Hungarian and broken English, while Robbin, who grew up in Montreal and New York, was fluent in English, French and German but knew no Hungarian. Nevertheless, they managed to communicate. "There is a language we both understand very well—visual arts and the philosophy of art," said Andras.

Their romance began slowly and not at all intentionally. They collaborated on a few projects together, then they started eating meals together and, almost reluctantly, they became crazy about each other. Then, they tried to talk each other out of it.

"We worked together so well, both of us thought, 'Why ruin this by falling in love, which is so difficult?'" Robbin said.

As it turned out, falling in love was easier than they expected, and the couple now live together in the converted horse stable. Andras is currently working with pencils, which he carves into elaborate miniature figures. "He's a pencil man, and I'm a paper woman," Robbin said.

Pencils and paper were the theme of their Jewish wedding ceremony, which took place on September 4 at Bargemusic, a converted coffee barge tied up to a dock in Brooklyn. The couple collaborated on the brown paper *huppah*, which showed a life-size print of her hand next to one

of his. They looked like handprints young lovers might leave in snow or on a dusty car window.

The bride made the paper runner for the center aisle, which looked like a crosswalk at traffic intersection. It was striped with lines made of crushed eggshells, pencil lead and tea leaves, and meant to illustrate the couple's crossing into marriage.

Several of the ninety guests were artists and wore outfits that looked like dresses or suits that might be seen in the window of an art-as-clothing shop. The bride, who often works in a jumpsuit, wore a fancy iridescent blue one custom-made by Marianne Novobatzky, a Hungarian designer in SoHo. Ms. Novobatzky also made the bridegroom's high-waisted linen pants, with a matching jacket that had pockets big enough to carry paintbrushes.

One of the guests, Louise McCagg, a sculptor, described their romance as an offbeat version of the "girl meets boy next door" story. "It doesn't happen like that very often," she said, "especially on Dobbin Street, where everything is heavy industry and factories are grinding and thudding and crunching and groaning all day long. And here were two artists living side by side."

Paula Carleton *and* George Evans NOVEMBER 5, 1994

"He didn't have
a ring, so he
snatched a piece
of bread from the
bread basket and
jabbed a hole into
it and put it on my
finger."

66 For some reason, I always thought I'd marry an English guy," said Paula Carleton, an artist and fashion stylist who grew up in Boston. "I remember sitting around with my sister, reading English novels and listening to the Beatles and wanting to marry an Englishman. Actually, my favorite Beatle was George Harrison, so I guess I wanted to marry an English George."

When Paula, thirty-four, met George Evans, thirty-five, he seemed exactly like the man she had envisioned while reading Jane Austen. A mutual funds manager at the Oppenheimer Management Corporation in New York, George grew up in Lancashire, England, and graduated from Eton College and Oxford University. He is known for his polished wit, waistcoats, cuff links and manners.

"At Oxford, he threw great parties, and he was quite intellectual as well," said Nicholas Horsley, an old friend. "He was very much what we'd call 'a bright star.' He exemplified success in British terms: If it is to count at all, it must appear effortless."

Shortly after the couple met two and a half years ago at an art-show opening in Boston, Paula sat down with a friend in a café and sketched her wedding dress on a napkin. "Paula always knew she and George would be married, even if he didn't see it right away," said Hannah Grove, who introduced the two. "Men never do."

Although the couple now live on the Upper East Side of Manhattan, their life is in many ways very European. They often travel abroad, and always in an Old World style. Like nineteenth-century adventurers who dressed as elegantly for a safari as for the opera, they pack their suitcases with pin-striped suits, taffeta pants, mules and bow ties, whether they're headed to Monaco, where his family has a vacation house, or to the jungles of Costa Rica.

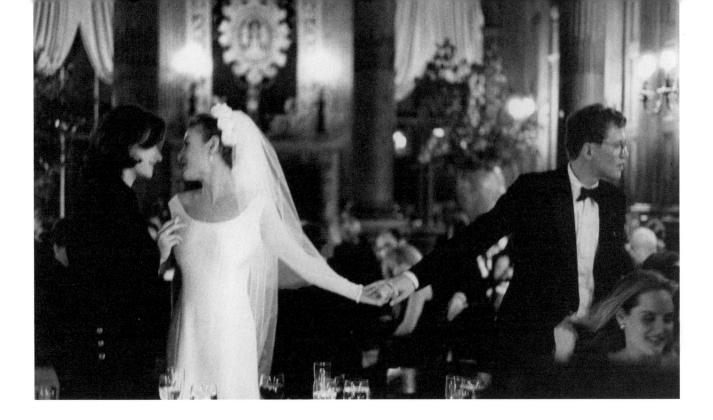

On July 5, George proposed over dinner at a small outdoor café on the Upper East Side. "I was filthy from painting all day long, and at one point he took a mighty swallow of wine and said he couldn't possibly live without me and would I marry him," Paula recalled. "He didn't have a ring, so he snatched a piece of bread from the bread basket and jabbed a hole into it and put it on my finger. I still have it wrapped up in a little napkin in our freezer. I'm terrified the cleaning lady will throw it out."

They were married before 190 guests on November 5 at the University Club in Manhattan, in a room with maroon brocade wallpaper, oil portraits in gilt frames and standing candelabra that looked like the sort of lighting fixtures you'd find in a haunted house. Paul Bott, a New York floral designer, decorated the candelabra with ropes of red roses that dripped to the ground like melted wax.

Hannah Grove, the only member of the bride's wedding party, complemented the Gothic mood in the room perfectly—she walked down the aisle wearing nearly black lipstick that she described as "very Elvira" and a tight-fitting scarlet dress.

The bride, who wore a white sheath gown with a scoop neck and flared hem, evoked the cool, poolside glamour of the actress Annette Bening posing for photographs. She looked the way people dream of looking when they put on sunglasses.

The newlyweds, who are spending their honeymoon in Thailand and have undoubtedly taken walks through the wilderness in formal wear, will be known as Mr. and Mrs. George Evans.

"I'm changing my name," said the bride. "It's very retro, I know. I just think it's so romantic. I wouldn't personally feel fully married otherwise, and I want us to feel as married as possible in the happiest of ways."

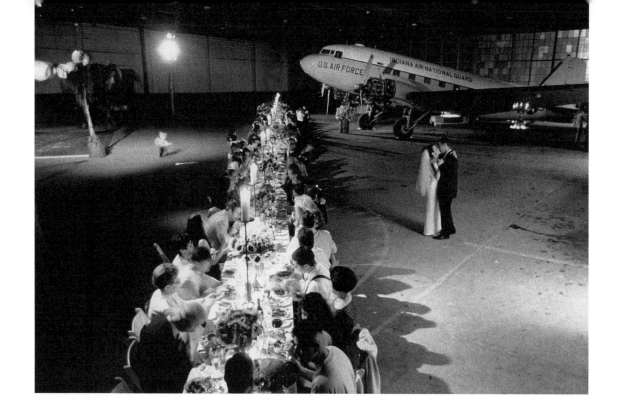

Cynthia Rowley *and* Bill Keenan MAY 11, 1996

Cynthia Rowley, thirty-seven, moved to New York City from Chicago fifteen years ago with a U-Haul truck, a sewing machine and an answering machine which featured the theme song from *The Patty Duke Show.*

She invited every important fashion editor in New York as well as Andy Warhol and a smattering of movie stars to her first show, though she knew none of them. More than one friend describes her as "pathologically optimistic."

She now has stores all over the country but treats success the way her idol, Lucille Ball, would—with humor, zaniness and plenty of superstition. Horseshoes hang upside down everywhere in her Manhattan showroom and she has been known to wear four-leaf clovers in her shoes during fashion shows.

A year ago, she met Bill Keenan, a store designer, when they were seated across from each other at a dinner party and spent the evening exchanging lines from *The Honeymooners* and *The Lucy Show.*

"A few minutes into the conversation, it was obvious we were on the same wavelength," said Mr. Keenan who is forty-three.

He sums up their shared worldview this way: "Death is serious, but everything else isn't."

Together, the two are as playful as her dresses, many of which could easily be worn with white go-go boots. They live in Ossining, New York, in a bungalow filled with toys, globes, a mirrored ball and an Elvis bust. A few days after moving in last December, Ms. Rowley nearly burned the

> "Bill and Cynthia are definitely
> more fun and whimsical
> than the average person.
> Maybe it's because when they
> were young, they had less oxygen."

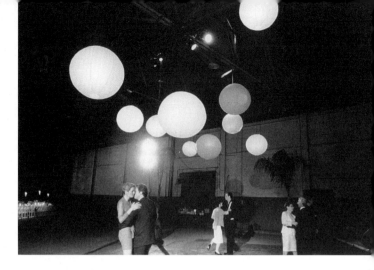

house down when she inadvertently lit a Christmas wreath on fire. "Oh, what a housewarming!" she said.

"Bill and Cynthia are definitely more fun and whimsical than the average person," said Beth Hutchens, an assistant designer with Ms. Rowley. "Maybe it's because when they were young, they had less oxygen."

On May 11, the couple were married in a courtroom at City Hall, where the 180 guests definitely stood out among the oil paintings of stern soldiers in uniform. There were guests with platinum hair and bald heads, wearing everything from slinky gowns to traditional Japanese robes. Chartreuse was the most popular color; there were chartreuse hush puppies, ties, bell bottoms and scarves.

While an accordionist played, the two bridesmaids walked in, wearing dresses designed by the bride, in the colors of Popsicles. Ilene Rosenzweig, the entertainment editor of *Allure* magazine, wore a pink sleeveless gown with an orange shawl and carried a blue purse filled with flowers; Laura Rowley, the other bridesmaid and a reporter for CNN, wore a mint-green gown and an ice-blue shawl and carried a hot pink purse.

The bride entered, wearing her signature bun and a white satin gown and looking happy, thin and almost exactly like Audrey Hepburn.

After Mayor Rudolph Giuliani officiated at a short ceremony, everyone boarded yellow school buses and rode to the reception inside Hangar Five at the Floyd Bennett Field in Brooklyn. The scene there looked like one out of *Casablanca*—it was raining and fog rolled around the deserted airfield, which is no longer in use.

Inside the hangar, where an old DC3 propeller plane is still parked, there were metal cans filled with tall sunflowers; paper Chinese lanterns hanging from the ceiling; and one enormously long dinner table with eighty seats on each side.

Nothing was symmetrical or serious in spirit. The seating cards looked like boarding passes, with directions on the back for folding them into paper airplanes; the napkin holders were giant plastic diamond rings; and the candlesticks on the dinner table were all of different heights—if you drew a line from one candle to the next, it would have looked like a cardiogram.

At one point, Ms. Rosenzweig stood by the bar smoking a cigar. Between puffs, she commented that a life-size DC3 was the perfect centerpiece for the couple's wedding. "Their romance happened very quickly," she said. "They fell in love, they knew it, they did it, they never looked back. They got into their own little airplane and took off."

Jane Katz *and*
Herbert L. Erlanger *April 28, 1996*

"We figured,
'Let's do it
while we're
still
ambulatory.'"

Dr. Jane Katz, a competitive long-distance fin and synchronized swimmer, grew up on the Lower East Side in the 1940s and 1950s. Even then, when most swimsuits were made of scratchy wool and young girls were told athletic activity could seriously harm their health, she spent almost all of her free time in public pools, racing the boys. She even swam in the wintertime, when icicles would form in her hair like hard candy.

"I'm a calamity Jane," said Dr. Katz, who holds a doctorate in gerontology. "I'm always klutzy on land but in the water I feel graceful and thinner and buoyant. As soon as I jump in the pool, everything's better."

Over the years, she has swum in almost every public pool in Manhattan (she calls them "ponds"), competed in races in the Hudson River, the Atlantic and Pacific oceans and lakes all over the world, and performed in synchronized swimming shows with canes between her toes and wearing a top hat.

Like a mermaid, she cannot stand to be out of the water for long—she swims at least twice a day and starts to feel homesick if she doesn't. In fact, she is known among friends for always wearing a bathing suit, even underneath formal gowns at black tie balls, just in case she comes across a body of water.

"When she came over to our house for dinner once, she found out we had a Jacuzzi and all of a sudden she was missing," said Tootsie Bjorklund, a friend. "We heard the Jacuzzi running and said, 'We know where she is.' She can't stay out of the water."

Kris Bjorklund, Tootsie's daughter, added, "She's the only dinner guest we ever had who took a bath between courses."

Dr. Katz met Dr. Herbert L. Erlanger in 1968 at the Brown Jug, an Upper East Side bar where she liked to play darts. They do not look alike—she is muscular, with broad swimmer's shoulders while he is tall and reedy and thin—but they call themselves "psychological look-alikes."

He is an attending anesthesiologist at New York Hospital–Cornell Medical Center and like her, he's playful, forgetful, interested in healing and sometimes silly. While he is seventy and she is fifty-two, both are perfectly willing to arrive at parties in neon yellow flippers. They describe themselves as kids who are sometimes "hard of thinking," as the bride put it.

"They're both oddballs, screwballs with a terrific sense of humor," said Holly Knight, the bridegroom's daughter from an early marriage. "They're kind of klutzy in a funny, cute way. They came up to see us in Connecticut and they fell asleep on the train and missed the stop. It's like the blind leading the blind."

While they dated for the last twenty-eight years, neither felt ready to marry until recently. "We figured, 'Let's do it while we're still ambulatory,'" said Dr. Katz.

During their wedding last Sunday evening at Tavern on the Green, they were especially playful. While about 175 guests watched, the couple took their vows on an outdoor terrace, under a *huppah* that was fashioned out of four fake palm trees and looked like it belonged in a Gidget movie. The bride wore a mermaid-shaped gown with a matching jacket and something blue—a pair of Speedo swimming goggles—for good luck while walking down the aisle.

Afterward, guests gathered for dinner at tables decorated with piles of aquatic presents—plastic fish, wind-up jumping frogs, sailor hats, sunglasses, palm tree pens, cans of pineapple juice and beach balls. Before long, the dance floor looked like a scene at the beach—guests were doing the twist in purple leis and sunglasses, or throwing beach balls at each other, while the bride ran around with a miniature white life raft on her head like a halo.

When reached during their honeymoon at the Peninsula Hotel in Manhattan, Dr. Katz said they were spending their time the way they love to—swimming, sitting in the Jacuzzi together and "just holding hands and being kids."

Melissa Richard *and*
Frank J. Oteri MAY 26, 1996

It was a cross
between a
walking tour of
Manhattan, a
piece of
performance art
and street
nuptials.

One guest at Melissa Richard and Frank J. Oteri's wedding wore a T-shirt that perfectly suited the occasion: On the back, it read "KEEP IT WILD."

Friends describe Ms. Richard, twenty-eight, and Mr. Oteri, thirty-two, as the sort of people who wouldn't have it otherwise. Mr. Oteri grew up in Manhattan and is the lead singer in the bluegrass band, the String Messengers, as well as a fiction writer, a poet and an avant-garde classical composer.

"Frank is a true New Yorker," said Michael Torke, a musician and a friend. "He's eccentric, he's creative, he walks everywhere."

Mr. Oteri met Melissa Richard over a year ago when a mutual friend brought her to a jam session with the String Messengers. Ms. Richard is an artist who grew up in Georgia and Alabama, never dressed conventionally and recently graduated from the School of Visual Arts in Manhattan with an M.F.A.

The night they met, the two didn't make plans to see each other again but over the next several weeks, they repeatedly ran into each other—on a #1 subway train, on the sidewalk outside the New York Public Library on Forty-second Street. The third time they crossed paths, on the corner of Fifty-seventh Street and Ninth Avenue, Mr. Oteri said, "We should make this official."

She invited him over for dinner and afterward, he recited several poems aloud, something he often does for friends. "I was smitten," she recalls. "He was smart and down-to-earth, musical, artistic, lots of things that interested me."

A few months later, while standing on the rooftop of the Dia Center for the Arts on West Twenty-second Street, she suggested they marry. "I was just fishing, but he said yes," she recalled.

The couple were married Sunday in a ceremony they called "A 7-Movement Wedding." It was a cross between a walking tour of Manhattan, a piece of performance art and street nuptials.

The ceremony began at 10:30 A.M., when about thirty guests met the bride and bridegroom in a coffee shop on Fifty-seventh Street and Ninth Avenue. From there, the informally dressed, spirited group wound through the city on foot, stopping at seven different locations chosen because they were important sites in the couple's romance.

Among the stops was Bryant Park on Fifth Avenue and Forty-second Street, where the couple once watched a movie in the rain together; a building on Thirteenth Street that the couple love, partly for its wacky name—The Great Building Crackup; and Dia Center for the Arts.

The group stopped for lunch at Kang Suh restaurant on Thirty-second Street near Fifth Avenue and everyone ate at one long table, blew bubbles and took pictures of each other, before moving on.

At each destination, Bettina Hubby, an installation artist who guided the ceremony, spoke about love and commitment and the couple recited a part of their vows. A few were completely nonsensical because, as the bridegroom said, there are aspects of love that can't be explained.

Throughout the day, all sorts of unplanned things happened. While walking down Fifth Avenue at one point, the wedding procession briefly merged with the Puerto Rican Parade, which also took place on Sunday.

"This is great," said Cybelle Paschke, a guest who is a student at Bennington College. "Everybody we come across is part of this wedding. It makes us feel more like a collective set of humanity rather than a couple of people going off with their best friends into a little church and keeping the fun to themselves."

The last stop was aboard the #1 subway train where the couple were pronounced man and wife by Esther Larsen, a nondenominational minister. They kissed, seven hours after the walking began.

Besides a lot of exercise, the wedding also contained moments of real eloquence, especially in some of the vows. In Bryant Park, the bride said to the bridegroom, "Of my own accord, I present myself, my days, my nights and my life. I present them freely and willingly because they cannot be better spent than in your company."

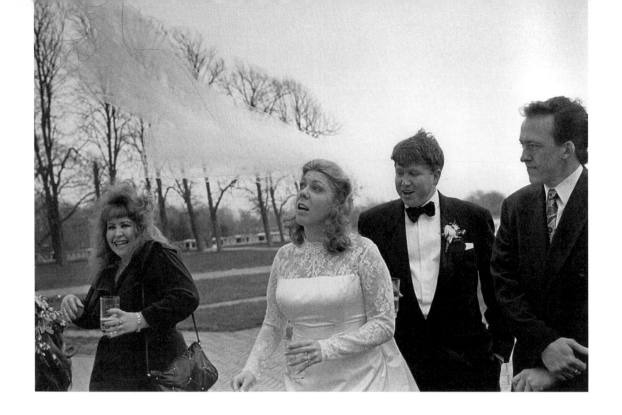

Heather Simson *and* Kevin Hanson APRIL 20, 1996

K evin Hanson, thirty-four, is the director of sales research at E!, the entertainment channel in New York. In his free time, he can sometimes be found surfing or skiing in blizzards with Myles Kleinfeld, one of his closest friends. "We're storm chasers, if you will," said Mr. Kleinfeld, who designs web sites for the Total Video Company in San Francisco. "We love a good snowstorm and a good hurricane."

Many agree that when Mr. Hanson met and fell in love with Heather Simson, he found his ultimate storm.

"Heather is a cheerleader, a good sport, a trooper and the life of the party," said Amy Drucker, a graphic artist in New York and college friend of the bride. "At the University of

Maine, hockey was a big deal and you could hear Heather at every game. She's definitely the funniest person I know. If I had to go to camp again, I'd want her in my bunk."

The couple met three years ago when both were working at PBS in New York, she in the fund-raising department and he in research. He noticed her for the same reason most people do—she was always talking.

"I immediately liked her," recalled Mr. Hanson. "She's a very outgoing, happy-go-lucky, cheerful, enthusiastic person. She told great stories about her adventures and travels; she's interested in politics. She's an American girl."

The bride, who is now twenty-eight and a freelance fund-raiser, had a bachelorette party that was like her personal-

"They are different seasons.
Heather is full of warmth
and wind and rain.
Kevin is like a breezeless,
calm summer day."

ity—a combination of fearsome and fun. It took place on the Upper East Side at a few different bars, mainly The Sand Bar and Polly Esther's.

The bride's best women friends made her a hat—an upside-down pink plastic flower pot with an enormous white flower taped to the side—that she was required to wear for the entire evening. She was also given a list of things she had to find or accomplish by the end of the party. It was like a cross between an urban survival course and a scavenger hunt.

"First, she had to go up to strangers in the bar and get people to sing the theme song from the Brady Bunch out loud, and she did," said Ms. Drucker. "Then she had to get a couple of people to buy her shots, and she did. We'd see her bright pink hat as she made her way through the bar. Heather's pushy, and I mean that as a compliment."

The couple were married on April 20 at Saint Luke's Lutheran Church in Babylon, Long Island. The bride and her two best friends, Kimberly Richardson and Kirsten Hamilton, rode in the limousine together, singing "We're going to the chapel" at the top of their lungs.

During the ceremony, the bridegroom was quiet and serene while the bride laughed and talked, to herself at times. "They are different seasons," said Mr. Kleinfeld.

"Heather is what spring is to the farmers—full of warmth and wind and rain. Kevin is the most even-keeled person I know. He's like a breezeless, calm summer day."

There was a reception afterward at the La Salle Center, a military school overlooking the ocean in Oakdale, Long Island. Inside the main redbrick building, which is available for parties, it looks like a bed and breakfast—there are different flowered wallpapers in each room, ornate fireplaces and unobstructed views of the ocean.

After cocktails, the entire wedding party was introduced as a band played in the dining room. When the newlyweds entered, the bride was screaming more excitedly than she does at hockey games. "And now," said the master of ceremonies, "the one bride who is louder than the band!"

Richard Sidler, one of the groomsmen, recalled, "When I met Heather I thought she was the perfect person for Kevin. She takes command. She has a very strong spirit. She's got that Long Island–New York personality and Kevin's got the West Coast free spirit, the I'll-yield-to-pedestrians spirit. He brings her insightfulness and sincerity, a yielding character, and she's the one who gives pedestrians the Bronx cheer and tells them to get out of the way."

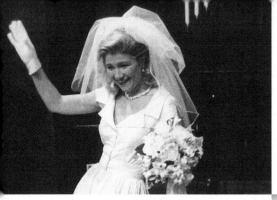

Cynthia Rhea *and* Harry Woods

SEPTEMBER 12, 1992

"We went out to lunch once, and I had to wear sunglasses the whole time because I was afraid of making eye contact. I was trying to be Mr. Noncommital."

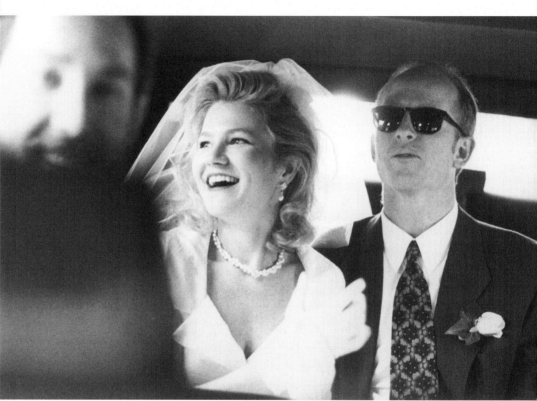

Cynthia Rhea, thirty years old, and Harry Woods, thirty-three, survived everything from a bicoastal courtship to several breakups, one so serious they burned each other's love letters.

"I threw his letters into the incinerator in my apartment building," Ms. Rhea said. "I thought, There, he's finally out of my life."

But soon, they were back in each other's lives. She coincidentally got a job at the same ad agency where he worked: TBWA Advertising in Manhattan. "We didn't talk for over a year in the office," Mr. Woods recalled. "In the hallways, we'd walk past each other and not know what to say. We went out to lunch once, and I had to wear sunglasses the whole time because I was afraid of making eye contact. I was trying to be Mr. Noncommittal."

At last year's Christmas party, they started talking again, and on Saturday afternoon, September 12, they walked down the aisle of the Fifth Avenue Presbyterian Church. The bride wore white gloves and a short white dress that Jacqueline Kennedy could have worn in the White House.

"She looked like a fifties' bride, very Princess Grace-ish," said Ms. Rhea's younger sister, Caroline Rhea, a comedienne. "Even her hair was retro. She wore it like an astronaut's wife from the sixties."

During the cake-and-cocktails reception at the Scott Alan Gallery in Soho, a jazz band played for the fifty-five wedding guests as they wandered around looking at the large abstract paintings on the walls. Several guests described what it was like to hold business meetings with the bride and bridegroom, both vice presidents at TBWA. Marianne Besch, an art director there, said. "In a recent meeting, Harry announced that they were coming back from their honeymoon a week early, and Cynthia kicked him under the table and said, 'We are? What honey?'"

Caroline Rhea sat near two pink-and-turquoise paintings and talked about being a bridesmaid (this was her eighth time), which is something she often spoofs in her comedy act. "Bridesmaids should be called wedding slaves," she said. "As Cynthia's wedding slave, I had to throw a shower for her. I had to make sure I didn't lose as much weight as her. I had to be nice to the husband-elect."

The bride added: "She took my ring to be steam-cleaned, which was frightening, considering the fact that she has no steady income. I was afraid she might melt it down."

The bride and her sister, who were roommates until the wedding, even had a message on their answering machine that said, "Hi, you've reached the home of Cynthia Rhea and her wedding slave."

Caroline added that she had began to have nightmares about being a bridesmaid forever. "Last night, I had a dream that I wasn't given my freedom back as a slave after the wedding," she said. "I thought I'd finally be emancipated but Cynthia said, 'No, I sold you to another bride.'"

Although many couples leave their wedding receptions early, Ms. Rhea and Mr. Woods stayed on with their guests. "I'm having a blast!" the bride said. "I'm not leaving until the fat lady sings."

Much later that night, Caroline Rhea performed her bridesmaid routine at the Manhattan comedy club Catch a Rising Star, with the newlyweds and several of their wedding guests in the audience. Wearing the same pearl necklace, pink lipstick and purple bridesmaid's dress she had worn for the wedding, Ms. Rhea walked onstage and began: "Do you like my dress?

"No wonder every bride is beautiful," she continued. "She's surrounded by eight women in the same hideous dress."

The next day, Mr. Woods reflected seriously on the marriage and the fact that it took place after he and the bride had been through various breakups and separations. "If you break something and use superglue on it, it's actually stronger," he said. "Scar tissue's tough."

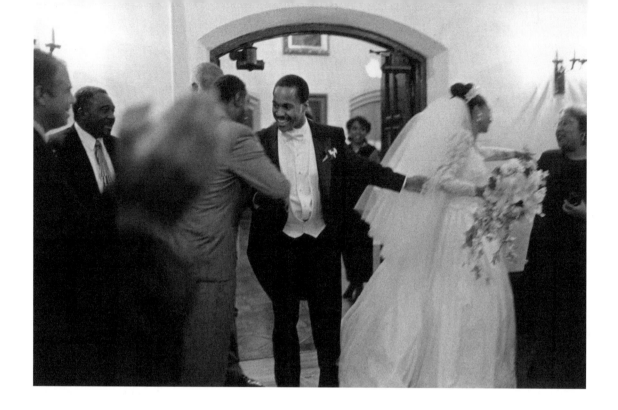

Alisa White *and* Joseph Holland OCTOBER 28, 1994

Alisa White, a correspondent for *American Journal,* a television newsmagazine, is athletic, spiritual, lady-like and often jet-lagged. (She covered the O. J. Simpson trial for the program, which is syndicated, commuting between New York and Los Angeles for the whole year.)

She never eats desserts. And when she has a problem, she often fasts and meditates until she feels clearer about it.

Until a friend introduced her to Joseph Holland last March, she had dated some men who took her out to dinner and described their oceanfront houses, powerful Porsches, celebrity friends and art collections. She wasn't impressed.

"It was important to me to find a man who was humble, who didn't drop names and talk about what he owned and whom he knew," said Ms. White, a graduate of San Fran-cisco State University. "I wanted to meet someone who let his life speak for itself."

By most accounts, there are few people as humble as Mr. Holland, who is the commissioner of the New York State Division of Housing and Community Renewal and the former co-chairman of Gov. George E. Pataki's election campaign. Friends describe Mr. Holland as a politician for the 1990s—quiet, community-oriented and so spiritual that he has an almost monklike presence.

An all-American football star at Cornell University and a graduate of Harvard Law School, he opened the Beth Hark Crisis Center thirteen years ago. It is a shelter for homeless, drug-addicted men in Harlem. Until recently, he lived there, eating meals and sleeping on cots in the same room

"It was important to me to find a man who was humble, who didn't drop names and talk about what he owned and who he knew."

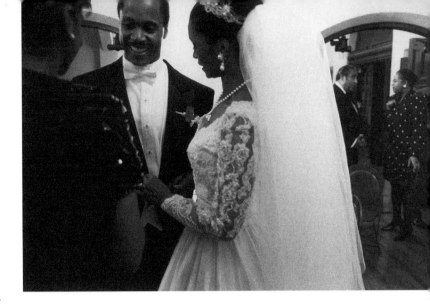

with the men. He even wrote a play about life in the shelter, *Home Grown*, which had a long run at the National Black Theatre in Harlem.

He also owns a travel agency and runs a Ben & Jerry's franchise in Harlem, where most of his employees are graduates of the shelter. "Joe is completely selfless," said Barbara Conroy, a friend and a producer for *Inside Edition*, the television program. "His father was an ambassador to Sweden; he's Cornell and Harvard educated. But he gave it all up to serve the homeless. How many people do we know who would do something like that?"

Ms. Conroy, who is also a friend of Ms. White's, introduced the couple. At her suggestion, Mr. Holland called Ms. White while she was working in Los Angeles, and for the next three weeks they often talked on the telephone about politics, religion, their families, race and Harlem.

When they finally were to meet in person, Ms. White was so nervous she was afraid to open the door. Mr. Holland was not at all apprehensive. "There was a peace and a calm about meeting this woman," he said. "I'd already felt the connection over the phone."

The two are very similar. They are in their mid-thirties and both run, mountain-bike, golf and regularly fast. Just before their wedding, they moved into a brownstone in Harlem, which they had renovated together.

On October 28, they were married at Abyssinian Baptist Church on West 138 Street, in a wedding with the Rev. Calvin O. Butts and the Rev. Dr. A. R. Bernard, Sr., officiating. The ceremony was like a conversation with the couple—spiritual, philosophical, probing and unhurried.

But it was not without glamour. "Alisa sparkled all the way down the aisle," said Liz Bruder, a guest who is a vice president at the Architects and Designers Building in Manhattan. "Her headpiece looked like a giant diamond bracelet wrapped around her hair. It was very poetic."

After the ceremony, 150 guests gathered for dinner at the Union Theological Seminary on 120 Street. Ken Frydman, who was a spokesman for Mayor Rudolph W. Giuliani during his mayoral campaign, said that friends of the groom had wondered for a long time when or if he would ever marry.

"Joe had everything a mate could want," Mr. Frydman said. "It was a conundrum. How does the perfect catch remain at liberty for so many years? Women often tell you there aren't many great ones. Joe was a great one."

Lorraine Sheahan *and* Alexander Lee MAY 25, 1996

> "I'm more of a free spirit and Alex reminds me to take my vitamins."

When it comes to food, Alexander Lee, thirty, seems hopelessly in love.

There are dishes and recipes he can't get out of his mind in the middle of the night, like the seaweed bread he once ate in France or the mango foie gras he's currently experimenting on. On Sunday, his only day off from his job as the chef de cuisine at Restaurant Daniel in Manhattan, he relaxes by playing squash in the morning, then preparing a five- or six-course dinner at home.

"He's so passionate about cooking, it's like someone who wears glasses and can't see without them," said Lorraine Sheahan, twenty-eight, a few days before she was married to Mr. Lee. "He doesn't feel normal when he's not cooking."

Mr. Lee and Ms. Sheahan met in 1984 when she was attending Wantagh High School in Long Island and he had just graduated from there. He was unlike anyone she had ever dated, she said. On Saturday nights, instead of going to rock concerts or beach parties, he would cook chocolate mousse for her and talk about herbs, rain, the color of tomatoes and the smell of rosemary. The couple broke up after a few years but she stayed on his mind as persistently as the seaweed bread, and he on hers.

Ten years later, she was living on the Upper East Side, working in a SoHo art gallery, taking dance classes and eating frozen eggplant Parmesan dinners almost every night. He was working about fifteen hours a day cooking at Le Cirque, a few blocks away from her apartment. They ran into each other occasionally in the neighborhood and eventually arranged to get together.

"We went out for coffee and caught up, and I definitely got those pangs of remorse," said Ms. Sheahan, who is now a trompe l'oeil artist. "I have never had the same connection with anyone that I had with Alex."

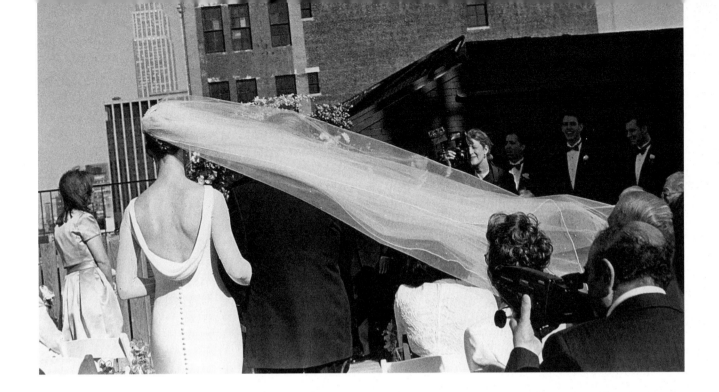

She recalls how the romance was very slowly "rekindled over art-house movies and dim sum."

Now, the couple share a duplex apartment on the Upper West Side, where Mr. Lee grows flowers, strawberries, radishes and forty different herbs on the rooftop of their building. He makes homemade mint teas and herbal face cleansers and does all the food shopping, cooking and worrying about their protein intake.

"I'm more of a free spirit, and Alex reminds me to take my vitamins and look both ways before I cross the street," Ms. Sheahan said.

Mr. Lee also meticulously prepares and plans Ms. Sheahan's meals for the week. Every day, she leaves for work with a lunch box filled with dishes like lobster with avocado, olives and a fava bean coulis. "I really believe there is truth to the saying that the way to someone's heart is through their stomach," Mr. Lee said.

The bride's mother, Jerry Sheahan, cannot believe her daughter's luck. "I do not know anyone whose husband ever said, 'Oh, darling, sit down and I'll make dinner for you,'" she said. "In my day, the wife would have to be in an iron lung for that to happen."

On May 25, the couple was married at Studio 450, the penthouse and rooftop of an industrial building on Thirty-fourth Street near Tenth Avenue. They look their vows on the roof, which is much like their roof at home—rough, urban, windy, decorated with flowers and very romantic.

After the ceremony, there was a feast prepared by the bridegroom's colleagues at Daniel. It began with hors d'oeuvres like caviar blini and lobster, laid out on tables on the roof decorated with four-foot-tall ice sculptures.

Ed Levine, a food writer and squash partner of the bridegroom, stood at one table talking about how the tale of two old sweethearts reuniting was one he especially appreciated. "Love is like food," he said. "A great meal, or someone you're really attracted to, can stay on your palate forever."

Kate Blow *and* Kevin McGloon

MAY 4, 1996

"As a bachelor, I was so tired of hearing, 'You'll know when it's right, you'll hear bells.'"

Kate Blow and Kevin McGloon live in Brookmont, Maryland, a neighborhood on the Potomac River that is filled with kayakers, mountain bikers, environmentalists and overgrown rather than manicured yards.

Like their neighbors, Ms. Blow and Mr. McGloon recycle nearly everything, own a dog (a golden retriever named Clifford), buy live Christmas trees and replant them and never use herbicides on their lawn. For presents, they often give each other living, growing things. The bride, a tall redhead who loves trees and plants, even has affection for Mr. McGloon's large collection of spider plants. On his recent thirty-fifth birthday, she gave him a dogwood sapling.

Ms. Blow is thirty-three and a vice president of community relations at Environmental Issues Management, a Washington consulting firm. She travels around the country constantly, acting as a liaison between companies doing toxic waste cleanups and the people in nearby communities.

"Kate is an environmentalist-in-a-suit," said Mr. McGloon, a senior vice president in commercial real estate at Smithy Braedon Oncor International in Washington. "She's got the green heart. She really believes in saving the earth."

The couple, who met at a party in Washington two years ago, have a lot in common—both run, mountain-bike, rarely wear black and like to spend evenings walking with Clifford by the river. They grew up in Connecticut, he in Darien and she in Fairfield. As Mr. McGloon put it, "We have the same data banks."

He added, "As a bachelor, I was so tired of hearing, 'You'll know when it's right, you'll hear bells go off' and all that stuff. I really didn't believe it. But when I met Kate, it happened."

Their wedding on May 4 was traditional and botanical at once. The ceremony took place at the Easton Congregational Church in the tiny town of Easton, Connecticut. To get there, you drive for miles through an evergreen forest, along the banks of a reservoir, before arriving at the church which is surrounded by old dogwoods. Furnished with wooden benches, clear windows and bare white walls, it looks like a space where someone might practice the harp or meditate for hours.

"The congregational theme of simplicity dovetails with Kate's environmentalism in the sense that you don't have things you don't need," said Richard Blow, a brother of the bride and a senior editor at *George* magazine in New York.

Before the ceremony began, it was possible to look through the windows and see the wedding party gathered around the trees, the groomsmen in pale yellow linen pants, navy blue jackets and periwinkle ties; and the bridesmaids in matching yellow shifts and carrying bouquets of flowers in various shades of lavender, periwinkle and cream.

The bride, who grew up in a house surrounded by gardens, chickens, ponies and dogs, looked as if she belonged in the woods—her dress was decorated with silk cabbage roses and green leaves and in lieu of a veil, she wore flowers in her hair. Following the tradition of wearing something blue for good luck, she placed a violet in her shoe.

The ceremony also had an environmental theme. A hymn praising roses, snowfalls and other natural things was sung and the officiants, Rev. Molly McGreevy, an Episcopal priest, and Rev. Craig Reynolds, the pastor of the church, encouraged the couple to make their home "a symbol of those living together in peace."

Afterward, everyone drove to a reception at the Fairfield Country Club in Fairfield. There, Margie Dwight, a cousin of the bride, described the couple this way: "Kate has boundless energy. She's like a comet—you can't catch her tail. Nor can you ever get her real voice. It's always her voice mail. If Kate's like a comet, Kevin is the one who stays in place so she knows where to come back to. He has both feet firmly planted on the ground."

Judy Collins *and* Louis Nelson

"She said,
'We should get
married.'
I said, 'That won't
keep me from
dying.'"

Judy Collins, the singer, and Louis Nelson, a designer of everything from album covers to the Korean War Veterans Memorial Wall in Washington, D.C., met on April 16, 1978. They were introduced by friends during an ERA fund-raiser at the Ginger Man restaurant, which had changed its name to the Ginger Person for the evening.

A feminist and a strong supporter of women's rights, she pursued him without inhibition. "She called me the next few days every day," Mr. Nelson recalls. "I was flabbergasted that she would be interested in me. She was a star. I owned all of her records."

Several days after they met, they went out to dinner, and, as he remembered, they "talked about those things like, you know, the handle of a cup and the rim touching your lips, and purple and green." The conversation went so well they have lived together ever since.

These days their social schedule is glamorous—during a recent week, they went out with Patricia Duff and Ron Perelman, Princess Margaret and Erica Jong on three consecutive nights. Yet in many ways, they still seem like a young, open-minded, down-to-earth couple from 1978.

They share a rambling Upper West Side apartment filled with colorful candles, guitars, an adopted tree that grew too large for a friend's apartment and oil paintings, not necessarily framed. The spend weekends in their country house in Connecticut, where she likes to record dreams in her journal and he paints watercolors or repairs the wind chimes.

In conversation, they talk about angels, peace, the design of toasters, therapy and the importance of equality in relationships. In a recent interview, they were even careful to talk for equal amounts of time. "If we go out to dinner, I pay one night, he pays one night," Ms. Collins said. "One takes care of the city house and

one takes care of the country house. We don't carry scales but we share equally."

In their years together, the two have been through almost everything but a wedding. Ms. Collins's only child, Clark, committed suicide four years ago. Three years ago, Mr. Nelson suffered a ruptured appendix and was near death for several days, with Ms. Collins by his side.

"She held on to me," he recalled. "She brought me crystals and a cross and smiles. She said, all pensive and serious, 'We should get married.' I said, in a Demerol fog, 'That won't keep me from dying.'"

On Tuesday, April 16, the eighteenth anniversary of the night they met, the couple was married at Cathedral of St. John the Divine in Manhattan, two hundred and eighty guests including Peter Yarrow, Gloria Steinem, Bill Moyers, Susan Cheever, and Donna Shalala, gathered in the Great Choir area, surrounded by the cathedral's craggy stone walls.

The couple arrived with their wedding party, a group of women in lavender satin gowns and men in morning suits winding their way through the canyonlike cathedral behind three vespers carrying candles. Ms. Collins sparkled and flashed like an S.O.S. signal—she wore a white shirt with rhinestone buttons, a long matching skirt, a white overcoat and a rhinestone-studded veil.

During the ceremony, the bride and bridegroom each stood up and told the story of their relationship in their own way. Ms. Collins sang a song she had written for the wedding standing on the altar with her veil flickering. "I was a gypsy soul," she sang. "When you found me in the darkness."

One of the most moving moments of the ceremony came when everyone stood and sang "Amazing Grace" together. As many in the crowd knew, the bride had sung "Amazing Grace" at her son's wedding, her granddaughter's christening and her son's funeral—with Mr. Nelson by her side each time.

"This wedding today is an affirmation of life, which contains both sadness and joy," said Iris Bolton, a guest. "It was a marriage of two souls who have risen above the pain of life and reminded us all to do the same."

Afterword

Four months after we met, my husband proposed to me one afternoon when we were sitting on his living room couch, which was about as comfortable as sitting on a log. It was not a fancy proposal. It was more of a conversation that began with his asking, "What do you think of the M word?" He didn't have a ring; we didn't break out champagne afterward or even call anybody. I do remember time slowing down practically to a halt— for me, it was the longest day of the year.

While I was planning the wedding, my biggest fear was that I would become obsessed about china patterns and trousseau items and forget all about my work, current events or even who was president. I was terrified of becoming a person who carried around lists with starred items like "Find lipstick to match hosiery."

It showed in the wedding. I was too busy to look for bridesmaid dresses, so my mother chose ones that were the color of cherry Kool-Aid and shaped like little Christmas trees. We didn't bother to get to know the minister who married us, a mistake. He ended up talking at length during the ceremony about madness, menopause and women. I wore my mother's dress (no time to shop), which fit me poorly—all night, it felt like the hem was caught on a branch or something.

Believe it or not, I look back fondly on my wedding, although I never developed the pictures because that would fall under the category of "too much information." I remembered plenty about the night.

But I now appreciate details like the flowers in the bouquets perfectly matching the lipstick of the brides-

maids. Or maps to the wedding that are drawn by the couple and decorated with their doodles and thoughts on love. Or invitations with baby pictures of the bride and bridegroom on the cover.

Whether you're getting married in a funky or traditional wedding, on the beach or in a cathedral, the details are what give it mood, beauty, humor and insight. They are what make you cry and a wedding that doesn't make you cry is like sunshine that doesn't warm you. It's not the end of the world, but it feels like it.

Because planning a wedding can be like making a movie—there's chaos, exhaustion, huge expenses and lots of costumes involved—here are some thoughts on how to make it fun and beautiful and something everyone you know will want to watch.

The Invitations

Invitations are the first detail that people see. Traditional hand-engraved invitations have their own kind of beauty—they are weighty and luxurious and stand out like a letter from the nineteenth century lying among all the usual bills and postcards. Like cashmere sweaters, they never go out of style and many couples choose them because it is a way to connect with other generations.

"Great life occasions are times when we want to be in

the continuum of tradition," says Joy Lewis, the proprietor of Mrs. John L. Strong Fine Stationery in New York City. "When you embrace tradition, it's like embracing all of the brides who came before you. But we don't suggest stopping the clock. We worked with a bride recently who ordered very traditional hand-engraved invitations with traditional wording on a 'stiffy'—a heavy card. But she chose an acid green border instead of the traditional gold. That was her touch of the contemporary. Another woman put her e-mail address on a very proper response card."

On the other hand, more and more couples are making their invitations at home—by hand or computer—and adding personality, color, Polaroid photographs, their own words and even sparkle dust to them.

There are couples who invite their guests over the phone and ones who make short stories out of their invitations, writing several pages on everything from how their astrological signs are compatible to their first impressions of each other. The best invitations I have seen fall somewhere in between a phone call and an autobiographical essay. Here are a few suggestions and thoughts:

One couple who met in a bookstore sent out appropriately literary invitations—bookmarks placed inside romance novels from the 1940s that they found in used bookstores.

Another couple getting married on an apple farm in Massachusetts made their own from plain white paper and photographs of themselves. On the cover of the invitation was a close-up color photo of the bride and bridegroom in the front seat of a car, looking back at the camera. The caption below read "You're invited . . . to Caroline & Peter's Rendezvous with Destiny."

Inside, there was a photo of the couple playing miniature golf glued to the paper and the words "Together with our parents, Caroline Anne Cleaves & Peter Pearmain Thomson invite you to join us in celebrating our very excellent wedding."

Another couple created their invitation at home on their Macintosh computer and mailed them in white poster tubes. The only problem was that the bridegroom's mother almost didn't open it. "She thought it was a detergent sample," said the bride.

The most romantic invitation I ever saw had a drawing of two different shoes on the cover, with a caption that read "A Wonderful Pair."

I think the most beautiful invitations are made by small letter presses, whose owners tend to be perfectionists and iconoclasts. They don't advertise a lot; you have to search them out. But it's worth it, especially if you're thinking nontraditionally. Their invitations stand out in the mail like traditional ones, but in a more modern way. With a small press, you can choose almost any kind of lettering and any type of paper—from bark rough enough to file your nails to paper with wildflowers woven through it.

Don't forget to have fun addressing them. It's an important ritual. As one bride said, "It was so romantic when we were addressing our invitations. We stayed up really late together and he'd tell me a story about an aunt or an uncle or certain friends we hadn't seen in a long time. I'll always remember the things we talked about during those hours."

Also, choose the stamps on the envelopes carefully. Make them like a knowing wink.

The Vows

Taking traditional vows, like sending out traditional invitations, is a way of embracing all the brides and bridegrooms who have come before you. Whether you say traditional Episcopalian vows from the Bible or Greek Orthodox ones chanted for you by three priests as you walk through heavy incense smoke, it's a way of inviting

the past into your wedding. While this may be the age of computers, two-career couples and bridal registration at The Home Depot, you're saying all brides and bridegrooms of all eras essentially go through the same thing and now it's your turn.

Traditional vows are also very private. They do not let guests in on how a couple met or feel about each other, and in some ways, that is how it should be—marriage is one of the most private journeys you can take. It is like getting into a car with only two seats. No one else can go along with you.

On the other hand, when you write your own vows, you do take others along with you—in spirit anyway. Also, composing your own vows can clarify your thoughts, like writing in a journal. I've met couples who wrote their vows together in their favorite restaurant, while traveling through Europe on bicycles, while drinking coffee in an all-night diner hours before the wedding. It's a way to express to each other, as well as to the guests, how you feel about everything from love to cooking dinner to children.

At one wedding I attended recently, the bridegroom recited his own vows, which were basically a list of things he loved and promised to honor about his bride, from her independence and sense of humor to the fact that she was a great gardener. At another, a couple read about fifty different vows between them, covering everything from how they planned to handle finances and arguments to their commitment to improve world peace.

If you write your own vows, they can cover any topic. I have heard couples promise to always listen to each other; to nurture each other's creative spirit; to make each other laugh; to save money for a mortgage together; to encourage each other to take outdoor adventures; to never leave New York unless absolutely necessary.

Whereas traditional vows are found mainly in religious books, nontraditional ones come from the heart as well as any literary source that inspires you. Homemade vows can include quotes from poets (Kahlil Gibran is the most popular), *New Yorker* cartoonists, favorite songs, lines from each other's love letters, diary passages about love and marriage. Reverend Mel Hawthorne, a nondenominational minister in New York, advises couples to collect all of their favorite quotes, poems and writings in a shoebox for several months, then create their vows out of the box.

Sometimes, the simplest vows are the most touching.

One bride wrote two short sentences as her vows, and I still remember them: "Of my own accord," she said to her husband-to-be, "I present myself, my days, my nights and my life. I present them freely and willingly because they cannot be better spent than in your company."

The Dress (and Other Clothes at the Wedding)

Wedding dresses are like first kisses. No one ever forgets a first kiss, as hard as he or she may try.

Some people never even let go of their wedding dresses. I know a woman who was married and divorced in the early 1970s but kept her wedding dress in a beautiful box under her bed for years like a good luck charm.

(When she remarried, she gave it to a child, who wore it as a Halloween costume.) Indian women sometimes preserve their wedding saris, which are often woven with real silver threads, by melting them down into dishes that are displayed in their houses.

Whether your wedding dress ends up as a Halloween costume or a serving dish, on the day of the wedding it is like the North Star. Everybody looks for it and rarely loses sight of it. It's always there, shining just a little brighter than anyone else's attire. And it should feel as right for you as the person you're marrying.

It's easy to buy the wrong one. "Marriage is bigger than any of us and the wedding industry is a force that cannot be controlled," said a woman who was married in 1994. "I went to buy my dress and wanted something very simple and the next thing I knew I had agreed to be strapped into forty pounds of lace. Now, I look at my pictures and I think I was abducted by aliens."

Candice Solomon, the owner of One of a Kind Bride, a bridal salon in New York City, describes herself as "a groovy chick brides can trust." She says that you have to really search for the right dress and listen only to your own heart—not to salespeople, relatives, best friends or onlookers.

"The most important thing is to give yourself time," she advised. "Try on a lot of dresses in a lot of different places. Go back a week later and try them on a second time. That will create a map to lead you to the right dress. By a process of elimination, you'll get closer and closer and eventually you'll get to the magical moment. I call it the 'magical moment' when a woman tries on a dress and feels totally, totally gorgeous. It's the moment she's able to say, 'I love it. This is the one.'"

I've seen brides wear everything from black to blue jeans—and still look beautiful. But the most memorable were more dressed up, such as one who wore antique gold jewelry and a long white Chanel sweater dress and carried a bouquet of tightly packed roses. With those three simple elements, she looked like a woman you might see lounging on a Victorian couch in a John Singer Sargent portrait.

Another wore a sand-colored sleeveless gown, a shoulder-length veil with a polka-dot border and a cameo pendant hanging on a pearl necklace. She traveled to her wedding in a horse-drawn carriage with the bridesmaids, who matched her perfectly in sand-colored paisley dresses. Their wedding party wound up and down the country roads, looking like a modern version of a wedding party out of a Jane Austen novel. I have never been one to believe in coordinating colors or outfits but it works at a wedding, in part because that is a time when two people are coming together to complement each other (in every sense of the word) for life.

Still, more and more bridal parties are uncoordinated and nontraditional in spirit as well as clothes. Some brides don't even know what their attendants will appear in; they simply ask them to wear everything from a favorite dress to their personal interpretation of black tie.

Others have coed wedding parties—"bridesmen" as well as bridesmaids. At one recent wedding, the bride's coed attendants were simply asked to wear clothes with a burgundy theme. While none of their outfits was even remotely alike—they ranged from a skintight slinky gown to overalls—watching them walk down the aisle was as entertaining as watching a fashion show.

It used to be that every bridegroom wore a tuxedo with a formal, sometimes ruffled, shirt and looked like the wedding photographer. Recently, I've seen a groom in an olive green Armani suit with a white bowler hat and sunglasses and another in khaki-colored linen pants, a beige vest and a white collarless shirt. More and more also wear old-fashioned morning suits, and look like bridegrooms out of the movie *Four Weddings and a Funeral*. Well-dressed grooms, like coed wedding parties and brides who smoke cigars with the guys, are part of weddings in the nineties.

The Place

The most beautiful spot I know of for a wedding is Chapel Island, in the middle of Saranac Lake in Saranac, New York. Built on a tiny island, the chapel is a handcrafted wooden cottage filled with Adirondack furniture and sitting on a tiny island. You can practically dive into

the water from its front steps. Couples who marry there arrive either by boat in the summer or by dogsled, skis or snowshoes in winter. It is non-denominational and welcomes anyone with an adventurous spirit.

The second most beautiful spot I've seen is All Souls Church in Tannersville, New York, also nondenominational. It is in the Catskill Mountains, at the end of a long country road that winds past weeping willows, dairy farms, general stores and small lakes. The church sits on a hilltop, a gothic stone building surrounded by nothing but flowers, butterflies, trees and the Catskills.

For guests, the wedding, and especially the reception afterward, should be an escape—from everyday life, from cooking dinner, from their living rooms and the nightly news. The dullest receptions usually take place in ballrooms with recirculated air, inedible microwaved hors d'oeuvres, middle-aged ficas trees in the corners and the overall feeling that you're at a business conference. On the other hand, the most wonderful receptions make you feel as though you've just stepped off a plane and everything is new. My favorites:

A backyard tent in Greenwich, Connecticut, decorated with large Venetian glass chandeliers (chandeliers of any kind always look great in a tent).

A candlelit loft in New York City where guests sat at one enormous table that was about as long as an Olympic swimming pool.

A country club in Connecticut where a traditional English garden had been planted outside so guests strolled through it as they arrived.

A wedding and reception at the Ellis Island Immigration Museum in New York, among suitcases and other artifacts left behind by immigrants (the bride and bridegroom's grandparents were immigrants).

A "snowball wedding" where everyone wore white in a small private apartment.

A surprise Halloween wedding where everyone wore costumes, including the hosts who were dressed as a bride and bridegroom. Halfway through the night, it was announced that there would be "a special surprise event" in the living room.

A tea dance reception in a private women's club. Several different teas and tea cakes were served and the women were given dance cards to wear around their wrists.

The Food

Frank Oteri, a bridegroom in this book, said the greatest thing about getting married was that he never had to eat alone again. He didn't mind going to a movie

on a Saturday night alone, walking into a party or vacuuming alone. But eating by himself always made him feel like he had a broken heart, whether or not he actually did. Everyone has a different definition of family but his was having someone to dine with every night.

The best wedding receptions evoke a communal feeling, a sense that everyone is sitting down to a meal to celebrate the fact that this bride and bridegroom will never eat alone again. But receptions are not only about eating together, they are about eating *well*. There is nothing more depressing than a wedding with mediocre food—you feel as though the couple is embarking on years of sharing microwaved mini-quiches and celery with a wobbly line of Cheez Whiz squirted on it.

These are a few receptions where the food as well as the communal atmosphere were particularly wonderful:

A Tucson meal served family style, at tables with lots of hand-painted, mismatched Italian ceramic plates in the center, all filled with different kinds of antipasto and pasta. People helped themselves, and each other.

An afternoon picnic where guests were assigned not to tables but to picnic blankets on a lawn. The blankets were named after flowers, so people were assigned to "Pansy" or "Lily of the Valley." On each blanket, guests found a picnic basket filled with plates, silverware, napkins, bug repellent, a bottle of wine and lunch.

A four-hour six-course dinner at the Plaza Hotel in New York, with buffet tables as long as bowling alleys. Although it was a black-tie wedding with four hundred guests, the bridegroom's mother wore an apron and helped out in the kitchen for most of the night, preparing a few favorite dishes to add to the extravaganza.

A potluck reception, the ultimate communal meal, in a wildflower meadow in Sun Valley, Idaho, where the bridegroom stood up and said to the guests, "Ever since we started planning this wedding, the idea of community has been really important to us. We thought it was important to ask people not only to bring their spirit but also some physical nourishment for the group."

A candlelit dinner for nearly two hundred guests at one long table in an airport hangar. The table was decorated with candles of all different heights; the napkin holders were shaped like huge, plastic diamond rings; and the place cards looked like airplane boarding passes.

At another reception, each table had a different cake as a centerpiece, and when it came time to "cut the cake," the bride and bridegroom did it along with their guests. It was a nice way of sharing the ritual.

But the best "wedding cake" I've ever seen was at a reception in a mansion in Long Island, New York. After dinner, guests retired to a room filled with cakes of all different sizes, colors, shapes and flavors, all displayed on stands like hats in a store.

Flowers

One of my favorite recent weddings took place in a vineyard on the north fork of Long Island. As a fiddler played, the bride walked down a dirt path between the grapevines to a spot in the middle of the vineyard where the bridegroom was waiting. Earlier that day, the couple had driven around town together in their Ford Bronco truck, picking wildflowers from the side of the road for the bride's bouquet, which was filled with daisies, sunflowers and tall grasses. They were an incredibly down-to-earth couple and that was their idea of romance—picking flowers together from the roadside.

Here are some other ideas:

I once saw a bride in springtime walk down an aisle that was lined with tulips the color of easter eggs, planted in terra-cotta pots.

One of the prettiest summer receptions I attended was held under a tent, with white tables and different bouquets of flowers at the center of each table. There was a bunch of sunflowers at one table, lavender tulips at another, pink roses at another, white lilies at another. It was fun, like different Popsicle flavors.

Vases are like picture frames—they make a huge difference, especially if they're interesting. I've seen flowers in everything from mason jars to silver teapots, antique milk pitchers, one-of-a-kind ceramic vases hand-painted by the bride, twig baskets and the couple's favorite coffee cups.

Wreaths of roses or wildflowers look beautiful on brides but even more eye-catching is a choker or an ankle bracelet made of flowers.

I'll never forget a wedding reception in Southampton, New York, that was held so close to the ocean that you could feel the sea spray in the air like an Evian spritzer. Everyone gathered on a large green lawn strewn with pink rose petals. Flower petals are poetic anywhere—on a path leading to a forest ceremony, on a church aisle, on a beach, on tabletops and even on windowsills.

I recently met a very outdoorsy couple who had the most original idea I ever heard for tabletop plantings at a wedding. They covered the tables at their reception with sod, so

that everyone would feel they were eating on the grass in an open field somewhere.

To save money, many couples go to the wholesale flower market, buy several buckets full of flowers and make their own bouquets and centerpieces. Arranging flowers is meditative, fun and great therapy for nervous brides and bridegrooms.

At one wedding I attended in a dark, normally musty church, the aisle was lined with enormous arrangements of flowers and the entire place smelled like an outdoor garden. Sitting in the pews was like sitting on a garden bench. I expected to see birds. Don't forget to consider the aroma of the flowers you choose.

At a wedding in the middle of a snowstorm a few years ago, flowers completely transformed the loft where it took place. Tall white Roman columns were placed throughout the loft and decorated with moss, bear grass, flowering pear branches and privet to look like columns you'd find in a slightly overgrown garden behind an old mansion. Meanwhile, snow covered everything outside like a thick down blanket.

Also, think of decorating unexpected things with flowers—backyard swings, bicycles or sailboats that might be within view, plates on a table. It's like sprinkling magic dust around.

And, if you're wearing something blue for good luck, consider a flower. Kate Blow, a bride in this book, wore a violet in her shoe.

Music

When planning the music for your wedding, think of elevators, movies, high school parties and convertible rides—music always sets the mood. In many situations, music is so important that without it there is sometimes no mood at all. At a wedding ceremony, it often makes the difference between crying and not crying, being bored and being interested, feeling what's going on or just watching what's going on.

I have seen brides walk down the aisle to a fiddler, a harmonica player, a Patsy Cline love song and instrumental music by Enya, the new age Irish singer. One couple in this book, Tracy Horton and Jon Leshay, created their own sound track for the ceremony, a tape of their most favorite songs. Mr. Leshay walked down the aisle to "Here Comes the Groom" by John Wesley Harding, while Ms. Horton appeared to "I Am Calling You," a plaintive ballad by Jevetta Steel.

Opera singers performed at the wedding of Joanna Romano and Joe Restuccia. "When you get married, you go through these incredible highs and lows," said Mr. Restuccia. "Singing, especially opera, expresses that."

Like most other details in the wedding, the music is most poignant when it's personal. At the recent wedding of two ballet dancers in New York, an old friend of the bride played guitar and sang one of their favorite songs. While she was not a professional musician, she belonged there; as she played, all alone on the altar without a microphone, you could imagine her and the bride sitting in a field somewhere, playing guitar and talking.

At another wedding in a Congregational country church, the bride, an environmentalist, chose songs from the hymnal that praised nature. They were played by a lone flutist as guests arrived in the church, which had lots of ladybugs crawling on the clear-pane windows.

At receptions, I've seen everything from boom boxes set up on picnic tables to an all-girl swing band in black mini-dresses to a klezmer band dressed in old-fashioned 1930s suits and fedoras. Looking for a band is like looking for the dress—don't settle for a bunch of mediocre musicians in wrinkled tuxedoes. Search for

magic, in both the way the band looks and plays. You'll find it.

The Memories

One thing many brides and bridegrooms fear, even more than walking down the aisle, is *forgetting* how it felt to walk down the aisle. More than a few people in this book said afterward that their weddings were a total blank to them.

"The whole wedding goes by so fast you can't really believe it happened," Heather Mee said a few days after hers on December 3, 1994. "All I have to prove it really happened are these little contact sheets. I guess I have a whole lifetime for it to sink in."

Weddings are like childhood; you want to remember as much as you can about them, because if you forget, it's like losing the place where you started. While I was growing up, my parents' wedding album was the most special, untouchable book in our house. It was larger than most other books, swathed in protective padding and locked away in a closet with other precious things like fur coats and heirloom jewelry. Whenever my mother unlocked the door and looked through the album, everyone in the house tiptoed and she usually cried. The photos in your wedding album should have that power—

like your favorite movie, you should never tire of looking at them.

In some ways, searching for a wedding photographer is like searching for an interior designer—everyone has a different style, which you will end up living with for a long time. "Having a connection with your wedding photographer is really important because the photos can either make you look the way you want or totally destroy your look," said Lyn Hughes, a wedding photographer in New York City. "If you're a real traditionalist and formalist, if you want the look of royalty, then you should hire a very formal photographer. If you hired an editorial photojournalist, it would be the ultimate disaster because he looks for spontaneous shots—of someone tripping on the dance floor. Traditional people don't like to be caught off guard. On the other hand, a very artsy couple might appreciate that."

Like marriage itself, wedding albums are becoming more and more demystified. My parents would never have thought of carrying around their album, but I met a woman recently who was carrying a little pocket-size, accordionlike album that contained about ten photos. She showed them to me the way she might show someone pictures in her wallet, then slipped them back into her jeans pocket. Another couple I know keeps their wedding album on a coffee table in their living room. Unlike my parents, who looked at their album only once or twice a year, they peruse it all the time, a daily reminder of the promises they made.

While most people try to preserve their weddings through photography, some attempt to capture the feelings that day with all kinds of different nets.

At a wedding in a city park in 1994, the bride and bridegroom passed a conch shell around to their guests and asked them to whisper their thoughts and wishes into it. The couple even whispered their own hopes into it. For them, the shell seemed more effective than a tape recorder which might record their friends' words but not necessarily document the unspoken feelings. Now it sits in their house, like something they brought back from a trip, and helps them remember.

A couple who were married on a beach in 1996 surrounded themselves with sticks of burning insense during their ceremony so that they could bring the day back through smell. Another bride remembers her wedding whenever she walks into her apartment; she framed and hung her wedding dress in the living room.

There are some who think it's more romantic to let the day slip by undocumented and keep no mementos but their own private memories. When the torch singer Andrea Marcovicci got married, she did not attempt to capture the moment in any way. She didn't hire a photographer—in fact, no picture taking was even *permitted* during the ceremony.

"For me, cameras create the smallest twinge of unreality," she said. "It's hard to fully experience the reality of the moment, which is the one thing you want to do when you're making such a magical step. Memory will be fine."

Weddings *are* magical, though rarely the way brides and bridegrooms expect them to be. Everyone says you should feel like a queen and king for a day, but I've never met a bride or bridegroom who did. Getting married is not about fantasy; it is perhaps the most real ritual there is. As one priest said to a couple at the end of their ceremony: "From now on, your lives will never be the same." That is where I think the magic lies in weddings. You walk in single and walk out married. That is a huge transformation, like changing water into wine.

When Congresswoman Susan Molinari got married, she and her new husband, Bill Paxton, drove away from their wedding in a wood-paneled Jeep with a message painted in the back window that perfectly expressed the fear and excitement of suddenly being no longer single. It read "HELP! WE'RE MARRIED!"

Acknowledgments

To begin, I want to thank Kathy Phillips and Jake Daehler, one of the first couples I covered in "Vows." A pair of struggling actors, they taught me that great love stories exist in all corners of the city and that a dream wedding can be made out of a roomful of funny friends and some carrot cake.

I also want to thank all the other couples who have so warmly and cleverly told me their love stories, invited me to observe their weddings, allowed me to ask their friends questions about them and then permitted me to put it into print forever. It is braver than getting married.

Thanks to the editors of "Vows," the toughest, smartest, most direct and inspiring group of people I've ever worked with. Stephen Drucker was the first, and such a perfectionist, I learned to polish the column as if it were a piece of wood—endlessly. Penelope Green, Dan Shaw and Eric Asimov, the next editors, taught me to write about flowers, wedding dresses and clouds of tulle in the least flowery way possible. And Walter Middlebrook, the latest editor, must be thanked for never letting the stories or descriptions get too quirky. He's like the column's lifeguard who says, "Stop! You cannot compare the color of a bride's headpiece to tofu."

Thanks to Henry Ferris, who edited this book in the most perfect way. He was like a ghost who materialized when I handed in a bad sentence.

But mostly, I have to thank my parents, who taught me important but unconventional lessons—to play touch football, listen carefully to the lyrics of Johnny Cash and always leave the keys in the car and the car doors unlocked, because it adds a certain edge to things. This book is dedicated to them because they taught me that in life almost everything is forgivable but chickening out.

And it's dedicated to my husband, Tom Van Allen, and to our son, Will. Together they taught me everything I know about love.

—Lois Smith Brady

Because of the nature of the course, photographers have more people to thank than most. I'm grateful to all those who believed in me throughout the years and, when few could detect a pulse, their kindness to see with their hearts that I was just a late bloomer. To my lovely and former landlady, Norma Martin, who cared for me like a grandmother and refused to put me out when things were lean; to Tony and Babs Abbott and their son, my best friend, Charlie, for being a second family on whom I could always depend; to Lucille and Alvin Boretz, my in-laws, for their never-ending love and support; to all the camera salesmen who lent or sold me a camera for neither cash or credit, but just the promise that I would make good; and to Skip James, Johnny Cash and Neil Young, all who could manage to crack a smile in spite of the most intense heat. All taught me that the trick to life is just to stay standing and keep playing.

I would like to thank those who early in my career decided to give me a chance. In particular, Nick Romanenko and Arnold Browne at *Columbia Spectator* for their constant mentoring; Alex Gregson at *Forbes* and Larry Lipman at *Business Week* for bringing me in off the street from time to time; and Mark Bussell at *The New York Times* for bringing me in off the street for good and giving me a place to hang my hat.

For the production of this book, special thanks should go to Nancy Lee at *The New York Times* for her unfailing support of my photography and for allowing me to run the "Vows" assignment; to Mike Levitas, the project head,

for all his diligence and patience and for his knowing how and when to use the carrot or the stick; to Karen Cunningham, Katherine Pollack, Robin Langsdorf and Marcy Walkow for their help in printing; and to my editor, Tiina Loite, whose dedication to the "Vows" column nearly every week for the past four years and whose work in helping me edit the photographs in this book has played a huge part in making this book possible.

I would like to thank my parents, Edward Sr. and Gloria Keating, both many years to the next world, for all the opportunities they gave me in both life and death. The memories of my pugilist father's credo of "Don't flinch" and my mother's constant claim that this world is as much mine as it is anyone else's have allowed me to live a full life and one without fear.

I want to thank all the couples who invited me and my camera into their lives and allowed me to photograph the most important and intimate day of their lives.

Lastly, and most important, I would like to thank my wife, Carrie, and my daughters, Caitlin and Emily, the two sweetest and funniest kids I know. To Caitlin and Emily I thank them for their intense love and devotion and for allowing their dad to work on weekends. And to Carrie, among everything else, the fact that our wedding still stands as the wildest and most fun wedding I've ever witnessed is a testimony to her enthusiasm and her love of life. Her total support and understanding, more than anything else, led to this book. I dedicate the photographs in this book to her.

—Edward Keating